Fashion and Masculinities in Popular Culture

'This book makes an invaluable contribution to the rapidly emerging field of masculinity and gender studies by providing innovative, critical insights into the impact of historic and contemporary popular culture icons and archetypes on the formation and expression of male identity and multiple masculinities. This engaging exploration of the origins and existence of contemporary male icons from vampires and hipsters to Barbie's Ken, exposes the socio-cultural contradictions that they espouse in their representation of dynamic masculinities. Finally we have a book that will spark lively interactions in the classroom and nuanced debates in future scholarship.'
—*Anne Peirson-Smith, City University of Hong Kong*

Popular culture in the latter half of the twentieth century precipitated a decisive change in style and body image. Postwar film, television, radio shows, pulp fiction, and comics placed heroic types firmly within public consciousness. This book concentrates on these heroic male types as they have evolved from the postwar era and their relationship to fashion to the present day. As well as demonstrating the role of male icons in contemporary society, this book's originality also lies in showing the many gender slippages that these icons help to effect or expose. It is by exploring the somewhat inviolate types accorded to contemporary masculinity that we see the very fragility of a stable or rounded male identity.

Adam Geczy is Senior Lecturer and Chair of the Faculty Board of Sydney College of the Arts, University of Sydney, Australia.

Vicki Karaminas is Professor of Fashion and Deputy Director of Doctoral Research at the College of Creative Arts, Massey University, New Zealand.

Routledge Research in Cultural and Media Studies

For a full list of titles in this series, please visit www.routledge.com.

104 Politics, Media and Democracy in Australia
Public and Producer Perceptions of the Political Public Sphere
Brian McNair, Terry Flew, Stephen Harrington, and Adam Swift

105 Spectral Spaces and Hauntings
Edited by Christina Lee

106 Affective Sexual Pedagogies in Film and Television
Kyra Clarke

107 Tracing the Borders of Spanish Horror Cinema and Television
Edited by Jorge Marí

108 Screen Comedy and Online Audiences
Inger-Lise Kalviknes Bore

109 Media Representations of Anti-Austerity Protests in the EU
Grievances, Identities and Agency
Edited by Tao Papaioannou and Suman Gupta

110 Media Practices, Social Movements, and Performativity
Transdisciplinary Approaches
*Edited by Susanne Foellmer, Margreth Lünenborg,
and Christoph Raetzsch*

111 The Dark Side of Camp Aesthetics
Queer Economies of Dirt, Dust and Patina
*Edited by Ingrid Hotz-Davies, Georg Vogt,
and Franziska Bergmann*

112 The Materiality of Love
Essays on Affection and Cultural Practice
Edited by Anna Malinowska and Michael Gratzke

113 Fashion and Masculinities in Popular Culture
Adam Geczy and Vicki Karaminas

Fashion and Masculinities in Popular Culture

Adam Geczy and Vicki Karaminas

Routledge
Taylor & Francis Group

LONDON AND NEW YORK

First published 2017 by Routledge

2 Park Square, Milton Park, Abingdon, Oxfordshire OX14 4RN
52 Vanderbilt Avenue, New York, NY 10017

Routledge is an imprint of the Taylor & Francis Group, an informa business

First issued in paperback 2019

Library of Congress Cataloging-in-Publication Data
CIP data has been applied for.

ISBN: 978-1-138-65868-4 (hbk)
ISBN: 978-0-367-33318-8 (pbk)

Typeset in Sabon
by codeMantra

Contents

List of Figures vii

Introduction 1

1 Vampire Dandies 7
The Dandy 9
The 'Crisis' of Masculinity 14
Metrosexuality and the Cult of Self 19
The Vampire of Capital and Commodity 20
Queer Vampire Masculinities 24

2 Playboys 33
Commodified Masculinities 34
On the Virtues of Bachelorhood 37
The Bachelor Pad, or the Sexual Lair 40
James Bond 007 41
Fashioning 007 44

3 Hipsters 48
The White Negro 51
Hipster vs. Beatnik 53
Hipster Style 58

4 Sailors 67
Men in Uniform 68
The Seepage of Sailor into Life and Lore 72
Sailors Big and Small 74
Disciplined but Naughty Boys 76
Bell Bottoms and Fly Fronts 78
Sailor Chic: From Boardwalk to Catwalk 79

5 **Cowboys and Bushmen** 85
Unknown Frontiers 90
Celluloid Cowboys 92
The Australian Bushman 95
Bush Wear for Bushmen 98

6 **Leather Men** 104
Reel Men 106
The Black Leather Motorcycle Jacket 110
Leathermen 111
Men of Rock 114
Greasers and Punks 116

7 **Superheroes** 120
The Origin Stories 121
Masked Masculinity and the Phallic Hero 123
The Costume, or the Superhero's Struggle with Fashion 126
The Fabric of Superheroes 129
Everyone's a Superhero: Role-Play and Cosplay 131
Who Does Batman Bat For? 133

8 **Gangstas** 139
'Ghettocentricity' and Street Cred 141
Early Gangstas Style: Pachucos and the Zoot Suit 142
Leave Political Correctness at the Door:
 Gangsta's Paradise 146
The Tyranny of Masculinity 149
White Gangstas 153

Conclusion: Men Without Qualities 160

Bibliography 163
Index 177

List of Figures

1.1 A Member of Water's Club. George Arents Collection, The New York Public Library. 10

1.2 Lord Byron. The Miriam and Ira D. Wallach Division of Art, Prints and Photographs: Print Collection, The New York Public Library. 12

2.1 Cary Grant. Billy Rose Theatre Division. The New York Public Library. 34

2.2 Rock Hudson. Billy Rose Theatre Division. The New York Public Library. 35

3.1 Cab Calloway in Zoot Suit Performing on Stage. The New York Public Library. 58

3.2 James Dean. Billy Rose Theatre Division, The New York Public Library. 61

4.1 Sailor (present day). George Arents Collection, The New York Public Library. New York. 70

4.2 Kaiser Wilhelm II in 1861. The Miriam and Ira D. Wallach Division of Art, Prints and Photographs: Print Collection, The New York Public Library. New York. 71

5.1 Cowboys Shooting Craps. The Miriam and Ira D. Wallach Division of Art, Prints and Photographs: Photography Collection, The New York Public Library. 87

5.2 A Serious Problem. The Miriam and Ira D. Wallach Division of Art, Prints and Photographs: Photography Collection, The New York Public Library. 92

5.3 Ned Kelly in Chains. Charles Nettleton photographer. Dolia and Rosa Ribush Collection. State Library of Melbourne. 96

5.4 Bushmen's camp in bush; Men and Australian stock horses at a camp by a river. Aston Wood photographer. Australian Post. Circa. 1939–1947). State Library of Melbourne. Public Domain. 97

5.5 A young bushman wearing an akubra hat riding an
 Australian stockhorse mare. Private Collection. 100
6.1 Vivian Leigh and Marlon Brando in the motion picture
 A Streetcar Named Desire Billy Rose Theatre Division,
 The New York Public Library. New York Public Library
 Digital Collections. 105

Introduction

> The man who is rich and idle, and who, even if blasé, has no other occupation than the perpetual pursuit of happiness; the man who has been brought up amid luxury and has been accustomed from his earliest days to the obedience of others—he, in short, whose solitary profession is elegance, will always and at all times possess a distinct type of physiognomy, on entirely *sui generis*.
>
> Charles Baudelaire[1]

With this long and languid sentence, Baudelaire opens his section on the dandy in his *Painter of Modern Life*. The dandy crops up elsewhere throughout the text, affiliated with the free, rambling urban wanderer, the *flâneur*, and is an embodiment of modernity itself. 'Modernity', by Baudelaire's reckoning, is 'the ephemeral, the fugitive, the contingent, the half of art whose other half is the eternal and the immutable'.[2] The dandy is a furtive and slippery figure that nonetheless guards an intangible essence. The dandy is for Baudelaire an entirely male domain. By contrast, Baudelaire's description of women is generic, female types are relatively contingent. Differences of class and fortune may pertain, but the dandy stands out for the way in which he creates a special domain for himself that seeks independence of material economies, and instead enters a world of abstractions. In short, the idea of a male type is something that is modern and is the province of men.

This seems like a particularly challenging distinction, and at first glance opens a great deal of the criticism and conjecture. It discounts the presence of the female dandy, the *gamine*, the coquette, and many others. Yet these are not quite the same as the male types that burgeoned in Baudelaire's time, but which became most discernible by the second half of the twentieth century, climaxing at the turn of the millennium. It is as if the male, the holder of subjectivity and the gaze over the objectified female, as arbiter of the phallic order is therefore capable of occupying certain roles. These roles are what enable them to exert their subjectivity. Yet it exposes several problems with the status of male subjectivity itself. The first is that males require these types to mobilise their subjectivity. The second is that, beginning with the dandy himself, character

types are not irreducible. And most ironic of all is that this irreducibility also means that lines of sexuality become increasingly blurred: from the muscle man to the cowboy, they become touchstone for gay as much as straight men, often in overlapping domains. Finally, the male icon has become a compelling way of understanding the way in which men assert, frame, and understand themselves in contemporary society. While masquerade has been discussed a great deal by feminist theorists in terms of framing identity, it remains relatively under-theorised when it comes to men. In short, what has come to evidence, and which is one of the central arguments of this book, is that male subjectivity is stalked, or haunted, by icons and types, which in a different way from women, have their own differentiating yet also objectifying effect. And while men have sought these types to explore and assert what it means to be male, each of these types proves to have their own particular unpredictability and ambiguity.

The idea of assuming a certain role is a very modern one and an important dimension of a secularised world. Social mobility and freedom entails that it is possible, at least in theory, to choose one's career, as well as other affiliations such as religion and sexuality. In pre-modern times there were identity paradigms but they were narrowly aligned to the nobility, the military, the civil service, and the clergy, all of which were associated codes of conduct. To impersonate someone was to commit a moral crime, whereas the fashion modernity, if we are again to follow Baudelaire, is always some form of dressing up, of masquerade.[3] Modern fashion as it evolved in the mid-nineteenth century was a matter of manipulation and alteration. In his praise of cosmetics, Baudelaire states that,

> Fashion should thus be considered a symptom of the taste for the ideal which floats on the surface of the crude, terrestrial and loathsome bric-à-brac that the natural life accumulates in the human brain: as a sublime deformation of Nature, or rather a permanent and repeated attempt at her *reformation*.[4]

This reformation begins with any enhancement or concealment that may have some perceived improvement in the appearance, or alterations that aspire to conformity with a particular stereotype. We know, for example, the dolls of antiquity were made in the mirror of particular women of eminence in order to help to shape the sensibility of young women, a role model that has indeed been compared with Barbie.[5]

But this comparison also serves to highlight a particular difference germane to the birth of fashion itself, with representation. The beginnings of the fashion system as we understand it today is inextricable from the circulation of fashion images, and hence the creation of 'image' per se, one that was oriented toward the individual as opposed to

sartorial codes and mores linked to god and state. This began with the *affiches* and the *feuilletons* of the eighteenth century, which occurred at the very same time as pervasive circulation of pornography. The link between the two is very important for the purpose of this book, as it helps to state the significance of the way fashion was a means of insertion into a particular way of looking that modulates not desire, but a range of other emotions, from dignity to envy.

Thus the type and the icon are inextricable with the birth of fashion itself. But their full realization only arrives fully with the eruption of mass popular culture after the Second World War. While it has always been commonplace for humans to follow, or emulate a particular image, fictional or otherwise, popular culture in the latter half of the twentieth century precipitated a decisive change in style and body image. Post-war film, the growing pervasiveness of television, radio shows, the proliferation of pulp fiction and comics placed heroic types firmly within public consciousness. Formerly, for men the aspirational uniformed type was largely limited to the military man, but with modern popular fantasy and mythology this tradition, persistent since ancient times, changed abruptly. Society's guardian and saviour were no longer associated with the soldier, but also the superhero. Embodiments of the authentic land warrior found its corollary in the cowboy, while the sinister but sensual outsider was the vampire. History had had their heroes—Jessie James, Ned Kelly, Buffalo Bill, General Custer—but what is striking about the hero of popular culture is that it is wholly or partly imaginary, and having a codified set of attributes that are copied or reinterpreted by people in the everyday life. This book will concentrate on these male types as they have evolved from the post-war era and have persisted to the present day.

The importance of these types goes well beyond flights of the popular imagination to that of being psychological registers for conduct and action. Commenting at the time of the publication of her now well-known book, *Sexual Personae* (1990), Camille Paglia observed that feminism had worked a corrosive influence on male role models such as superheroes, thereby depriving boys of aspirational stereotypes, rendering them directionless and guilty of their popular pleasures. Although she is a controversial figure, the remark sheds light on the dominant role that popular characters and contemporary mythic personages have in moulding personality and in shaping aspiration. If these figures ever had an occasion to dwindle at some point, they were noticeably reasserted with the coming-out of gay culture in the 1970s. Historically, gay men's style found expression in the dandy, a type that was not exclusively gay but which gay men inhabited and helped to create, in all its discernible indiscernibility (the author of the first text on the dandy, Jules Barbey D'Aurevilly, emphasised the difficulty in pinning dandyism down). But while the dandy would continue to live on in many incarnations, another form of gay identity entered society with the hyper-muscular clone,

which became household knowledge with the American disco band the Village People. Every band member of the group performed a masculine stereotype; the cowboy, the American Indian, the construction worker, the policeman, and the leather-clad biker.

Gay culture, with its love of artifice and play, deployed a number of types as forms of queer expression, many of them formerly associated with archetypal heterosexuality, such as the cowboy and the policeman. Indeed, it was at this time that gay male culture, which had always struggled with the stereotype of effeminacy, began to embrace hyper-masculinity, as in the clone and in the hyperbolic male forms in the gay comic by Tom of Finland. Ironically enough, this new face of gay men's style occurred at the same time as the bodybuilding's entry into mainstream culture during the early '80s. Western culture had always valued the Hellenic physique, in life as in artistic representation, but to recreate it with one's body and in proportions well exceeding those of Greco-Roman sculpture, is still a relatively new idea. A critical watershed for bodybuilding occurred in 1977, with the documentary *Pumping Iron* of Arnold Schwarzenegger and his friends (such as Lou Ferrigno, who would later play the Hulk in the television series) preparing for the Mr Olympia bodybuilding contest. In addition to those found in classical sculpture, muscular physiques were also a staple of superhero comics, but in the 1980s it became an increasing commonplace of masculine identity, embraced by both hetero- and homosexuals.

Shifts in body ideals are not only regulated to women, masculine ideals have also shifted across periods from the slim Victorian and Edwardian silhouette to the muscular shaped body of the 1950s and 1960s epitomised by Hollywood icons James Dean, Marlon Brando, and French actor Alain Delon, and made popular through magazines such as *Playboy* and *Hustler*. The über-masculine male portrayed in the Solo and Marlboro Man advertisement campaigns in the 1970s and 1980s depicted the ideal man as rugged, hirsute, and in the company of other men or alone in the wild. Ideal masculinity was represented as synonymous with nature, wild and untamed. From the 1970s onward, gay men began fashioning clothing styles that allowed them to 'blend in' to mainstream culture. It was the birth of the hyper-masculine 'clone' with a standardised dress style consisting of flannel shirt, baseball hat, jeans, army fatigues, and hiking boots.

The 1980s gave rise to the commercialization of masculinity that was made popular by the 'New Man' and the increase of male retail outlets and style magazines such as *Arena*. The metrosexual of the 1990s gave way to the 'lumber sexual' of the new millennium and its latest incarnation, the contemporary hipster.

The new millennium sees the presence of various types that are the symptoms of post-industrialisation and the age of technology. But there is also a radical turn to a specially modified and mythologised past: the

sheer preponderance of vampire books, films, and television series suggests an interest in the vampire that outweighs the basic liking of horror film, and rather suggests that the vampire is a symbolic figure in the era of what Slavoj Zizek refers to as 'end times': ecological degradation, overpopulation, fiscal volatility.[6] The vampire is one who lives on after destruction and in spite of it.

There are roughly two kinds of types, which thickly overlap: the historical and the mythical. Historical figures range from Kublai Khan to Alexander to Napoleon, while mythic types are Hercules or Siva. As historical types sail in history, they are apt to have mythic qualities assigned to them. To be sure, history itself is assailed by these distortions, which it can never deliver itself from, owing to the particular tenor and temperature of the present in which that history is written. What is striking about the twentieth century is the extent to which the two forms become almost indistinguishable, given the proliferation of popular genres such as comics and most significantly, film. There is a litany of memorable roles in historical parts, such as Gene Kelly as D'Artagnan or Christopher Plummer as the Duke of Wellington (or Rod Steiger as Napoleon, or indeed Orson Welles as Louis XVIII in the same film, *Waterloo*, directed by Sergei Bondarchuk in 1970). More recently, history and myth intertwine with historical figures assuming outlandish roles, as in the dark fantasy horror film *Abraham Lincoln: Vampire Hunter* (Timur Bekmambetov, dir. 2012). A film such as this is simply not possible without the infiltration of comics into mainstream cinema, where the conflation of comic narratives (e.g. Batman meets Superman) finds itself in film.

While it is something of a given that the desire to emulate and conform to certain models of appearance and action is an active component in socialisation, but what is very new is the way in which, most noticeably since the 1960s, men express their social and sexual identity through the vector of particular types (or stereotypes). While to some extent traceable to historic or mythic figures, they are not reducible to them. Rather, from the cowboy to the playboy, they are objectified manifestations of social roles and commodified identities constructed through marketing campaigns. And to a greater or lesser extent these roles exist only as floating signifiers, unmoored from their original function. Hence the cowboy clone as seen in a city may not even know how to ride a horse, and the playboy may be content to look as such and not go to the effort to womanise. But what is also curious is that this kind of personal, signifying typology emerges at roughly the same time as the gay and lesbian pride movements (an historical marker is Stonewall of June 1969), and when straight males were made to reflect on their own sexuality as a result of first and second-wave feminism. As a result, these icons help to effect or expose numerous slippages in gender. It is in the desire to find something definite, through becoming a character presumed desirable,

that the indefinite emerges. By exploring the somewhat inviolate types accorded to contemporary masculinity, we see the very fragility of a stable or rounded male identity.

Taken from a political and philosophical standpoint, this book is very much a politics of the male self, and the different forms in which such politics are played out. It is instructive, for instance, to see the extent of the difference between the hipster of the 1960s and 1970s and the hipster of today: in many ways the smug and politically emasculated contemporary hipster is a personification of the crisis of class struggles and the widespread disenchantment with democracy. Today's 'gangsta', evolved from the gangland youth of the early twentieth century, are embodiments of clubbed street culture and in their lurid, brash aesthetics, a formal fillip to traditional canons of good taste. And the playboy is the epitome of self-interested and self-assured consumption.

The chapters in this book examine what we view as some of the more recurring and tenacious male types as they have emerged out of history, literature, lore, and popular culture over the last century into this. It is a roll call that is not exhaustive. Indeed, there can be no such list, as these types are perpetually mobile and permeable. Take, for example, the playboy as seen through the lens of James Bond: there is a marked difference between the Bond played by Pierce Brosnan and that by Daniel Craig. But somehow the image, the conception of the playboy, while irreducible, remains coherent and intact. These studies will traverse the history, the paragons, the circumstances, the literature, the narratives, and the images that have all contributed to one or another male identity. In doing so, these studies expose some ambiguous polarities, which extend not only to gender itself, but the extent to which personal identity is caught up with clothing, styling, and the narrative expectations inscribed within them.

Notes

1 Charles Baudelaire, *Peintre de la vie moderne*, *Œuvres complètes* (Paris: Gallimard Pléiade, 1954), 906. Translation taken from Charles Baudelaire, *The Painter of Modern Life and Other Essays*, trans. and ed. Jonathan Mayne (London: Phaidon, 1970), 26.
2 Ibid., 892; 13.
3 'If for the necessary and inevitable costume of the age you substitute another, you will be guilty of mistranslation only to be excused of a masquerade prescribed by fashion'. Ibid. bcv.
4 Ibid., 912; 33; emphasis in the text.
5 See Fanny Dolansky, 'Playing with Gender: Girls, Dolls, and Adult Ideals in the Roman World', *Classical Antiquity* 31, no. 2 (October 2012): n. 12, 260.
6 Slavoj Zizek, *Living in End Times* (London and New York: Verso, 2011).

1 Vampire Dandies

For the Western male image, and one that filtered to the rest of the world, the 1980s was very much that of the slim and fashion forward 'New Man' represented in the fashion style press; or, the muscle-clad, hypertrophied body of cinema's he-men. The kind of musculature body made popular in cinema is not achievable to all body types and is potentially dangerous (injuries, steroid abuse). It is also not necessarily always desirable, and, in the end, is simply difficult to sustain, as the demands of life limit the many hours in the gym required for it. As a backlash and as an alternative, the 'New Man' emerged only a small time later, followed by the 'New Lad' and the metrosexual in the 1990s. The metrosexual was a yuppie with a particular accent on appearance and manner that was a kind of urbanised glamour. The explosion of male fragrances in the 1990s and the growing industry of male cosmetics proved congenial to the new male subject, one that appeared to take pleasure in beauty regimes desired by both men and women. The hypermasculine body that was so much part of the Reagan era was in many respects the somatic climax of the Cold War era, an era that conveniently divided the world into a simple binary structure: the Western Bloc, which included America and its allies, and the Eastern Bloc comprising of Russia and the communist states of Central and Eastern Europe. The fluctuating uncertainties of politics after the post-Perostroika era became noticeable on innumerable levels, including, male identities, which became a great deal more fluid and its orientations diverse. The representation of men was noticeably within a space that provoked both men and women to desire and consume the male image. The languid, svelte, brooding, and, above all, enigmatic male type to enter into the new millennium was a particular kind of dandy that had its roots in the nineteenth century decadent aesthete. His eschewal of nature over invention and contrivance also meant a special relationship to sexuality and death that had already been fermenting since the rise of Romanticism at the turn of the century. This love of the gothic emerged in decadent writing from about the 1850s until the end of the century, moving through salons, boudoirs, and private clubs embodying the world of corruption, intrigue, and decay that became associated with the English decadents, the aesthetes.[1]

The aesthetes aspired to set art and literature free from the materialist preoccupations of industrialised society. The metaphor of the vampire was a persistent theme in decadent writing and creative practice. The vampire and its accompanying behaviors and appearances were popular amongst the aesthetes of London and Paris.

In his poem *Giaour* (1813) Lord Byron writes of 'the freshness of the face, the wetness of the lip with blood, are the never failing signs of a vampire'[2]. And then there was Byron's medical practitioner, John Polidori, who wrote the novel *Vampyre* (1819). It is the story of a libertine, Lord Ruthven, modeled on Byron himself, who is an unscrupulous parasite who pursues, seduces, and kills women. Similarly, Bram Stoker's classic horror novel *Dracula* (1897) was written to encapsulate this time of sexual ambiguity and anxiety present in Victorian society where conflicting discourses circulated about proper gender conduct (sexual and otherwise). The vampire embodied the 'spirit of the times', namely decadence, excess, artifice, beauty, and aestheticism. But glamour was always at a price: the *fin de-siècle* decadent maintained a rueful relationship to his delights, awaiting their imminent decay.

Historically the sexuality of dandies could often be ambiguous, and it is also true that men who secretly identified as homosexual would inhabit the dandy persona, there was a discernibly new bent to the character by the end of twentieth century.[3] For the end of the millennium—together with impending ecological disaster and a myriad other interconnected pressures such as overpopulation and social division—had cultivated well-warranted global anxiety. In many ways the seemingly unquenchable public thirst for books, television series, and films with vampire themes and characters for the last twenty or so years is popular expression of such anxiety, as an expression of gloom but also as an antidote: the vampire lives on after the apocalypse. The dandy, the vampire, and the metrosexual are highly eroticised figures. All three figures embody alternatives to the common ways of living and acting and all three have an appetite for what is deemed perverse but which is also secretly desired. More than that, the vampire dandy that has its roots in *fin-de-siècle* literature can be seen to represent the new postmodern, posthuman body, as well as the conclusion of late capitalism itself, which has sapped the life from developing countries, and where the division between rich and poor continues to widen. Moreover, the age of so-called post-democracy, the end of faith in revolutionary change, the perceived indissolubility of capitalism, the doubtfulness of an alternative, all pointed to a circumstance of a death, but a death in which we somehow live on. But to take a dandified stance was to keep some vestigial defiance, and to assert, small as it might be, one's place within the confused and unstructured contemporary continuum. This chapter focuses on the concept of the vampire dandy and its explicit/implicit relationship to the nineteenth century dandy, the vampire, and its twenty-first century incarnation, the

metrosexual. These figures, or models of masculinity, in many similar ways interrogate conventional conceptions of masculinity and sexuality, appearing during times of political or economic crisis.

The Dandy

The dandy is what James Eli Adams calls an 'icon of middle-class masculinity', that emerged in England at the turn of the nineteenth century. The dandy wore clothes that were of a simple design with a clean cut and trim silhouette made of the finest fabrics. Thomas Carlyle described the dandy as

> a Clothes-wearing Man, a Man whose trade, office, and existence consists of the wearing of Clothes. Every faculty of his soul, spirit, purse, and person is heroically consecrated to this one object, the wearing of clothes wisely and well: so that as others dress to live, he lives to dress.[4]

Yet there is no conclusive definition of the dandy. He occupies a space a contradiction, blurring the line between sexual orientation. He was neither heterosexual nor homosexual, but what today we might call queer. His sense of style hovered between exaggeration and discreetness (Figure 1.1). Sima Godfrey identifies this conflict as essential to the dandy's character and entire state of being: 'An eccentric outsider or member of an elite core, he defies social order at the same time that he embodies its ultimate standard in good taste'.[5] Sobriety was a mark of ideal beauty that was characterised by perfectionism rather than ostentatious luxury. The dandy strove for calm and relaxed expression. Simultaneously he was a mixture of smouldering passions and sangfroid hidden depths masked by desuetude—what we might call the romantic epitome of cool. His beguiling presence was imbued with immense calm. As Charles Baudelaire emphasises, 'The dandy is blasé, or pretends to be so, for reason of policy and caste'.[6] At this juncture it is worthwhile to revisit the opening lines of Baudelaire's essay on the dandy: 'The rich, idle man, who is even blasé, has no other occupation than to follow the path of elegance'. He has 'no other occupation than elegance', and is always 'distinct' (*à part*). 'Dandyism is a vague institution' that is 'beyond laws'.[7] It is a compelling definition of the 'everything and nothing' sort. The dandy is the shadow of the conqueror of old, a shadow as he exists in world in which either everything is conquered or he is disable by his own aloofness and desuetude. In this, the dandy is the early modern exemplar of 'cool', wherein the exertion of too much effort is to betray a sense of need for what one does not have. To be cool is to be self-possessed and unencumbered by outside forces or stimuli. Hence as Baudelaire stipulates, dandyism's own laws are beyond 'excessive delight

PLAYER'S CIGARETTES

A MEMBER OF WATIER'S CLUB

Figure 1.1 A Member of Water's Club. George Arents Collection, The New York Public Library.

in clothes and material elegance' and have more to do with cultivating an 'aristocratic superiority of spirit'.[8] Dandyism is an 'unwritten' caste of the 'cult of self' that has the measure of a 'strange spiritualism'.[9] It was a new modern religion of hypostatised but indeterminate subjectivity.

Baudelaire could not have written with such ebullience and conviction if it had not come from himself. The essay is in many ways a self-manifesto. As to his own appearance, Anita Brookner paints a vivid picture:

> ...as a young man he made determined efforts to outwit his dual heredity, the historical and the familial. He dressed with outland-ish distinction: black broadcloth coat, very narrow black trousers,

snowy white shirt, claret-coloured bow tie, white silk socks and pat-
ent leather shoes. He aspired to the form of distinction, emblem of a
highly controlled mental and spiritual life, worn by that curious type
of moral pilgrim and sartorial perfectionist whom he calls a dandy.[10]

His frequent impecunity prohibited him from maintaining such appear-
ances, which he nonetheless sought through affecting defiance that re-
flected a new kind of aristocracy of the spirit of which art and poetry
were the necessary off-shoots. The distinctiveness, separateness (*à part*)
of the dandy is best exemplified by the first great dandy, George Bryan
'Beau' Brummell. At one stage a friend of the Prince Regent himself,
Brummell was known entirely for himself and his appearance. He was
neither an aristocrat nor an artist. He refined codes of fashion and ap-
pearance, stressing simplicity and cleanliness. Today Brummell is read
retrospectively as a progenitor to the artists who made life their per-
formance, such as Leigh Bowery or Andy Warhol, but he was also the
result of the need of certain members of educated society to assert them-
selves on terms that were not those of the established nobility nor those
of the careful (and middle brow) middle class. As Rosalind Williams
observes, 'in a society where the bourgeoisie loudly proclaimed the vir-
tues of thrift, utility and work, the dandy rejected all these values as
vulgar and sordid, and increasingly as irrelevant'.[11] Brummel was the
first great dandy, a precursor to celebrity culture and arguable the first
public fashionista. He played an important role in the modernization of
men's clothing in which embellishment was jettisoned for fine tailoring.
He objected to wearing pantaloons, which was the fashion of the times,
preferring to wear trousers which soon became a staple of men's fashion.
His trousers were always tucked into his boots, giving his ensemble an
equestrian look complete with tailored jacket and cravat. As we wrote
in *Queer Style*, Brummel brought taste to the level of the person. 'Taste
was a common topic of concern for the upper classes of the eighteenth
century in social manners and in the growing field of aesthetics'.[12]

Brummell had innumerable successors, documented and not, notably
the Comte d'Orsay whose studied and extravagant appearance involved
perfumed gloves, rings, furs, velvets, and silks placed together with little
care for restraint. Barbey d'Aurevilly, Baudelaire's contemporary, com-
mented that the dandy 'is always to come up with the unsuspected, what
a mind accustomed to the yoke of rules cannot arrive at using regular
logic'.[13] It therefore unsurprising that the dandy became closely affili-
ated to the bohemian, who also wanted to flout the mores of the middle
classes. There would continue to be a prevailing erotic dimension to the
identity of the dandy.

Another important figure that straddled aristocracy, art, transgres-
sion, heroism, and outsider-dom was George Gordon, Lord Byron, who
would also be an early prototype of the modern playboy (to be discussed

in the next chapter). Byron was a best-selling author and a known phi-
landerer who was also suspected of having had incest with his sister. He
was so famous in his day that he gave birth to what would henceforth
be called the 'Byronic hero', also reflecting the way fiction had conflated
with fact. Many likenesses were made of Byron during his lifetime and
posthumously, and with the exception of the famous portrait of him
in Albanian robes by Thomas Phillips (executed eleven years after his
death), what is common to all is the high open collar, which may or may
not include a loosely tied cravat. Byron often wore brightly coloured
corseted waistcoats and trousers and gloves that were so tight that they
often split. Little has been written about Byron's obsession with dress
and posture, often wearing Turkish turbans and perfecting the look
of 'studied boredom' disinterest and disdain, which became a popular
stance of the dandy (Figure 1.2). His self-enforced exile in Venice and on

Figure 1.2 Lord Byron. The Miriam and Ira D. Wallach Division of Art, Prints
and Photographs: Print Collection, The New York Public Library.

Lake Geneva gave him the aura of an outcast, helped in no small part by his own semi-autobiographical poetic annals, *Childe Harold* and *Don Juan*. Byron's reputation was always a mixed one that combined a sense of doom with sexual profligacy, which made the analogy to vampirism easy to make. It was an association that was only grounded in legends and gossip of Byron's feckless womanizing, but Byron's sexual tastes were not limited to women, and his flight from London also owed itself to his tarnished reputation as a buggerer and pederast. Yet it was not despite, but because of this, that the bourgeois public remained fascinated with Byron who, until this day, symbolises a range of opportunities, talents, tastes, and inclinations related to freedom, nobility and personal sovereignty.

In the nineteenth century appearance, dress, and manners would feature in the dandy and the aesthete, comprising a new modern cult of self, the decadents, whose predilection was for artifice over naturalness. The dandy Oscar Wilde was famous for what he wore as well as what he wrote. He claimed that 'one should be either a work of art, or wear a work of art'.[14] At Oxford and in London in the late 1870s, he became an instantly recognizable figure, dressed in a loose velvet coat, a large flowing necktie, knee-breeches, and black silk stockings, topped off with a wide-brimmed hat and black cape.

Wilde was in every way an aesthete, he was a person who was affected by music and had a great love of poetry and literature. But above all Wilde professed a great love for the twin beauties of art ('art for art's sake') and nature and displayed an indifference to matters of the everyday. Like his fellow decadents of the late nineteenth century, Wilde was interested in cultivating and perfecting the idea of beauty itself, which was exercised via an ascetic regimen of the body (speech, dress, and pose) elaborately articulated through self-disciplinary practices. This self-construction takes place by means of 'asceticism', whereby the subject performs ongoing work on himself in order to 'perfect', or become his own master, or put in another way, a master of a self.[15] For Jean Baudrillard, the dandy was an 'institution' with its own set of self-disciplinary rules: 'Dandyism, an institution beyond the laws, itself has rigorous laws which all its subjects must obey, whatever their natural impetuosity and independence of character.'[16] The Victorian aesthetes developed a 'cult of beauty' that would manifest again one hundred years later in the 'the new man' and the figure of the metrosexual.

In his seminal study of Victorian masculinity, *Dandies and Desert Saints*, Adams writes that masculinity was an ontological reality that was based on 'doing' gender, rather than 'being'. Adam's borrows Michel Foucault's term, *askesis*, to describe the performativity of gender that Victorian men practiced through disciplinary acts. He argues that before non-normative masculine identities (that is, homosexuality) were pathologised and institutionalised (*scientia sexualis*) in the late

nineteenth century, (famously outlined by Foucault in *The History of Sexuality, Volume 1* from 1976), different types of masculinities were not pathologised but were performed.[17] Adam isolates these 'models of masculine identity into five types; the prophet, the gentleman, the priest, the soldier and the dandy'. Adam suggests that these performative masculinities were transgressive, 'because self-discipline perplexes the binaries of active and passive, of self assertion and self-denial, tributes to it frequently confound traditional assignments of gender'.[18] In a nutshell, rather than being defined by their sexuality, as either homosexual or heterosexual, Victorian men *performed* gender as a type of masculinity. In other words, to call a man 'effeminate' during Victorian times was to have no bearing on his sexuality. The question then begs, what conditions allowed for the emergence of the dandy as a model of masculinity and why did the dandy coincide with the appearance the vampire in Victorian literature?

The 'Crisis' of Masculinity

What we now have come to call 'the crisis of masculinity', is not only a phenomenon that can be attributed to contemporary times and the social and political movements of the sixties; feminism, civil rights, and gay and lesbian liberation which rocked the bedrock of 'traditional' (read 'white') masculinity. This so-called 'crisis' first appeared during the shift in the European market economy in the wake of industrialization. Prior to the industrial revolution the English were governed by 'the fixed, invariable, external rules of distinction of rank'.[19] The profound transformation of English culture from an agricultural to an industrialised economy produced structures of class that gave way to the rules of rank and along with it, the Victorian attribute of self-discipline. It was in Thomas Carlyle's words, the passing of 'the old ideal of Manhood',[20] or what Peter Stearns has called 'the unsettling of patriarchal manhood',[21] that revealed the first signs of a 'crisis' that was effecting men's sense of being and belonging. In the West, at least, it would not be for another one hundred years before the bedrock of masculinity would be shaken once again.

The 'New Man', as he arose in the 1980s, was a confluence of a number of factors that had destabilised traditional, white middle class masculinity. The manufacturing and industrial post-war boom of the 1950s created an influx of disposable income that changed patterns of consumptions and encouraged men (and women) to spend on consumer goods. The sexual revolution of the 1960s also heralded a new view on sexuality that considered clothes a hindrance to liberation. It was about this time that the magazine centerfold, a gate-folded spread of a nude or semi-nude inserted in the middle of a publication, took hold. Hugh Hefner, founding editor of *Playboy* magazine, coined the term based

on the traditional pin-up, introduced in America by *Esquire* magazine in 1940.[22] It became so popular that other magazines followed suit. The April 1972 issue of the women's lifestyle magazine *Cosmopolitan* contained a semi-nude centerfold of actor Burt Reynolds as the popular press began depicting nudity in line with the countercultures love of bodily pleasure. Wider social and political movements of the 70s, such as gay and lesbian liberation and civil rights, were also partially to blame for masculinity's displacement. For the measure of success for became the corporate marketplace. What Michael Kimmel calls 'Marketplace Man'.[23] It was also something of a logical consequence of second-wave feminism, which demanded sexual and political equality and a different kind of masculinity from that of the authoritative patriarch. In all, feminist Susan Faludi argues that men 'were surrounded by a culture that encourages people to play almost no functional role, only decorative or consumer ones'.[24] From a commercial point of view this presented a number of advantages, since it opened up a wider range of options for style and self-presentation. Men's magazines were no longer 'men's' magazines, that is, filled with soft pornography and man-to-man secrets and advice as was found in *Playboy*, *Hustler*, and *Penthouse*. Other publications such as *GQ* ('*Gentleman's Quarterly*') and *Arena* presented a new turn that helped both to form and reflect the shifting cultural conceptions of what it meant to be male. An important feature in this new formation of male subjectivity was the extent to which it was carried out in advertising, in retail shops, and the popular press—and rather aggressively. Male subjectivity became a construct at the behest of advertising and marketing discourse, which shaped a range of idealised and eroticised masculine identities. 'The basic approach to these ads', writes Rob Latham, 'involved appealing to consumerist narcissism by fetishizing images of sleek young bodies living a dream of glamorous affluence'.[25] Men were being taught that 'masculinity is something to drape over the body, not draw from inner resources' and that manhood is 'displayed, not demonstrated'.[26]

This 'new man' was also partially a reaction to the aggressive, uncommunicative, and overly phlegmatic 'traditional white' males as represented in American cinema which were a direct result of the fitness movement that was emerging out of California in the late 1970s. Images of body's that were 'buffed' and 'worked' that conformed to strict fitness regimes of 'pumping iron' and the consumption of anabolic steroids began circulating in the popular press as ideal visions of muscularity and masculinity. He-men such as Charles Bronson and Clint Eastwood were so notorious for their limited emotional range that they became fair game for parody. Their examples were closely followed by the likes of Lou Ferrigno, Sylvester Stallone, and Arnold Schwarzenegger, men of inconceivable musculature, made possible by copious steroid use. Some of their earliest roles such as John Rambo (Stallone), Conan the Barbarian

(Schwarzenegger), and the Hulk (Ferrigno) were of emotionally scarred men of unusual taciturnity, who enacted exaggerated performances of masculine rage and virility. It was also a posture that worked well with the hawkish Reagan years that for many were welcomed redemption from the emasculating pacifism of the Carter era.[27] These portrayals of He-men, notes Michael Kimmel, were a direct result of men 'trying to live up to impossible ideals of success leading to chronic terrors of emasculation, emotional emptiness and a gendered rage that [left] a wide swathe of destruction in [their] wake'.[28] Ultimately the 'New Man' saw the prevailing inscrutable bravado of male identity as its own dead-end. Consumer capitalism effectively convinced men that masculinity could only be achieved through buying power and material goods; designer clothes, beauty products, fast cars, and luxurious apartments.

In 1988 the spring issue of *Arena* magazine posed the question, 'How *new* is our New Man?' Other style magazines such as *ID* and *Face* were also active in circulating the image. The journalist Jon Savage defined the new man as 'up to date yet aspirant, recognizable yet admitting a certain kind of vulnerability, still able to be interested, obsessed even, with clothes, male toiletries and new gadgets'.[29] Although not to the extent of the latter day aristocratic dandy, the 'New Man' was openly interested in appearances, not afraid to show emotion and affect, and had a liking for beautiful and things. In many respects the 'New Man' was the olden day dandy in a diluted, consumable, and comprehensible form. Savage adds that style culture 'has effectively helped to fuel a new type of consumption and have codified a fresh marketplace: the 19–45-year-old male'.[30] As the end of the decade presented new challenges that had to be dealt with in more than a unilateral way, the message became significantly clear to men that masculinity could be bought and displayed, as Paul Schrader's 1980 cult classic *American Gigolo* attests.

Richard Gere's character, Julian Kaye, is the embodiment of the solipsistic 'New Man' who works as a highly paid male prostitute to support his taste for luxury goods. He lives in a modern apartment in Westwood, Los Angeles, has a wardrobe of designer clothes (Giorgio Armani[31]), works out in a home gym, and has a penchant for his black convertible Mercedes. He speaks five languages and frequents the best bars and restaurants in Los Angeles. Like all 'New Men' of the times, he feels emotionally empty and misunderstood but gains pleasure in the ability to sexually satisfy women. The focal point of the film is Gere's lean and muscular body, which is often displayed as semi-naked and made desirable and available for consumption to the spectatorial gaze. Julian Kaye is filmed parading and posing in his linen sports jacket and sunglasses on Rodeo Drive, LA's luxury shopping district. Dressed in Armani from head to toe, Kaye is constantly slicking his hair and changing attire throughout the duration of the film. One of the most iconic film scenes in the history of men's fashion is contained in *American*

Gigolo—the wardrobe scene. Topless from the waist up, dabbing in cocaine and singing along to Smoky Robinson, Kaye places ties, shirts, and jackets on his bed and proceeds to match their textures and colours in a dress ritual that he often performs. It is within this scene, John Potvin comments, 'that we realize the materiality and materialism that supports his lucrative career'.[32] Susan Bordo calls Julian Kaye 'sexually suspect', that is, he is narcissistic and overly concerned with his appearance to the extent that of seriously questioning his sexuality. The film contains a homosexual subtext that threatens Kaye's masculinity (emasculation) and his ability to perform sexually. But Kaye is positively heterosexual. This is made evident (and secured) when Kaye tells his pimp that 'he doesn't do fags' In another scene, Kay attempts to protect the reputation of his client by prancing around the antique shop pretending to be her gay companion. Homosexuality is the invisible enemy lurking in the shadows. As Bordo writes in *The Male Body*,

> in every film in which the hero treads just a little too close to what straight audiences might identify as the gay man's world—*American Gigolo*, for example (1980) in which Richard Gere plays a narcissistic male prostitute—extra insurance is required to make sure the audiences don't get confused.[33]

The same can be said of the New Lad and the metrosexual, both of whom skirt dangerously close to homosexuality and queerness but are essentially straight men.

The New Man contained two types of representations, the narcissist and the nurturer in touch with his feminine side, sensitive and emotionally skilled. Emotionally adept, he no longer need feel inadequate ('castrated'). He is less inclined to be faced with the longstanding gender paradigm of women as more emotionally responsive or better verbal communicators of affect. This New Man was as comfortable caring for children and raising babies as he was nurturing his appearance. In many ways, the bias cultivated in the late nineteenth century by founding theorists of fashion such as Georg Simmel, that fashion was the province of female self-consciousness and vanity, had come full circle. By the 1990s, this new man had virtually disappeared and was replaced by the 'New Lad', which was an amalgam of various cultural trends such as depictions in popular culture of men behaving badly, football, and manly undertakings such as hiking and kayaking, aggressive military-derived activities but transformed into what could be called aggressive leisure. As a result this period witnessed the proliferation of 'lad' magazines such as *Loaded, FHM, Maxim*, and *Men's Health*. The title *Loaded* was of course a double entendre on 'loaded gun' and 'loaded with sperm', the gun acting as a metaphor for the phallus. The magazines reflected a growing porn culture, but also a perception of Western manhood in

which the capacity for expressing manhood was more substantive and solipsistic, and a need to end in the producing progeny. The 'money shot' was all that was required.

In the first issue of *Loaded*, which appeared on the newsstand in April 1994, the magazine's editor James Brown wrote;

> *Loaded* is a new magazine dedicated to life, liberty and the pursuit of sex, drink, football and less serious matters. *Loaded* is music, film, relationships, humour, travel, sport, hard news and popular culture. *Loaded* is clubbing, drinking, eating, playing and living. *Loaded* is for the man who believes that he can do anything, if only he wasn't hungover.[34]

The development of the raffish and blustering New Lad was a counter-reaction to the effete and aesthetic New Man. 'Whilst the New Man was caring and sharing, if overly concerned with the cut of his Calvin Kleins', notes Tim Edwards, 'the New Lad is selfish, loutish and inconsiderate to a point of infantile smelliness. He likes drinking, football and fucking, and in that order of preference'.[35] The link with football and fashionable style has always been associated with muscular, lean, and sculptured bodies and 'suit swaggering, sharp looking English laddism'.[36] The influence of gay pornography in the 1990s—via visually erotic discourses that took its materiality from homosexual sex and desire—became a prominent feature of fashion iconography. What became visible, but anathema to the marketed persona of the lad to heterosexual male consumers, was that the contemporary lad and the masculinised and sexualised homosexual had striking similarities from a visually marketed point of view, much as the political horseshow has fascism and communism almost meeting when at their most extreme. Although gay culture still met with considerable resistance from conservative parts of society, it did continue to permeate the media. In the 1990s photographers such as Bruce Weber and Herb Ritts produced fashion images with a distinct homoerotic edge. Other photographers such as Nick Knight and Pay Petri presented a new, preening, almost narcissistic male, self-consciously beautiful and easily objectified.

As such this new imagery depicted men as either actively masculine or passive, thereby inviting men to look at themselves as they also did women. They became objects of desire and for consumption, a dynamic that Latham calls 'consumer vampirism':

> The capitalist market, in its ceaseless hunger for profit infects the consumer with its own vampiric appetites, in the process of conflating relations based on voyeurism, narcissism, and homoeroticism with specifically consumerist desires and pleasures.[37]

This new form of marketing in which the homoerotic became infused in what were formerly 'uninfected' heterosexual imagery marked a new phase in the way the mass market represented sexuality. To have men as the object of scopophilic pleasure was no longer an exception, but increasingly a convention. But this also prompted questions as to who precisely the market for these images were since they were evidently not just directed at gay and bisexual men, but also to heterosexual men *and* women.

Metrosexuality and the Cult of Self

Labels come and go, and by the beginning of the new decade in 2001, the New Lad, with all his loutishness, had given way to the stylish metrosexual, a term coined by journalist Mark Simpson and embodied by the British footballer David Beckham. Beckham's 'narcissistic self-absorption' and his 'departure from the masculinized codes of footballer style'[38] heralded a queer, or quasi-queer, type of masculinity that was attractive in various ways to straight and gay men alike. This sharply dressed metrosexual had a perfect complexion and precisely gelled hair and maintained a strict body regime of bodybuilding, waxing, and laser hair removal. In short, the metrosexual maintained a body that was buff and hairless. In 2007, *Observer* journalist Barbara Ellen wrote of the metrosexual: 'Could it be that post-feminism has created its own Frankenstein's monster? The man who is so like a woman he's unfanciable?'[39] Such retorts beg bigger questions with regard to the solipsism of narcissism and the powers of autoerotism. For just as women since the 1960s objected to the feminist reproach that long nails and high heels were strategies of pandering to male desire but rather acts of self-celebration, the metrosexual could be seen as a grooming machine in which self-love replaced the love of a mate. In short, commodified masculinities such as the New Man, the New Lad, and the metrosexual can all be seen as symptoms of a growing concern with the representation of masculinity and gender norms that have their roots in the figure of the aesthetic dandy, who also appeared at a moment of crisis, rebelling against the encroaching aristocracy. Similarly, the figure of the playboy appeared at a time of post-war uncertainty when men returned from war and questioned their role in society. The playboy and its impact on masculinities is further explored in the following chapter of this book.

Like the New Man, the metrosexual was a consumer of high-end luxury goods, styling products, after-shaves, and cosmetics, and lived in high-end suburbs with the best restaurants and cafés where they could converse with others and be seen. The difference between the New Man and the metrosexual was a matter of timing. Whilst the metrosexual maintained all the attributes of the New Man, he could be read as queer, or straight, or queer and straight. Strikingly, the man's sexuality was

no longer relevant, as the metrosexual supported tendencies that were neither stereotypically heterosexual or homosexual, although often more queer. Making once normative boundaries fluid, men looked at other men who, in turn, took pleasure in being looked at. Cosmetics widened to entire ranges (Biotherm, Clarins), while men were no longer the exception on fashion catwalks. The extent to which women were encouraged through buying products for their male partners is hard to measure but it was certainly a factor. But the idea that now men were subject to the machinations of advertising is to return to the notion of fashion belonging to the domain of the feminine. Yet what is certain is that the new man meant that women were no longer dominant consumers or marketing targets. Historically the dandy was a highly studied and stylised personality, but this fashioning of personal identity was conducted alone or through a small community. For the first time the dandy, or at least a digestible, comprehensible version, had become a staple to the mass market and was delivered to men as a desirable image.

The Vampire of Capital and Commodity

The encounter with the metrosexual and the vampire seems imminent and inevitable. The so-called cult of self that was one of the distinguishing hallmarks of the metrosexual had much in common with the Victorian dandy. One key distinction, however, is that while dandyism was always an elite and rarified system of acting and style, its own self-disciplined and constructed form of aristocracy, metrosexuality, on the other hand, was far more of a construction of mass-consumption.[40] With this aside, both, however, are very much endemic of their time, which is to say they reflected a taste for decadence and aestheticism, and they were responsive to beauty and artifice. And both confounded expected gender roles that leaned toward a hybrid or even queer identity.

In 2008 a spate of vampire fiction, television series, and films became popular entertainment across the globe. First there was *Twilight*, the romantic young adult book series by Stephanie Meyer that was later adapted into a film and television series by the same name. Then there was the Swedish art film *Let the Right One In* (directed by Thomas Alfredson, 2008) followed by *The Vampire Diaries* (2009), a television series based on the novel by L. J. Smith about 'high school femmes and hommes fatales'.[41] The vampire became the 'new James Dean'[42] according to the series writer and executive producer Julie Plec. 'There is something so still and sexy about these young erotic predators'.[43] HBO's television series *True Blood*, created by Allen Ball and based on the Gothic novel, *Dead and Gone* (2009) by Charlaine Harris, then followed suit.

The very striking resurgence of the vampire at the same time, in not only film, but in photography and fashion, is inextricable from the shift in the way masculinity was configured and deployed. For example, in

Robert Geller's Fall 2009 collection in New York, the male models has their hair powdered and their faces made pallid to look like fierce hybrids of vampires and dandies of late nineteenth century Vienna. In the same year vampires were centerpieces of the fashion film *The Golden Mirror* directed by Luca Guadagnino for Fendi. What vampires share with the dandy and the metrosexual is they are too are liminal figures. Not only are vampires at the cusp of life and death, disturbing boundaries, vampires are consuming bodies, with voracious appetites—just as dandies are consumers of art, and metrosexuals of style. Fashion's attraction to the vampire is 'all about the titillation of imagining the monsters we could be if we just let ourselves go', suggests fashion designer Rick Owens, 'we're all fascinated with corruption, the more glamorous the better.... Devouring, consuming, possessing someone we desire'.[44]

The notion of the vampire as sapping the life from people and its connection to economic crisis, and the avarice of capitalism has a fairly solid lineage. Famously Karl Marx in *Capital* (1867) called upon the vampire as a metaphor for the way in which human life is turned into dead labour in order to feed capitalism's unremitting march of consumption and profit. In fact Marx gleaned the metaphor from Frederick Engels who referred to the 'vampire property-holding class' in *The Condition of the Working Class in England* (1854). For Marx the image of the vampire was grafted onto the bourgeoisie who indiscriminately stole life from peasant. The middle class had 'become a vampire that sucks out the peasant's blood and brains and throws them into the alchemist's cauldron of capital'.[45] The corollary with vampirism and consumerist greed was a pervasive one and was a metaphor that also permeated French popular fiction from as early as the 1820s.[46] As Chris Baldick points out, for Marx the basic vampiric relationship was between labour and capital.[47] The process of capitalism is to suck the life out of living labour to make things of abstract value commodities. The living labour of the proletariat was consigned to oblivion by the rule of dead products. These products were not of any benefit to those who produced them; they were not to their immediate benefit but rather to advantage of the middle class. Thus, in chapter ten of *Capital*, Marx states that 'Capital is dead labour which, vampire-like, lives only by sucking living labour, and lives the more, the more labour it sucks'.[48] Embellishing on this point, Slavoj Zizek argues that

> The paradox of the vampires is that, precisely as 'living dead', they are *far more alive* than us, mortified by the symbolic network. The usual Marxist vampire metaphor is that of capital sucking the blood of the workforce, embodiment of the rule of the dead over the living; perhaps the time has come to reverse it: the real 'living dead' are we, common mortals, condemned to vegetate in the Symbolic.[49]

It was about the time that Marx wrote *Capital* that the vampire made its first appearance in English literature with the publication of James Malcolm Rymer's *Varney the Vampire,* published in 1845. Rymer's tale is about a possessed corpse that becomes a vampire and terrorises a village and causes havoc in aristocratic bedchambers. Then followed Joseph Sheridan Le Fanu's gothic novella *Camilla,* a story about a female vampire who preys upon women, published in 1871. Stoker's *Dracula* soon followed in 1897: the novel tells the story of vampire's spirit that lands on the shores of England, well before his earthly body arrives on a ghost ship whose crew are already dead from his monstrous appetite. Several commentators, including Talia Schaffer, have noticed the extent to which *Dracula* was written under the spell of Oscar Wilde, for it was written in a period of extreme paranoia and anxiety about sexuality and the Other, the apex of which had been the Wilde Trial a couple of years earlier in 1895.[50] She argues that Stoker's Count is a dramatic, if extravagant, refiguring of Wilde as an abject and effete monstrosity.[51] In many ways the vampire is the embodiment of the del;icate boudary between sex and death (as is frequently cited, the French expression for a female orgasm is a 'petit mort', a little death), and in many respects a conjunction of extremes. The oblivion of death meets insatiable sexual desire. 'The vampire of folklore', states Paul Barber,'is a sexual creature, and his sexuality is obsessive—indeed in Yugoslavia, when he is not sucking blood, he is apt to wear out his widow with his attentions, so that she too pines away, much like his other victims'.[52]

The depiction of the Victorian vampire as an eloquent and aristocratic dandy whilst simultaneously a menacing threat can be attributed to a series of events that coincided and led up to the publication of Stoker's *Dracula*. The figure of the vampire was the embodiment of fear and anxiety towards the Ottoman Empire and its encroaching Eastern army. The Ottoman Empire's boundaries stretched from modern day Turkey into Eastern Europe and contained a large powerful army that was made up essentially of janissaries, young Christian slaves conscripted from the Ottoman dominions. The British (and French) considered the Ottoman's a threat to Christianity and were often depicted in Orientalist art as dark and menacing and as an emasculated effete dressed in flowing silk robes and turbans. Eugene Delacroix's *Massacre at Chios* (1824) and *Death of Sardanapalus* (1827) depict the Ottoman's as ruthlessly cruel. The Romantic poets, including Lord Byron, considered the intellectualism and creativity of classical Greece (and Rome) as the foundation of the Western world and the Ottoman's as backward and a threat. Greece had been under Ottoman occupation for four hundred years (known as the Dark Ages) and all forms of intellectualism and creativity were squashed or forbidden.

While England was experiencing industrial and scientific growth, Greece was embroiled in a War of Independence staged by Greek revolutionaries

against the Ottomans. The Greeks were assisted by the British Empire and many intellectuals and literati saw it their duty to travel to Greece and fight against the marauding Ottomans including Byron. 'To him Greece was more than a country. It was the birthplace of Homer and Plato of Pericles and Aeschylus. These were the isles of Greece where burning Sappho loved and sang'.[53] Although Byron's intentions were well-founded, he never quite made it to battle, dying of fever in Missolonghi in Central Greece. His heart was buried there under a cascading olive tree and his body shipped back to England for burial along with his curved dagger, sabre, and Turkish slippers which are on display in a glass case at Harrow school library, Byron's alma mater. The central character, Dracula, in Bram Stokers' novel of the same name, was loosely based on Vlad Dracul, the Prince of Wallachia (1448–1477) whose purge and acts of cruelty against the Ottomon Empire were well documented by historians. Prince Dracul earned the cognomen Vlad the Impaler because he would impale his Turkish enemies on poles as a form of psychological warfare as they entered the city.

In other words, we are petrified by the myths around us, condemned constantly to ventriloquise. The emulation of a particular character type is an attempt to confront this, and to capture and identify the symbolic network, to stare it in the face by consciously living it out. In all accounts, the vampire is fraught with the tension of contradictions and personifies real-world anxieties. 'Especially during those post-9/11 times of increased vigilance', states Dylan Foster, 'representations like the *Twilight* [film] series reflect a kind of conspiracy-theory mentality, a fear that there is something secret and dangerous going on in our community, right under our noses'.[54] In Milly Williamson's words, the vampire 'resonates with many experiences of the self in Western modernity for those who do not occupy the normative identity'.[55] One could even go so far as to say that the vampire is an elaborate symbol of those ostracised and marginalised from exclusive mainstream groups, with the mixture of fascination and disgust that this entails. And as someone considered 'not normal', the vampire exists in a zone of uncertainty with regard to life and death, good and evil, man and woman.

In many ways the vampire is the embodiment of the fine between sex and death, and in many respects a conjunction of extremes—one source of the vampire myth is the unsavoury practice of necrophilia, copulating with corpses. Closer to home the vampire symbolises the ineffable space of sexual ravishment and the oblivion of death. 'The vampire of folklore', writes Barber,

> is a sexual creature, and his sexuality is obsessive—indeed in Yugoslavia, when he is not sucking blood, he is apt to wear out his widow with his attentions, so that she too pines away, much like his other victims.[56]

Although present in hundreds of years of European folklore, this association has been exploited at the end of the twentieth century and into the new millennium with the growth of Internet pornography. For what vampirism and pornography share is the absence of 'productive' sexual congress, and rather a gratuitous and endless series of encounters that exist for their own sake as opposed to propagating the species. And it is this relationship between the perverse, solipsistic, unproductive sexuality of vampirism that also allies it so closely to the ethos of queer, inasmuch as queer is queer by very dint of being out of the compass of 'legitimate' procreation (hence the illegalization of buggery and later homosexuality).

Queer Vampire Masculinities

Despite the many depictions of the ferociously heterosexual vampire in film and literature, from Bela Lugosi in *Count Dracula* (directed by Tod Browning, 1931) to Christopher Lee in *Dracula has Risen from the Grave* (Freddie Francis, dir. 1969), many vampire stories of the 1990s onward have taken a different turn. For instance in Poppy Z. Brite's *Lost Souls*, certain encounters between vampires and mortals are distinctly queer, heightening a world of decadence and unaccountability:

> Christian nipped the boy's throat gently, not breaking the skin this time. He ran his hands along the length of the boy's body under the jacket, caressed his smooth bare chest, slipped one hand beneath the belt of the boy's jeans and found molten trembling heat. The boy's back arched; he made a low gasping sound. Christian's tongue found the tender spot under the jaw, and he sank his teeth in…. He clasped the boy more tightly, and their bodies locked together in a final wash of ecstasy.[57]

For now it is best to overlook the popular soft-pornography element of this kind of literature in order to see the way it embraces a concept of queer that began to be shaped at the end of the twentieth century and which continues to evolve to this day. In a relatively early essay (1991), Sue Ellen Case explains that the term 'queer' is one that presents a very different sense of being-in-the-world from one conventionally held. For to be queer is to be the

> taboo-breaker, the monstrous, the uncanny. It is not the *Other* in this arrangement; it gains its effect by continually collapsing the conventional polarity of 'life' and 'death', normality and the unnatural, regeneration and sterility – what is familiar and what is unfamiliar…[58]

The vampire is particularly congenial to this particular type and disposition because the manner of its reproduction is not strictly biological

but transformational, a magical change that can be equated to gay and lesbian 'turning'. Williamson goes so far as to suggest that

> Some post-Freudian theorists have suggested that the vampire signals an end to gender distinctions… the vampire is a subversive borderline figure which problematises representation and destabilises the boundaries of gender… the vampire disrupts because it exists between the boundaries through which we conceive of being.[59]

Because the vampire exists outside of human time, it is also prone to different rules, and because it is (generally or often) evil, it is not as rule-bound and may even be inclined to offend traditional human sensibility. An earlier psychoanalytic reading is offered by Ernest Jones when he argues that the vampire is a cipher for 'most kinds of sexual perversions… a fantasy that returns to infantile sexual anxieties… where the more perverse forms of sexuality manifest themselves'.[60] If the vampire is a soul condemned, the condemnation comes at the tempting, Faustian, price of having access to forbidden pleasures. Because the vampire is bereft of innocence it is therefore a fractured and ironic figure whose horror tempts more than repels us, as he shows us the outer limits of what humans can 'be'.

In Anne Rice's novel, *Interview with a Vampire* (1976), the troika of Louis, Lestat, and Claudia are very much a queer family. Louis and Lestat are both Claudia's parents and her lovers, leading Gelder to assert the 'queerness of their relationship lies partly in folding together gay love with heterosexual incest/paedophilia'.[61] In the film *Twilight* (Catherine Hardwicke, dir. 2008), based on the novel by Stephanie Meyer, the Cullen's are a queer family and their siblings are also lovers. In a Swedish film of the previous year, *Let the Right One In* (Thomas Alfredson, dir. 2008), the characters Håkan and Eli are also queer. Based on the very successful novel by John Ajvide Lindqvist, Eli is a two hundred-year-old vampire inside the bodily shell of a twelve-year-old girl while Håkan is a man in his mid-thirties. While passing to the outside world as father and daughter, in private they have a pederastic relationship. This is just a small list of a larger and growing mass of film, television, and literature in which the vampire's differences from human beings is echoed in their different sexual inclination. But that does not rule out quite a distinctive queer space for the vampire character. Even when there is no explicit sexual content there is a constant sensual undercurrent to all of vampire fiction. Similarly, Ursini and Silver remark that

> … the character of the vampire itself, whether described as a vortex of malevolence, lust, and savagery or, alternately, as the unwilling victim who becomes a tormented, driven, even tragic figure… [is] seductive, erotic, possessing a hypnotic power which makes its questionable charms seem irresistible to its victims.[62]

What is also worth noticing is how the vampire genre since the 2009 has shifted away from the vampire as lone (heterosexual male) figure to one that belongs to a family, sect, or group. Yet it is a heterosexuality with distinctly feminine traits, suggesting a curious transcendence of sexual roles. In many ways this 'making familiar' of the formerly strange leads to the conclusion that another important factor in the popularity of the vampire and the vampire genre in popular culture over more than the last two decades is they allegorise new conception of family that are not based on one model, but on many in a variety of permutations. We can venture further to argue that, just as the homosexual of the nineteenth century inhabits the dandy, the contemporary queer inhabits the vampire as an expression and a celebration of alterity. In one of his eccentric but enlightening analogies with lowbrow cinema, Zizek writes that

> One could venture the hypothesis that horror movies register the class difference in the guise of the difference between vampires and zombies. Vampires are well mannered, exquisite and aristocratic, and they live among normal people, while zombies are clumsy, inert and dirty, and attack from the outside, like a primitive revolt of the excluded.[63]

With all exceptions aside (such as derailed zombie vampire as found, for instance, in the 2014 vampire television series *The Strain*, directed by Guillermo del Toro), this comment is certainly true. In other cases with persistent regularity, vampires are paradigmatic Athenians of the undead and werewolves the *barbaroi*—take the HBO television series *True Blood*, or the film series *The Twilight Saga, Blade,* or *Underworld.* Whether zombies or werewolves, vampires live in castles, are slim, worldly, better educated, and better dressed.

The vampire as described by Bram Stoker and other literature of his time was, like the dandy, a person who was by degrees out of the ambit of the march of industrialization. The dandy, who for Baudelaire represented 'the last splendor of decadence',[64] was an alternative to the explicable and a foil to what could be rationalised. The vampire hailed from a distant, mysterious past and has seductively old-fashioned manners—something that Gary Oldman who memorably portrayed as the dandified Dracula (in Coppola's 1992 *Bram Stoker's Dracula*) in his more palatable guise when he arrives in London. Where not evincing manners of a bygone age, the vampire's movements are slow and stylised, ignorant of time, such as Gary Oldman as the 'real' Dracula or even Klaus Kinski's role as the repellently tragic monster in *Nosferatu the Vampire* (Werner Herzog, dir. 1979). His penchant for different forms of action are what lend the vampire a distinctive affectation, a penchant for contrivance that moves unmistakably into the territory of camp.

The same insouciance to the world outside occurs with Lestat and Louis, who both affect values foreign to the bourgeois and more germane to yesteryear. And when not on violent rampages, vampires show a penchant for culture and educated pleasure. To Lestat's aristocratic hedonism, Louis plays the man of culture. As Williamson avers

> Lestat and Louis express this in the two modes common to modernity: Lestat's conspicuous consumption and addiction to luxury and Louis' bookish asceticism. Both vampires spend much of their time in philosophical contemplation (of the meaning of their existence), hold an appreciation of the arts, travel and adventure.[65]

And they like to collect objects d'art. Again in reference to the aestheticist stance of the vampire couple, Ken Gelder observes that 'Rice's fiction flaunts its high cultural orientations, drawing in particular on Italian Renaissance and Baroque iconography—where high culture is at its most sensual'.[66] For Gelder asserts that 'To be a vampire is to *be* 'cultured'—that is to have 'aristocratic' tastes-and also to be idle. Louis, Lestat and other vampires do not work... their job is, instead, to find out who they are and where they come from'.[67]

One of the earliest of the litany of examples of the vampire aesthete can be found in the work of Rosa Praed and her books from the late 1800s in which the tipping of normative sexuality is evident everywhere, especially in the way she uses Oscar Wilde as material for her work. In novels such as *Affinities: A Romance of Today* (1885) and *The Soul of Countess Adrian: A Romance* (1891), the vampire and the aesthete intersect in ways that are not limited to character, for the aesthete is made into someone who devours beauty and is an active participant in modern commodity culture.[68] After all, where has anyone encountered a vampire who is destitute? On the contrary, the model of the vampire as surrogate for the wealthy sugar daddy is tenacious and as recent film and fiction would have it, on the rise.[69]

In the early stages of Rice's chronicles, Lestat is a mentor to Louis, not only in the conventional sense of educator, but one who teaches him that being immortal means that idleness is no longer time wasted, but the opposite, the adoption of a refined stance. Louis is initiated into certain rules of vampire-dom, which are a mixture of courtly protocols and mores belonging to the undead.[70] Although these rules are frequently broken, vampiric iconoclasm and apostasy remains bracing within the realm of upper class panache. Thus, as Gelder notes,

> 'Lestat is essentially *different*, he has style; he breaks the rules... with his Parisian background and his refined sensibilities, he might in fact be viewed as a kind of flâneur... a Parisian dandy [who] puts his idleness to good use'.[71]

Lestat's Parisian credentials are meant to evoke a stream of associations, as a place of luxury, culture, and as a place largely overlooking sexual deviation (Wilde exiled himself there until his death). Yet central Paris is not only associated with pleasure but has layers of history, and the archetypal settings for vampire dramas are places that exude ghosts of the past. In Europe the vampire capitals are Paris and Prague, in the United States it is New York or New Orleans, both the historic crossroads of cultures, classes, and creeds.

In an almost uncanny way, since the 1990s New Orleans has emerged as something of a vampire hub: it is the setting for *Interview with a Vampire*, Brite's *Lost Souls*, and also the TV series, *True Blood* and *The Originals*. Situated at the mouth of the Mississippi River, since 1718 New Orleans was an important French and Spanish colonial trading port, and considered the 'gateway' to the exotic New World. At this time much of the population consisted of deported galley-slaves, fur trappers, gold hunters, carpet baggers, and confidence men as well as wealthy plantation owners, the city has come to be represented as a mixture of high and low, on a level more extreme than Europe. As a crossroads of class and creed, New Orleans becomes the convenient stage for other crossing, fusions, or dissolutions, between not only life and death, but class, sexuality, and gender. In her analysis of *True Blood*, Michelle Smith argues that,

> While scholars have recognized that the contemporary vampire is usually less monstrous than its earlier counterparts, the vampire in *True Blood*, rather than emphasizing the transgression of racial and sexual boundaries between 'us' and 'them', injects uncertainty into the foundation of the binary oppositions that make such metaphors surrounding their transgression possible.[72]

The American South, with its dark history of racial segregation and violence, is the setting for further confusion and degradation, but is also the incubator of untold secrets as the many histories that are retold there. Furthermore, Gelder calls New Orleans 'simultaneously 'primitive' and sophisticated', both decadent and aristocratic, consisting of a mixture of people amounting to a 'global exotic'.[73] In *Twilight* vampires are able to mix with humans in broad daylight. They are an example of a more amiable, less formidable type that mixes with humans and satiates their thirst for blood on animals so as to do so.[74]

A malleable yet still recognizable cipher, recent vampire fiction (and its moving-image counterparts) overrides class, gender, age, sexual, and ethnic differences. As Gelder affirms, 'The vampire was consciously constructed as a so-called citizen of the world, a figure to whom boundaries (national boundaries in particular) meant very little'.[75] If Baudelaire's dandy was a *flâneur* of Paris, the vampire dandy is a *flâneur* of the

world, but will most likely rest and nest where his finer tastes for beauty in people, interiors, and material objects meet his satisfaction.

The symmetry between the extraordinary influx of the vampire in every form of popular media since the 1990s and the rise of the new man is unmistakable, and in hindsight seems entirely logical. In light of the eschatological rhetoric of the new millennium, and the myriad crises of world resources, financial markets, capitalism, overpopulation, and so on, the resuscitation of the vampire—as one who lives on the fringes of society regardless—seems understandable. But when he arrives into the world of fashion, he brings with him a set of associations that render gender stereotypes, unstable and fluid. The conflation of the vampire and the dandy is an historic one that is applied sympathetically to the man who is no longer encumbered by the need to be physically strong, or rather the strength comes from elsewhere. In a curious and ironic inversion, while the vampire had always been surrounded by anachronisms that reflect his embeddedness in an imponderably distant past, the contemporary vampire dandy is arguably an after-effect of technology. Here physical strength is not enough and cannot prevail over the power and intricacies of technology. This man must either capitulate or find some space where he has made his coeval with untold evils and threats, finding consolation in whatever beauties and pleasures that remains.

Notes

1 For a comprehensive study of 'la belle dame sans merci', see Mario Praz, *The Romantic Agony*, trans. Angus Davidson, 2nd ed. (London and New York: Oxford University Press, 1970).

2 Martine Blythe, "Vampire Poetics: George Sand and her Lovers", *Emergences* 10, no.1 (2000): 128.

3 For a detailed discussion of the history of the dandy with respect to culture and sexuality see Adam Geczy and Vicki Karaminas, *Queer Style* (New York and London: Bloomsbury, 2013).

4 Thomas Carlyle, cited in, Giacomo Lipardi, *Moral Tales*, vol. 1, trans. Patrick Creagh (Manchester: Carcanet New Press, 1982), 51–52.

5 Sima Godfrey, "The Dandy as Ironic Figure", *SubStance* 11, no. 3 (1982): 31.

6 Charles Baudelaire, *The Painter of Modern Life and Other Essays*, trans. and ed. Jonathan Mayne (London: Phaidon, 1970), 9.

7 Baudelaire, 'Le dandy', *Œuvres completes*, 906.

8 Ibid., 907.

9 Ibid.

10 Anita Brookner, *Romanticism and Its Discontents* (Harmondsworth: Penguin, 2001), 65.

11 Rosalind Williams, *Dream Worlds: Mass Consumption in Late Nineteenth-Century France* (Berkeley and Los Angeles: University of California Press, 1982), 117.

12 Geczy and Karaminas, *Queer Style*, 57.

13 Jules Barbey D'Aurevilly, *Du Dandisme et de George Brummel* (Paris: Éditions Balland, (1897) 1986), 34.

14 Oscar Wilde, "Phrases and Philosophies for the Use of the Young", in *Complete Works of Oscar Wilde* (London: Heron, 1966), 180.
15 For the concept of asceticism see, Michel Foucault, *The History of Sexuality*, vol. II (Harmondsworth, 1988).
16 Charles Baudelaire, "The Painter in Modern Life", *The Painter in Modern Life and Other Essays*, trans. Jonathan Mayne (London: Phaidon, 1981), 26–27.
17 Michel Foucault, *The History of Sexuality*, Vol. I, London: Vintage Books, 1978.
18 James Eli Adams, *Dandies and Desert Saints, Styles of Victorian Manhood* (Ithaca and London: Cornell University Press, 1995), 7.
19 Harold Perkin, *The Origins of Modern English Society, 1780–1880* (London: Routledge and Keagan and Paul, 1967), 25.
20 Thomas Carlyle, in James Eli Adams, *Dandies and Desert Saints*, 4.
21 Peter N. Stearns, *Be a Man! Males in Modern Society*, 2nd ed. (New York: Holmes and Meyer, 1991), 51.
22 In 1940 American *Esquire* magazine introduced the "Varga Girl". These portrait illustrations of glamour models by Peruvian artist Alberto Vargas were depicted in revealing garments such as swimming costumes or tight twin sets that heightened the curves of their bodies. Vargas was later hired as an illustrator by *Playboy* magazine in 1960.
23 Michael S. Kimmel, "Masculinity as Homophobia: Fear, Shame and Silence in the Construction of Gender Identity", in Tracy Ore ed. *The Social Construction of Difference and Inequality*, 4th ed. (New York: McGraw Hill, 2008), 34.
24 Susan Faludi, *Stiffed: The Betrayal of the American Man* (New York: Morrow, 1999), 35.
25 Rob Latham, *Consuming Youth: Vampires, Cyborgs and the Culture of Consumption* (Chicago, IL: University of Chicago Press, 2002).
26 Faludi, *Stiffed: The Betrayal of the American Man*, 35.
27 Susan Jeffords makes a persuasive case for this connection between muscle movies and the Reagan era in *Hard Bodies: Hollywood Masculinity in the Reagan Era* (New Brunswick and New Jersey: Rutgers University Press, 1994).
28 Michael S. Kimmel, "Masculinity as Homophobia", 134.
29 Jon Savage, "What's So New about the New Man?", *Arena* March/April, no. 8 (Spring, 1988): 34.
30 Ibid.
31 Italian designer Giorgio Armani was hired to design Gere's entire wardrobe for the film, which launched Armani's career and changed the direction of menswear in the 1980s. Armani redesigned the suit, removing the internal padding, heightening the color palette, and used lighter fabrics such as linen instead of the usual heavy woolen fabrics that was in fashion at the time.
32 John Potvin, "From Gigolo to New Man: Armani, America and the Textures of Narrative", *Fashion Theory* 15, no. 3, (April 2011): 287.
33 Susan Bordo, *The Male Body: A New Look at Men in Public and Private* (New York: Farrar, Strauss and Giroux, 1999), 157.
34 James Brown, in Ben Crew, *Representing Men: Cultural Production and Producers in the Men's Magazine Market* (Oxford: Berg, 2003), 48.
35 Tim Edwards, "Consuming Masculinities: Style, Content and Men's Magazines", in Peter McNeil and Vicki Karaminas eds. *The Men's Fashion Reader* (Oxford: Berg, 2009), 469.
36 Ibid., 470.
37 Latham, *Consuming Youth*, 100.

38 Gary Whannel, *Media Sports Stars: Masculinities and Moralities* (London and New York: Routledge, 2002), 187.

39 Tom de Castella, "Whatever Happened to the Term New Man", *BBC News Magazine*, 30 January 2014, www.bbc.com/news/magazine-25943326. Accessed January 15, 2017.

40 M. Simpson, "Meet the Metrosexual", www.salon.com/ent/feature/2002/07/22/metrosexual/. Accessed February 5, 2016.

41 Ruth La Ferla, "From Film to Fashion, a Trend with Teeth", *The New York Times*," https://mobile.nytimes.com/2009/07/02/fashion/02VAMPIES.html. Accessed February 16, 2017.

42 Ibid.

43 Ibid.

44 Ruth La Ferla, "From Film to Fashion, a Trend with Teeth".

45 Karl Marx, *Capital* (New York: Appleton, 1889), 816.

46 Matthew Gibson, *The Fantastic and the European Gothic: History, Literature and the French Revolution* (Cardiff: The University of Wales Press, 2013).

47 Chris Baldick, *In Frankenstein's Shadow* (Oxford: Clarendon, 1987), 207.

48 Marx, cit. Ken Gelder, *Reading the Vampire* (London and New York: Routledge, 1994), 20.

49 Slavoj Zizek, *For They Know Not What They Do: Enjoyment as a Political Factor* (London and New York: Verso, 1991), 221.

50 From the 1880s Richard Vin Kraft-Ebbing and Havelock Ellis pathologised sexuality as a science in which categories were created and analyzed including 'homosexual' and 'nymphomaniac'. These categories became central to a person's identity and lifestyle. Oscar Wilde was prosecuted under Section 11 of the Criminal Law Amendment Act 1885 commonly known as 'gross indecency' and carried a two-year prison term. The law was used to punish men who had committed sodomy, which was considered a homosexual 'act'.

51 Talia Schaffer, "A Wilde Desire Took Me: the Homoerotic History of Dracula", *ELH* 61, no. 2, (1994): 381–425.

52 Paul Barber, *Vampires, Burial and Death: Folklore and Reality* (New Haven and London: Yale University Press, 1988), 9.

53 John Mortimer, "Byron's Greek Odyssey", *The Telegraph*, 28 September 2005, www.telegraph.co.uk. Accessed February 18, 2017.

54 Ruth La Ferla, "From Film to Fashion, a Trend with Teeth".

55 Milly Williamson, *The Lure of the Vampire: Gender Fiction and Fandom from Bram Stoker to Buffy* (London: Wallflower Press, 2005), 2.

56 Barber, *Vampires, Burial and Death*, 9.

57 Poppy Z. Brite, *Lost Souls* (Harmondsworth: Penguin, 1992), 67.

58 Sue Ellen Case. "Tracking the Vampire", in K. Gelder ed. *Reading the Vampire* (London and New York: Routledge, 1991), 61–62.

59 M. Williamson, *The Lure of the Vampire*, 157.

60 Ernest Jones, *On the Nightmare* (London: Hogarth Press, 1931), 67.

61 Ken Gelder ed. *Reading the Vampire* (London and New York: Routledge, 1994), 113.

62 J. Ursini and A. Silver, *The Vampire Film* (London: The Tantivy Press, 1975), 54

63 Slavoj Zizek, *Trouble in Paradise: From the End of History to the End of Capitalism* (Brooklyn and London: Melville House), 2014, 73.

64 Baudelaire, *Œuvres complètes*, 907.

65 Williamson, *The Lure of the Vampire*, 38.

66 Gelder, *Reading the Vampire*, 119.

67 Ibid.

68 Andrew McCann, "Rosa Praed and the Vampire-Aesthete", *Victorian Literature and Culture* 35, no. 1 (2007): 175–187.
69 Ananya Mukherjea, "My Vampire Boyfriend: Postfeminism, 'Perfect' Masculinity, and the Contemporary Appeal of Paranormal Romance", *Studies in Popular Culture* 33, no. 2 (2011): 1–20.
70 Catherine Spooner, "The Gothic charm school; or, how vampires learned to sparkle", in *Representations of Vampires*, ed. George and Hughes, 150.
71 Ibid., 120.
72 Michelle Smith, "The Postmodern Vampire in 'Post-Race' America: HBP's *True Blood*", in ibid., 192–193.
73 Ibid., 110–111.
74 See Spooner, "The Gothic charm school", in *Representations of Vampires*, ed. George and Hughes, 146–164.
75 Ibid., 111.

2 Playboys

When commonly used in everyday conversation, the term 'playboy' is met with a very particular mixture of scorn and envy. Scorn at the perceived indulgence of the playboy, his promiscuity, and lack of scruples. Envy for precisely the same reasons: for here is a figure with sufficient aplomb and resources to do precisely as he wants and to get what he wants into the bargain. In many respects, the figure of the playboy is the progeny of the libertine of the seventeenth and eighteenth centuries, but with a distinctly sanitised and more decorous demeanour. In early modern times where feudalism and the arbitrary rule still held sway, it was possible to exploit privilege to an extreme degree. However the playboy manoeuvres within the law, even if he stretches its limits, and his most risqué exploits are kept secret, so long as rumour of exploits are there. Seen as a pared down version of male conquest, it is also apt to speculate that the playboy is the caricatural embodiment of imperial will, who appears toward the end of the imperial age and flourishes thereafter. Imagined as slim, well educated, confident, and well dressed, the playboy represents the dimension of the establishment that makes the best of privilege. While typically associated with extreme, womanizing heterosexuality, the playboy nonetheless has a sleek and vulpine air that comes dangerously close to that of the dandy. Perhaps the quintessential playboy in popular memory is James Bond who is possessed of a seemingly endless array of abilities—he skis like a professional, speaks numerous languages, is at home in all parts of the world, and so on—which he wears with the indifference of someone who has had the benefits of the best circumstances of the developed world. Other onscreen playboys of the era include Gary Grant (Figure 2.1), Gary Cooper, Rock Hudson (Figure 2.2), and Dick Powell.

Embodied in the ambivalent figure of the bachelor, the playboy was more than a romantic male movie hero or man of action. His refusal to accept the privilege and responsibilities afforded by marriage (in exchange for his sexual freedom) was met with suspicion at a time when traditional masculinity was the bastion of society. Choosing the decadent and narcissistic pleasures of a life of conspicuous consumption, he was at once a 'lady killer and a woman hater, a party animal and a lonely guy', as

Cary Grant, 1935

Figure 2.1 Cary Grant. Billy Rose Theatre Division. The New York Public Library.

Stephen Cohan puts it.[1] As well as tracing the genealogy of the playboy, it is, in today's world of androgynies and the 'third sex', important to ask as to what he means today, not only as a popular archetype but as a reflection of capitalism and heteronormativity. The playboy of today has evolved slightly from his modern incarnation. A few slightly effeminate qualities have been added— the 'New Man', the 'New Lad', and the metrosexual—while ensuring that the hedonistic essence remains intact.

Commodified Masculinities

The ascendance of the male consumer as a commodified masculinity and can be traced to the emergence of *Playboy* magazine in 1953, which targeted the single male and the disenfranchised returning soldier. *Playboy*, although associated with the rise of mainstream pornography, was also an innovative lifestyle magazine, a genre that rose out of the economic boom in the US in the 1950s. Fashion publication and advertising since the eighteenth century had always incorporated a sense of the desirable,

Figure 2.2 Rock Hudson. Billy Rose Theatre Division. The New York Public Library.

but lifestyle magazines were more packaged, directed, and specific. From the post-war period until today, lifestyle magazines offer consumers a viable and appealing alternative way of living: how to dress, what to wear, what car to drive, movies to watch, the best in jewellery and watches, and the best books to read. Tied to the conspicuous and narcissistic pleasures of consumption, lifestyle magazines tap into the Zeitgeist of the times—or purport to. It has always been moot as to what extent such vectors of commodity consumption shape or reflect contemporary taste, most likely both. What is important here is that the male lifestyle magazines from the 1950s until the 1980s objectified women as sexual objects to reassert heterosexuality and represent male bodies as aesthetically worked machines. Although historically the concept of work has been the source of masculine identity, it has become increasingly fragmented in late modernity. In this context, the body has become an alternative site were masculinity is constructed and produced through regulatory regimes of consumption.

Founded by Hugh Hefner, *Playboy* magazine offered men a consumer-oriented style of masculinity that targeted single affluent middle-class

men who rejected marriage to pursue their own pleasures and interests, cardinal among them the erotic consumption of women free from the responsibilities of commitment. Returning from the war with the promise of work and the continuation of public life, the men of the 1950s, '60s and '70s saw in *Playboy* a kind of popular serialised manifesto of an escape (and rejection) from the traditional (restrictive) hegemonic model of the male as the ideal breadwinner was so strong at the time. Instead, it offered its readership an escape into a world of fast cars, designer apartments, gadgets, slick suits, and the availability of sexually promiscuous, available, and unjudgmental women. In 'I Buy it for the Articles': *Playboy Magazine and the Sexualization of Consumption*, Gail Dines argues that 'soft porn' or 'men's entertainment magazines' offer a lifestyle that involves the consumption of the ultimate prized commodity, 'lots and lots of big-breasted women, just like the ones masturbated to in the centerfold'.[2] As Karaminas and Hancock have argued elsewhere,

> Playboy magazine served as a guide to a new masculine consumption, guiding its readers on what music to listen to, what clothes to wear, alcohol to drink and furniture to buy in order to participate in a fashionable version of professional-class taste culture.[3]

Branding itself as 'entertainment for men', *Playboy* magazine, initially called *Stag Party*, played a major role in the construction of the post-war playboy. The magazine featured articles on fashion, lifestyle, and leisure, as well as short stories by notable novelists such as Vladimir Nabakov and Ian Fleming (the author of the *James Bond* series), as well as interviews by successful architects, athletes, and politicians such American civil rights leaders Martin Luther King and Malcolm X. The success of the magazine, however, has largely been attributed to its centrefold (pin-up) that featured nude and semi-nude centrefolds (called Playmates or Bunnies) that appeared in every magazine issue since its inception in December 1953. These began with the famous nude photograph of Marilyn Monroe that Hefner purchased from the John Baumgarth Company for a $500 publishing fee. This mix of sex, pornography, and status was a winning combination that gave the magazine access to mainstream readership and distribution channels and provided the male reader with access to an narcissistic world of commodities and display. As Bill Osgerby observes, 'Playboy testified to a growing hegemony of a middle-class male identity for whom responsibility, domesticity and puritanical abstinence were anathema, while hedonistic fun and sensual indulgence were defining virtues'.[4] Moreover, as David Haberstam explains:

> Playboy shepherded a generation of young men to the good life. It helped explain how to buy a sports car, what kind of hi-fi set to buy, how to order in a restaurant, what kind of wine to drink and

what kind of meal [to order]. For men whose parents had not gone to college, Playboy served a valuable function: It provided an early and elementary tutorial on the new American life-style. For those fearful of headwaiters in fancy restaurants, wary of slick salesmen in stores and in foreign-car dealers who seem to speak a language never heard in Detroit, Playboy provided a valuable consumer service: It midwifed the readers into a world of increasing plenty.[5]

In short, *Playboy* acted as a finishing school for young working-class men on the virtues of modern middle-class life. To put this in yet another way, *Playboy* provided a new discourse for the construction of the young American urban bachelor. This new single, heterosexual man became a central figure in the counter-narrative of the American dream. The playboy was America's 'new male bourgeois' complete with his love of fashion, style, and spending. In the April 1953 issue of *Playboy* magazine, Hefner described the playboy as

> A sharp minded young business executive, a worker in the arts, a university professor, an architect or an engineer. He can be many things, provided that he possesses a certain kind of view. He must see life not as a vale of tears, but as a happy time, he must take joy in his work, without regarding it as an end to all living, he must be an alert man, a man of taste, a man sensitive to pleasure, a man who— without acquiring the stigma of the voluptuary or the dilettante— can live a life to the hilt. This is the sort of man we mean when we use the word playboy.[6]

On the Virtues of Bachelorhood

The playboy rebelled against the traditional male work ethic of married breadwinner and what Pamela Church Gibson describes as an 'oppositional'[7] masculinity embodied in the likes of working-class heroes James Dean, Marlon Brando, and Elvis Presley. Confused outsiders, misfits, and brooding figures, Dean and Brando's choice of garments, namely jeans (associated with worker's clothing such as denim dungarees), plain T-shirts (lifted from army standard issue), and leather jackets (adapted from the bomber jacket) would become emblematic garments of youth culture and a casual lifestyle. There were two types of masculinities in circulation at the time, the fashionable slim and affluent bachelor and the tough and rugged action man of the outdoors. Women were often absent from images that appeared in popular culture or they acted as sexual objects to prop up and sustain a staunchly heterosexual masculinity that was constructed and understood as 'natural'.[8] *Playboy* magazine offered men an exit-gate from the traditional role of masculinity, what Feona Attwood describes as 'tits and ass and porn and fighting'.[9]

In the 1950s, gender relations were extraordinarily patriarchal. Women were connected to the domestic sphere and men with work and the public domain. (The explosion of domestic products such as the vacuum cleaner, the television, and the washing machine, made possible by the technologies used in the Second World War, introduced the propaganda concept of the modern woman's domestic heaven, although they were soon seen as devices that engendered the opposite.) The conservative and traditionalist Eisenhower era and the onset of the Cold War, this era was steeped in all manner of political and military tensions between the Eastern Bloc (the Soviet Union and its satellite states) and the Western Bloc (the United States, Britain, and its allies). Communism became the name not only for a political enemy, but became metonymic of any social and ideological nemesis, the straw man for any ills besetting the ostensible prosperity of Western capitalism. Propaganda on both sides was rife, permeating deeply into popular culture. Television programs reflected such anxieties with shows such as the comedy series *Get Smart* (Gary Nelson, dir.) that followed the mishaps of secret agent Maxwell Smart (and his seductive female partner Agent 99) in their attempts to save the world from various threats. The book series involving the exploits of agent 007, James Bond, began what is now a genre industry with the adaptation of Flemming's *Dr No* (1958) in 1962 (Terrance Young, dir.), starring the Scottish former bodybuilder Sean Connery. Such entertainment fuelled popular imagination and helped to demonise communism, translating into a heightened sense of paranoia against anything that contravened the dominant ideology of the times. This reached its high point, or nadir, the hearings of Senator Joseph McCarthy vilifying all forms of left liberalism in what were effectively modern witch hunts to weed out communism, which was characterised as a political cancer.

The post-war economic prosperity in the manufacturing and production industries resulted in an increase of living standards, leisure time, and spending. The process of post-war suburbanization and economic boom in the United States created a greater division between genders as women were encouraged into the interior and the domestic space of the home, while men were encouraged to spend more time outdoors fishing, hiking, mountaineering, and generally spending their leisure time in the company of other men. While men's lifestyle magazines circulating at this time appealed to the working class set, *Playboy* was pitched at America's new cosmopolitan middle-class man. Osgerby maintains that 'The morality of pleasure as a duty was matched perfectly by the way that *Playboy* fetishized the sophisticated world of the connoisseur'.[10] As Hefner announced to his readers in the November 1953 issue of *Playboy*,

> We don't mind telling you in advance—we plan on spending most of our time inside. WE We like our apartment... We enjoy making up cocktails and an hors d'oeuvre or two, putting a little mood music

on the phonograph and inviting in a female acquaintance for a quiet discussion on Picasso, Nietzsche, jazz, sex.[11]

The endnote, the punctuation point, was sex. It was the fulcrum for all the rest, from sport to pop-philosophy. And the fulcrum for *Playboy* was its 'Playmate of the Month' centrefold. So as to ward off any ambiguity about its heterosexual credentials, Osgerby maintains that '*Playboy*'s centerfold existed, at least partly, as a device that could neutralize any suggestion of effeminacy'—thus affording the reader's 'safe' passage into the realm of self-satisfaction and free consumption of things and female bodies alike.[12] Although it is now a commonplace to say that *Playboy* objectified women, representing them as available exclusively for the pleasure of men, the magazine played an important role in reconfiguring masculinity from traditional breadwinner to swinging bachelor, destabilizing the scales of gender relations.

Material objects are always tied cultural and political landscapes because they are a product of social relations and forces that are imbued with power. *Playboy* magazine arrived at the right time and at the right place. *The Kinsley Report* on human sexual behaviour was released in 1948 indicated that '86 percent of American men had premarital sex, 70 percent had sex with prostitutes and 40 percent engaged in premarital intercourse'.[13] *Playboy* magazine was born against this background. Simply put, not only did this new masculinity continue to function in the public domain, he had now entered—quite comfortably into the private sphere of the home, a smooth transition that was aided by new 'gadgets and toys', technological fetishes. While women were offered numerous 'white goods' and electrical devices from irons to washing machines to ease the rigors of domestic life, men were offered material goods to enhance their leisure time. In a curious but persistent paradox, the man for whom sex was available indulged in a whole series of activities with specialised objects that were the *Ersatz*, the replacement for sex.

This early form of new man had now become woman's strongest rival, or can be conceived as a sexual predator that invaded the 'enforced' domain of her home. For while the playboy was a wanderer and explorer, he was also a party-goer and sybaritic pleasure-seeker. From 1953 onwards, every issue of *Playboy* included an article about the reappropriation, what Beatriz Preciado termed 'recolonisation',[14] of this new masculinity into the domestic interior space: weekends away, nights entertaining in the city bachelor pad, European sports car commuting between residences, or simply basking on the private yacht.

Yet the married man who had it all was hankering for his freedom. Despite all the coveted trappings of domestic bliss, a loyal wife, children, and an affluent career, he nonetheless was deeply dissatisfied, 'trapped by marriage and green-lawn suburbia'. His flight was encapsulated by an early *Playboy* editorial:

He had everything a man could want—a beautiful loving wife, two fine children, a magnificent home and a good job. The problem was that he was bored beyond belief. He hated tennis club, the endless round of barbeques and cocktail parties, the small talk and the smug respectability of the middle class American dream. Extra-marital sex, he ruefully reflected, represented the only prospect of excitement. One day in 1953, he simply walked out and never returned.[15]

The answer to the playboy's dilemma lay in the bachelor pad, a home that he could call his own. Referencing Virginia Woof's plea 'for a room of one's own' that later became a political catchphrase for feminists, the editors of the September 1954 issue of *Playboy* wrote,

A man yearns for a quarter of his own. More than a place to hang his hat, a man dreams of his own domain, a place that is exclusively his own... Playboy has designed, planned and decorated, from the floor up, a penthouse apartment for the urban bachelor—a man who enjoys a good living, a sophisticated connoisseur of the lively arts, food and drink, and congenial companions of both sexes.[16]

The Bachelor Pad, or the Sexual Lair

In her book, *life should be Life*, Elizabeth Frateriggo states that in the early 1960s a journalist reported on the growing number of

girly magazines entrapping young American men in a Never-Never land, where bachelorhood is a desired state and bikini-clad girls are overdressed, where life is a series of dubious sex thrills, where there is a foreign sports car in every garage, a hi-fi set in every living room and 'Home Sweet Home' is a penthouse pad.[17]

The bachelor pad was an important site for constructing a masculinity that was liberated from the constraints of family and marriage. Not only did it provide the playboy with a domestic haven for entertaining and sexual trysts but it was a space that provided a repertoire of new products and technological gadgets that promoted masculine glamour and consumption. In September and October 1956 *Playboy* magazine contained a two-part step by-step article titled 'The Playboy's Penthouse Apartment. A High Handsome Haven Pre-Planned and Furnished for the Bachelor in Town' that provided the single male with guidelines on how to furnish the ideal apartment, or 'bachelor pad'. The apartment contained designer furnishings; an Eero Saarinen couch and armchair, a Versen floor lamp, a Bruno Matheson table, Herman Miller cabinets, and a walnut chair designed by Charles Eames. It was also contained

'the good things that come in leather cases: binoculars, stereo, and reflex cameras, portable radio and guns'.[18] These are the gadgets that provide the playboy with the visual and creative products that enhance the pleasures of the sexual hunt. Doubling as a sexual lair and as a place of male bonding, the apartment was 'perfect for all-night poker games, stag or strip'. It contained a 'box fireplace that suggests a téte-a-téte', a bedroom 'where a bachelor can have a romantic nightcap with a chosen guest' and glasses that bore 'he imprint of a lipsticky kiss'.[19] In all, the apartment was equipped for a man to live a 'life of masculine elegance'. In her article 'Pornotopia', Beatriz Preciado argues that the bachelor pad functioned as a means of a return to the domestic interior that was traditionally ruled by women: '*Playboy* actively promoted the masculine occupation of the interior space'.[20] This was achieved by including articles on the reappropriation of 'quasi-domestic' space; 'the house in the country, the private yacht, the studio, or simply the car'.[21] The playboy had become a woman's rival rather than her domestic compatriot.

James Bond 007

Hollywood cinema in the 1950s contained numerous playboys that epitomised this new masculine ideal of bachelorhood. Rock Hudson, Cary Grant, Tony Curtis, and Gary Cooper all portrayed affluent and independent men who refused to be 'tied-down' in marriage, but opted for the freedom of the single life of a playboy bachelor. But let us return then to the quintessential post-war playboy, James Bond, as he has come to us through mainstream American cinema. Created in 1953 (the same year as *Playboy* magazine) by British writer Ian Fleming, secret agent James Bond 007 appeared in twelve novels and two short story collections. The first cinema adaptation, *Dr No*, featured Connery as Agent 007 and supermodel Ursula Andress as the first Bond girl, Honey Ryder (the Bond equivalent of a Playboy Bunny). In the film James Bond is sent to Jamaica to track the disappearance of a fellow British agent. In his search he stumbles upon the cave of Dr No, who is plotting to overthrow the American space launch with a radio beam weapon. *From Russia with Love* (Terrance Young, dir.) screened the year after, followed by *Goldfinger* (Guy Hamilton, dir.) in 1964. All three films cast Sean Connery as the suave and sophisticated British secret agent.

It is not surprising, then, that the popularity of the Bond films was a reflection the public's fear and suspicion of Communism that was further enhanced by the endorsement of the young and newly elected American president John F. Kennedy. In a 1961 issue of *Life* magazine, Kennedy had listed *From Russia with Love* (1957) as one of his favourite novels, after Stendhal's *The Red and the Black* (1830), quite a literary juxtaposition. Kennedy was attracted to the secret agent's urban sophistication and adopted the trim two-button tailored suit that was becoming

very fashionable. 'Unlike most presidents and politicians', comments Jay McInerney, 'J.F.K. looked like a guy who could have stepped out of the pages of *Esquire* [magazine]—and he slept with the girls that stepped out of the pages of *Playboy*, although we didn't know it as the time'.[22] (Common knowledge now is that he had an extra-marital affair with Marilyn Monroe.) McInerney goes on to note that at the beginning of the fifties, the concept of sophistication was seen as dubious and 'un-American'. Rather, urbanity was seen as European or 'continental' and any interest in food, wine, or fashion was considered louche and feminine, and therefore 'dangerously' homosexual. In addition to JFK's endorsement of Bond, the March 1960 issue of *Playboy* magazine published a novella by Ian Fleming titled *The Hildebrand Rarity*, followed by a further five adventure stories during the sixties. In addition to the growing popularity and interest in Fleming's work, Hugh Hefner was fascinated by the 'tall, Continental-suited, profoundly British, profoundly sophisticated author and his creation'.[23] To this tune, Fleming himself noted that 'James Bond, if he were an actual person would have been a registered reader of *Playboy*'.[24]

The philosopher Gianni Vattimo makes a penetrating statement about James Bond's place as a role model in contemporary life, and the way in which he is a prime example of the manner in which figures shaped through the media have usurped 'traditional' codes of morality. Moreover, he confirms that cultural archetypes as shaped by the media become models of aesthetic priorities and desirability. It is worth quoting in full:

> What we commonly take as aesthetic experience—the enjoyment of works that are not unquestionably epoch making or foundational like the examples I just mentioned—retains, albeit transformed and decreased, the character of an encounter with the origin that constitutes the essence of the enjoyment of art.
>
> An example of this can be seen precisely in the type of aesthetic experience that might seem also the farthest remove from authenticity, the experience of the 'mass arts' of the mass media. I would say that the belongingness of the reader to the work, a belongingness that in its authentic form is typical of the experience of encountering great works of art, can be found also in the mass media, albeit mystified. A mystified form of aesthetic belongingness to the work is found also in the attitude of the public to James Bond, which takes him as the model for its own behavior, ranging from the manner of dressing to that of treating women to the more general way of relating to life. Even though we can concede that it is a mystified form (but we should ascertain to what extent and why this is the case), an encounter with the movie character James Bond and its public represents an encounter with a world in which one must inhabit, attempting to live up to it in one's experience.

Now, just as in the case of James Bond, we have an example of aesthetic experience as the experience of the origin in the form of the maximum distance away from authenticity, so all our aesthetic experiences can be arranged on a kind of scale of maximum or minimal nearness to authentic originality.[25]

Hence again the mixture of contempt and envy when faced with the playboy, in this case Bond, whom two factors are tightly caught up. When not 'performing his duty' for his country, he satisfies his own desires without much scruple, an instinct that jars with public ideology but which delights just as much because of it. Although there has been some attempt to give a more feminizing touch to the film adaptations—with Judy Dench cast as M, the head of the British Secret Intelligence Service (also known as MI6) and with Bond being caught up with fewer and more challenging, intelligent, and self-assertive women (and older: Monica Belucci in *Spectre*)—such nuances only tend to reinstate the default position of the active, well-dressed, and sexually predatory heterosexual male.

What is also highlighted in the passage above is that the playboy is a pre-eminently aesthetic being in more than one sense. He follows his own sensual pleasure while also being aesthetically appealing, both because and despite his attributes and tendencies. To some extent there are several overlaps between the dandy and the playboy, but unlike the playboy, the dandy is ambiguous and aloof about his sexuality (little is known, for instance, of Beau Brummell's sexual inclinations), and is more experimental and unusual in his dress, and potentially more eccentric in his speech and demeanour. If the dandy is oriented toward the aristocratic—which means, as Baudelaire emphasised, an aristocracy that existed outside the realms of consensus or material legitimacy—the playboy is of the upper middle classes. If the dandy is the aesthete and the connoisseur, the playboy, while a man of culture, also revels in technology. Dandies real and imagined, from Baudelaire (who composed an ode to hashish) to Huysmans's Des Esseintes in *À Rebours*, have sought recourse to mind-altering drugs, the playboy prefers alcohol, preferably hard spirits (cognac, scotch, vodka). Given historically that gay and bisexual men used the dandy as a vehicle to both hide and express their queerness, the playboy persona is far less equivocal, less oblique, but rather forthright and uncompromising. Yet many of Bond's traits, his intense preoccupation with the satisfaction with individualism, and his impeccable style and dress can be attributed to the dandy. Like the dandy who shunned the work ethic of the times and lived by his wits alone, so, too, did Bond. As described by Elizabeth Wilson,

The role of the dandy implied an intense preoccupation with self and self-presentation; image was everything, and the dandy a man

who often had no family, no calling, apparently no sexual life, no visible means of financial support. He was the very archetype of the new urban man who came from nowhere and for whom appearance was reality. His devotion to an ideal dress that sanctified understatement inaugurated an epoch not of no fashions for men, but of fashions that put cut and fit before ornament, colour and display... The dandy was a narcissist. He did not abandon the pursuit if beauty, he changed the kind of beauty that was admired.[26]

Fashioning 007

Not only did the playboy maintain a penchant for smart trim fit suits, but sartorial advice in lifestyle magazines promoted a casual 'preppie look' or 'ivy league style' embodied in the figure of the American college graduate. This style consisted of casual loafers (worn by Hefner), sports orduffer coats, and long sleeve cashmere pullovers. Sportswear was also advocated by *Playboy* magazine, 'pleatless poplin olive green shorts and a plaid shirt for golf, white shorts with a French Lacoste knit shirt for tennis and trim, fly front cotton poplin trunks for swimming'.[27] The promotion of men's fashion and lifestyle products by magazines such as *Playboy* (as well as *Esquire* and *Gentlemen's Quarterly*) developed a renewed interest in men's fashion and spawned an unprecedented growth in the men's fashion industry. At the same time, the men's ready-to-wear manufacturing industry was expanding its sports and casual wear to meet this growing demand for casual and leisurewear. The style of James Bond has always been an important factor in creating an action hero that possessed all the hallmarks of expensive tastes and upper-class attitudes. James Bond had many of the attributes of the playboy including his penchance for fast cars; Rolex watches (that he uses as knuckle-busters), Fabergé cigarette cases, Dunhill lighters, and tankards of Taittinger Vintage 1943 Brut champagne, and accompanied with Russian beluga caviar. 'Expensive toys demanded by todays would be men of action'.[28] Nick Sullivan writes that the world of Bond was one of material certainties rather than an abundance of choices. 'There was the right drink (vodka martini), the right cigarettes (Mooreland Specials), the right car (his supercharged 4.5 litre Bentley).... and even the right shampoo (Pinaud Elixir)'.[29] Other cars included the Aston Martin and the Lotus.

The Bond fictional character liked to dress in dark single-breasted suits, white shirts, and thin black silk ties, or as Major Townsend, an operative in the British Secret Service, referred to as his 'usual rig'. Stella Bruzzi, in her seminal book *Undressing Cinema* (1997), proposes that some film costumes function as 'iconic clothes, spectacular interventions that interfere with the scenes which they appear and impose themselves on the character they adorn'. This can easily be said of James Bond and the suit. Often referred to as a 'suited hero', the costuming of James

Bond is essential in representing him as a fashionable-forward bachelor and as a hero. The suit was an essential sartorial device for Bond because its fine tailoring revealed the contours of his body, enhancing his sexuality, and distancing him from the lower classes. Historically, the suit has always indicated a position of social class, either that of wealth or leisure or, as in the case of the playboy, part of the professional middle class. The tailored suit gained popularity during the 1930s and continued to be fashionable attire for men up until the seventies when the unisex safari suit became *du jour*. Whilst the tailored suit is associated with the 'Establishment', the safari suit, made fashionable by Yves St Laurent, represented adventure and freedom from life's constraints (like that offered by the hunt) and worn later by Roger Moore as James Bond. As Sarah Gilligan suggests, the suit initially signified 'sobriety, simplicity, conformity and restraint, the man's tailored suit functions to construct an image of an idealized male body'.[30]

Clearly, James Bond's choice of attire is informed by contemporary fashion and the key to Bond's success as a playboy lay primarily in the suit's designer. As Neil Norman argues,

> The trick of tailoring for James Bond is to give him a look that is essentially, though not aggressively, British. Classic, with a twist of international flair ensures that he can move from Whitehall [the British Secret Service in London] offices to Turkish bordellos; from a Bajan beach to [a] Monte Carlo Casino.

Anthony Sinclair designed the tailored garments for Sean Connery who starred as Bond in the fifties and sixties, and Cyril Castle would later design for the Roger Moore Bond in the seventies and early eighties. Sinclair's suits were made of Shetland tweed and contained two buttons with a close-fitting chest and narrow shoulders. The trousers tapered at the leg. Cyril Castle designed the button-one 'Kent' style double-breasted jacket that was made for Roger Moore's Bond. From about the late fifties and throughout the 1960s Castle's tailored suit contained three buttons, roped sleeve heads, a full chest, gauntlet cuffs on the jacket with very narrow lapels. Bond's suit aided in representing him as a cosmopolitan European style 'man about town' and his 'expensive tastes identified him as a well-heeled bachelor with no strings. In other words, he spent all his money on himself'.[31]

By the eighties, Georgio Armani would become Bond's designer and by the nineties, Tom Ford (then creative director for Gucci) would create an American style wardrobe that replaced European cut and styling. Not only did Ford design Bond's wardrobe from suits to cardigans and jackets, he also created sunglasses and other accessories. The masculinity represented by *Playboy* was, as Pam Cook and Claire Hines put it, 'defined by an aggressive individualism signified by a sophisticated style

based on conspicuous consumption and sexual promiscuity and an easy familiarity with the brand-names products represented as the necessary accessories of his bachelor lifestyle'.[32]

The playboy's fastidious obsession with fashionable style and the cultivation of a casual and aloof demeanour was an essential aspect of the playboy lifestyle. Though very few men could attain the material possessions and the look and lifestyle that *Playboy* advocated, the magazine offered men a vision of masculinity that was uncomplicated, fun, and adventurous. Against a society of shifting sexual and moral mores that emphasised sexual pleasure and liberation, the playboy offered men a distinctly modern lifestyle that was leisure-orientated, glamorous, and hedonistic.

Notes

1 Steven Cohan, "So Functional for Its Purposes: Rock Hudson's Bachelor Apartment in Pillow Talk", in Joel Sanders ed. *Stud: Architectures of Masculinity* (New York: Princeton Architectural Press, 1996), 29.
2 Gail Dines, "I Buy It for the Articles': Playboy Magazine and the Sexualization of Consumption", in Gail Dines and Jean M. Humez eds. *Gender, Race and Class in Media: A Text Reader* (Thousand Oaks, CA; London and New Delhi: sage, 1995).
3 Joseph H. Hancock II and Vicki Karaminas, "The Joy of Pecs: Representations of Masculinities in Fashion Brand Advertising", *Clothing Cultures* 1, no 3, (2014): 275.
4 Bill Osgerby, *Playboys in Paradise. Masculinity, Youth and Leisure Style in Modern America* (Oxford: Berg, 2001), 122.
5 David Halberstam, *The Fifties* (New York: Fawcett Columbine, 1993), 575–576.
6 Ibid., Osgerby, 2001, 127.
7 Ibid., Church Gibson, 70.
8 Tim Edwards, "Sex, Booze and Fags: Masculinity, Style and Men's Magazines", in Bethan Benwell ed. *Masculinity and Men's Lifestyle Magazine* (Oxford: Blackwell Publishing, 2003), 132.
9 Feona Attwood, "Tits and Ass and Porn and Fighting: Male Heterosexuality in Magazines for Men", *International Journal of Cultural Studies* 8, no. 1, (2005): 97.
10 Ibid., Osgerby, 126.
11 Ibid., Osgerby, 126.
12 Ibid., Osgerby, 127.
13 Becky Conekin, "Fashioning the Playboy: Messages of Style and Masculinity in the Pages of Playboy Magazine 1953–1963", in Peter McNeil and Vicki Karaminas eds. *The Men's Fashion Reader* (Oxford: Berg, 2009), 431.
14 Beatriz Preciado, "Pornotopia", in Beatriz Colomina, Annemarie Brennan and Jeanie Kim eds. *Cold War Hothouses* (New York: Princeton Architectural Press, 2004), 222.
15 Ibid., Preciado, 222.
16 Ibid., Preciado, 223.
17 Elizabeth Frateriggo, *Playboy and the Making of the Good Life in Modern America* (Oxford, New York: Oxford University Press, 2009), 01.

18 "Playboys Penthouse Apartment, A High Handsome Haven for the Bachelor about Town", in Joel Sanders ed. *Stud: Architectures of Masculinities* (New York: Princeton University Press, 1996), 62.

19 Ibid., *Playboy*, cit. Sanders, 62–65.

20 Ibid., Preciado, 220–223.

21 Ibid., Preciado, 222.

22 Jay McInerney, "How Bond Saved America", in Jay McInerney et al. *Dressed to Kill: James Bond the Suited Hero* (Paris and New York: Flammarion-Pere Castor, 1996), 22.

23 Pam Cook and Claire Hines, "Sean Connery is James Bond': Re-fashioning British Masculinity in the 1960s", in Rachel Moseleley ed. *Fashioning Film Stars: Dress, Culture, Identity* (London: Bfi Publishing, 2011), 152.

24 Ibid., Cook and Hines, 152.

25 Gianni Vattimo, *Art's Claim to Truth* Santiago Zabala ed., trans. Luca D'Isanto (New York: Columbia University Press, 2008), 104–105.

26 Elizabeth Wilson, *Adorned in Dreams: Fashion and Modernity* (Berkley and London: University of California Press, 1985), 180.

27 Conekin, in McNeil and Karaminas eds. *The Men's Fashion Reader*, 438.

28 Pamela Church Gibson, "Brad Pitt and George Clooney, the Rough and the Smooth", in Rachel Moseley ed. *Fashioning Film Stars: Dress, Culture, Identity* (London: Bfi, 2005), 71.

29 Nick Sullivan, "Dressing the Part", in Jay McInerney et al. *Dressed to Kill: James Bond the Suited Hero* (Paris and New York: Flammarion-Pere Castor, 1996), 132.

30 Sarah Gilligan, "Branding the New Bond: Daniel Craig and Designer Fashion", in Robert G. Weiner, B. Lynn Whitfield and Jack Becker eds. *James Bond in World and Popular Culture*, 2nd ed. (Newcastle upon Tyne: Cambridge Scholars Publishing, 2011), 78.

31 Ibid., Cook and Hines, in Moseleley, ed., *Fashioning Film Stars* 150.

32 Ibid., 155.

3 Hipsters

In many respects, the hipster is to the twentieth and twenty-first century what the bohemian was to the nineteenth. He descended from the jazz culture of the 1940s and is synonymous with the invention of 'cool', a word that began to be used more widely in the 1950s. Adapted from the slang "'hep cat'", as the name suggests, a hipster is into what is "'hip', and what is hip is what is what is slightly awry of 'square' middle class norms. A modernised dandy but without the dandy's aristocratic pretentions, the hipster is laconic, relaxed, and 'smooth' in his choice of clothing, is unafraid of risqué language, employs a sense of humour, is imbued with an air of insouciant impertinence, and has a penchant for mild recreational drugs—because they're taboo and also because they keep him 'cool'. Unlike the dandy, the hipster affects a rarified form of impoverishment, irrespective of his actual impecuniousness, in order to express affinity with the itinerant, gypsy order of society, the socially unencumbered and unrepressed. Writing in 1948 in the *Partisan Review*, Anatole Broyard's 'A Portrait of Hipster' called him a 'keeper of enigmas, ironical pedagogue, a self-appointed exegete'.[1] He was someone whose rebellion was in the interests of not being easily defined and irreducible to a function, or manipulable to a foreign agenda. The Beat hipster was a product of the cataclysm of the Second World War, and embodied the need for dissent but without any sense of destiny—James Dean, the 'rebel without a cause', was very much a hipster.

Hipsters confessed a deep affinity with mid-century jazz and popular culture, which meant that race played a central role. The sympathy with Afro-Americans and Negro culture would be varied and fraught—it was often criticised for being superficial—but it was fundamentally rooted in being subcultural outcast by default, or design. In its still dominant incarnation, the white hipster reinterpreted popular Negro culture, especially with regard to its rebarbative behaviour as a form of social resistance, and the aesthetics of cool. In *The Birth of Cool* (2016), Carol Tulloch locates the term 'cool' as an aesthetic of presence across the African diaspora. Tulloch cites the work of Peter N. Sterns, who wrote that the concept of cool is distinctly American and that it permeates across American culture to argue that cool is an 'expansive diasporic

act of Black aesthetics'.[2] And in his important text, 'An Aesthetic of the Cool,' written in 1973, Robert Farris Thompson argues that the concept of cool interweaves serious and playful elements of control and pleasure articulated amongst African American back to African expressive performance and dance so as to provide depth and historical continuity. He contends that

> control, stability and composure under the rubric of the cool seem to constitute elements of an all-embracing aesthetic attitude. Struck by the re-occurrence of this vital notion elsewhere in tropical African and in the Black Americas, I have come to term this attitude 'an aesthetics of the cool'.[3]

The hipsters were a literary movement that was associated with a prominent group of American writers known as The Beats: Jack Kerouac, William Burroughs, and the poet Allen Ginsberg that became known as the Beat Generation. (Purists at the time would see the hipster and the Beat as different, something which we will deal with below, but by and large the differences boil down to tribalism, especially since the two were almost impossible to tell apart.) Essentially, the Beats admired and were influenced by the Negro hipster and often forged intimate relationships that were accepted by the subculture without prejudice. They even adopted extensive vocabulary derived from 1940s jive talk, women were 'chicks' and men were 'cats' and people were either 'hip' or 'square'. The Beats were anti-materialists, read French existentialist philosophy, listened to bebop jazz, favoured the Theatre of the Absurd, and non-objective gestural abstraction. Although no particular subcultural style is associated with the early hipsters, they often wore baggy chino pants, red and white gingham shirts, polo neck sweaters, and desert boots. By the 1950s berets, black and white Breton sailor tops, and tight-fitting jeans became popular, as well as 'goatee' beards that became associated with French intellectualism.

Nearly 50 years later, on August 8, 1994, *Time* magazine declared that, 'Everybody's Hip' and 'Hipness is bigger than General Motors'.[4] By the end of the 1990s, Zeynep Arsel and Craig J. Thompson write, 'leading business media such as *Brandweek, Fortune* and the *Wall Street Journal* were all discussing the hipster as a commercially significant cultural category'.[5] In the beginning of the new millennium, the hipster re-emerged as a subculture that was quite different from its hipster predecessors and set them apart as a subcultural group. In the early 2000s, *The New York Times* published an article profiling the suburb of Williamsburg using the term 'bohemian' to describe the 'creative types' that were moving into the district, in droves. It was not until 2003, in an article published in the same newspaper, that the term hipster reappeared. '[Williamsburg] started to get too cool and too hip. All

the hipsters were dressing the same way. Sideways trucker hats, tight T-shirts, vintage jeans and Converse high-tops for guys'.[6] Marked by grunge subculture and Indie music, the hipster was an evolution in vintage fashion, styled with a bricolage of accessories and garments that had been recycled, redesigned, and reused. 'Subcultures rarely totally disappear', notes James Arvanitakis,

> 'they simply go in and out of fashion. Youth subcultures are like mushrooms; even after they seem to have died off, their spores linger in the soil of society, awaiting the right conditions – a certain movie, a band-to trigger their re-emergence.'[7]

This new millennial hipster was a product of the sustainability movement with its slow design strategies and slow food—paddock to plate and nose to tail—approach to farming methods and eating. In most respects the contemporary incarnation of the hipster is a nostalgic celebration of the non-conformism and anti-consumerism of the Beat hipster. Or so it seems. Rather than being located on the radical fringe of society rebelling against materialism, this type of hipster was stripped of any meanings of deviance or social protest, but instead, was a fashionable counterculture commodified through marketing and consumption practices. The hipster wore

> long-forgotten styles of clothing [and] beer, cigarettes and music were becoming popular again. Retro was cool, the environment was precious and 'old' was the new 'new'. Kids wanted to wear Sylvia Plath cardigans and Buddy Holly glasses – they reveled in the irony in making something nerdy so cool. They wanted to live sustainably and eat organic gluten free grains. For this generation style wasn't something you could buy in a department store, it became something [that] you found in a thrift store, or ideally made yourself. The way to be cool wasn't to look like a television star: it was to look as though you've never seen television.[8]

Has the hipster been so co-opted by the market-place that it has lost its meaning as a subculture, becoming more of a lifestyle choice? Or as Caroline Evans asks, 'is authentic resistance now a dream that only money can buy?'[9] If hipsters are embroiled in consumption practices, mass media, and the cultural industries, then claims to authenticity can look dubious, since the concept of style is the active enactment of resistance. Dick Hebdige wrote of bricolage as creative and dynamic, in contrast to the passive consumption of goods and commodities.[10] Style, in terms of bricolage, no longer makes reference to an 'original' meaning with underlying messages, instead it is all about a fashionable 'look'. Even the fashion critics condemned hipsters as a bourgeois

affectation that 'fetishizes the authentic and regurgitates it with a winking inauthenticity'.[11]

Today the millennial hipster has its own particular caste, its ethics of social indeterminism admitting of a variety of social groups and sexual persuasions. While the 1950s hipster was a cultural iconoclast who rejected the trappings of middle-class American culture, 'the millennial hipster increasingly came to be represented as an überconsumer of trends, and as a new, and rather gullible, target market'.[12] But the persistence, or resurgence, of the hipster begs the question if it is a sanitised, troped form of subcultural expression (as arguably the punk is today), or whether it is a genuine expression of both determination and despair in the face of the threat of impending financial and ecological cataclysm. While the confusion over world demographics and the nature of democracy is very much a contemporary problem, to look at the historical origins of the hipster is to reveal that perhaps the conditions of rebellion and the justification of lawlessness in the face of authority were no more coherent in the 1940s and 1950s than they are today. The hipster is the figure of uncertainty and anxiety, yet attractive either because of the bold values he represents, or appears to represent. This ambiguity and the role of appearances are key. For the hipster is so often the dreamy man with one foot permanently in adolescence who affects a bewilderment at the frenetic modern world, a bewilderment that stalls him from action, and without action there is no real commitment. At best, the hipster is about disillusion at the depersonalization and complexities of the world, at worst it is lassitude and intransigence justified by what it sees is the implacability of the world, a world with too many secrets and vested interests. While some of other male figures have a set of easily perceptible identifiers—the gaunt lizard-like dandy, or the muscle-clad brute, or the playboy in his suit or designer clothes—the hipster is much more elusive on the level of material culture. 'Hip', it may be argued, is the equivalent of 'chic' for late twentieth century countercultural discourse, both in terms of outward style and progressive personal ethics.[13] Or alternatively it has been defined as a portmanteau term for post-war subcultures in general, and it is also very much a state of mind that opposes the numbing and exploitative of forces of late capitalism, particularly as it relates to the (now fragile) supremacy of the United States.

The White Negro

Norman Mailer's paean to the hipster in his influential essay 'The White Negro' (1957), a reply to Albert Camus's *The Myth of Sisyphus* (1942, translated two years before Mailer's essay in 1955), is inflected with Nietzschean bombast. One commentator believes that it sits 'on the border of sociological observation and aesthetic manifesto'.[14] In many ways the essay is a 'Will to Power' of the powerless, the disenfranchised, and

the shocked of the post-war era: 'The Second World War presented a mirror to the human condition which blinded anyone who looked into it…if society was so murderous, then who could ignore the most hideous of questions about his own nature?'[15] Diatribe, rant, mystical tract, Mailer's essay is full of infuriating speculation and unsubstantiated assertions, but nonetheless is an unforgettable document.[16] It is a wordy essay that unpacks the hipsters' disenchantment with mainstream conformist culture and the adoption of African American jazz culture as their own.

The most polemical part of the essay is arguably in the title itself, where Mailer presumes to show kinship with the Afro-American experience, which includes (for the white man) unimaginably harrowing physical, psychological, spiritual, and social degradation. But Mailer was always spurred by divisive attention-grabbing measures. Is 'white negro' an oxymoron, or fathomable hybrid, a well-needed term to mark a collective Zeitgeist? Mailer keeps the scruples of the term conveniently at bay. By invoking the 'white negro', Mailer attempts to draw attention to the feelings of personal inefficacy in the face of both past and impending conflict and violence, which Mailer argues is inextricable from the Negro condition. The Negro is both the symbol and the subject of injustice, as his view of life is the result of having internalised hatred and subjugation which has made him a marginal figure, yet ensures as with any person who goes against the grain, due to 'disproportionate courage'.[17] It was by living on the periphery that also allowed one to place in proportion codes and mores that are delivered as immovable and true, and they were sceptical to the point of contempt of the voice of privilege that aired such beliefs:

> 'Sharing a collective disbelief in the words of men who had too much money and controlled too many things, they knew almost as powerful a disbelief in the socially monolithic ideas of the single mate, the solid family and the respectable love life'.[18]

This 'respectable love life' was not entirely a call to promiscuity, as it would in part eventually be, but something much broader. For later in the essay, Mailer contends that, 'many hipsters are bisexual'.[19] (Although he did not count himself among their number.) If we are to understand hipsterism in the broadest sense of the term, it does admit of queer identity, by dint of its hostility to 'square', but it must also be acknowledged that its historical definition is within fairly clear heterosexual contours. Moreover, it is also worth remembering that in the 1960s, a time when many men were beginning to listen to their wives and girlfriends about their need for liberation and changes in societal values, the Beats remained fiercely masculinist, defending commitments that were not binding, eschewing marriage, and hitching up with females that were sexually available, attractive but not intellectually challenging.[20]

The hipster (or Hipster, as Mailer also capitalised the word) was of an existentialist but an unerringly American creation, since he is imbibed with the discriminatory and sorrowful history of the Negro:

> In places such as Greenwich Village, a *ménage-à-trois* was completed—the bohemian and the juvenile delinquent came face-to-face with the Negro. And the hipster was a fact in American life. If marijuana was the wedding ring, the child was the language of Hip for its argot gave expression to abstract states of feeling which all could share, at least all who were Hip.[21]

What Mailer describes is a reaction to cultural propriety made decisive by the Second World War. Not only were traditional mores no longer inviolable, but a growing number of society were realizing that certain conventions were as unattainable as they were unrealistic. 'The cameos of security' for the everyday middle-class white American such as a stable home, a reliable job, and a healthy happy family 'are not even a mockery to millions of Negros: they are impossible'.[22] Such deprivation elicits a choice between 'constant humility or ever-threatening danger'.[23] The hipster lives under the spell of this danger 'and for practical purposes could be considered a white Negro'.[24]

Hipster vs. Beatnik

The beatniks, or the so-called Beat Generation, is unmistakably allied to the seismic influence of Jack Kerouac's *On the Road*, published the same year as Mailer's essay in 1957, but also John Clellon Holmes' *Go!* (1952), Alan Ginsberg's *Howl* (1956 and to which Mailer is said to have expressed a debt in conceiving his polemic),[25] and William Burrough's *Naked Lunch* (1959). They were disposed to drug use, preached a free-wheeling and carefree lifestyle, and are regarded as the progenitors to the hippie movements of the 1960s and 1970s—'hippie' being a denigration of hipster, implying a dilution of the original term. But the title of the Beat Generation has come for some to be misleading, since it only revolved around a handful of people, or rather, the said generation was the generation of followers, try-hards, blow-hards, and wannabes.

In his 'Footnote to "The White Negro"', Mailer's seeks to separate his concept of the hipster from that of the beatnik whom he argues was quick to be absorbed by the mass media. While the term 'beat' had been used years earlier, 'beatnik' was coined by a journalist for the *San Francisco Chronicle*, Herb Caen, in 1958 after the launch of the Russian sputnik, while the 'Beat Generation' is believed to have been used by Kerouac a decade earlier to describe being 'beat' by mainstream society. The 'nik' was a Yiddish diminutive that, Mailer explains, 'proved agreeable to the newspaper mentality'. Both hipsters and beatniks share the

love of alcohol, poetry, jazz, sexual excess, and drugs for creating mind-bending experiences and for inducing state of intoxicated madness, but that is not to confuse them, avers Mailer.[26] 'Hipster and Beatnik both talk Hip, but not in the same way—the beatnik uses the vocabulary; the hipster has that muted animal voice which shivered the natural attention when first used by Marlon Brando'.[27] (Mailer is referring to Brando's role as a renegade biker in the 1953 film *The Wild One*.) Mailer continues by arguing that the hipster is a 'lazy proletariat, a psychopath or a spiv', while the beatnik largely derives from the middle class, and adds witheringly that his unwillingness to work is in reaction to the 'conformity of his parents'. In short, he is a counterfeit 'white negro', who plays out his *ennui* without his *anomie*. And while Mailer is highly opinionated in his assessment, his condemnation of the beatnik does ring true, especially for those who have seen the rise and fall of that and the hippie generation:

> If there are hipsters and beatniks, there are also hipnicks and beatsters like Ginsberg and Kerouac, and across the spectrum like a tide of defeat—rebellion takes its price in a dead year and a deadened land—there are the worn-out beats of all too many hipsters who made their move, lost, and so have ended as beatniks with burned-out brains, listening sullenly to the quick montage of words in younger beatniks hot with the rebellion of having quit family, school, and the flag, and on fire with the private ambition to be charged one day so high as the hipster oneself.[28]

The bedraggled fate, according to Mailer's image, is the proof of his insincerity, laxity, and lack of cultural viability. Presumably, the beatnik lacks the same courage and resolve as the hipster, and it is again testament to the distinction—fine and nuanced to the brink of arcane—that hipster lives on as a term to the present day. By contrast the beatnik is locked in history and is a symbol of the innocence and possibility of modern post-war youth, a generation unencumbered by AIDS, overpopulation, high costs of living, and the prospect of ecological disaster. It was of a time when hitchhiking could be done with little danger and 'hanging out' without impunity. But a persistent stereotype of the beatnik was his dishevelled appearance, long hair, facial hair, and creased shirts.

It is in the signature insouciance of the Beat, and the notion that he existed at a time that was more navigable sexually as well as demographically, that lends him to a great deal of nostalgia. As Karen Gaylord, writing as early as 1965, wistfully reflects,

> According to that legend, the archetypal Beat, for all his waywardness, was still an oddly familiar figure. He was young Lochinvar in hasty retreat, the heir to bourgeois respectability escaping once more from Babbitt's version of the American Dream, fleeing

affluence and materialism, small-town or suburban together-ness, and the lock-step march upward toward the ever-receding heights of social success. The first innovators—as exemplified, for instance, by the picaresque and 'real-life' characters of *On The Road*—possessed a sort of raffish innocence, as they hurtled back and forth across the country like a phalanx of minor Walt Whit-mans in search of some new vision of the people. Their mysticism might be over-blown with marijuana, their prattle of Zen vague and muzzy, but their transcendental quest had stubborn roots in the soil of the American past.[29]

These words suggest that the Beats were destined to be integrated into the American dream, the acts of disturbance being just salutary acts of freedom whose means are justified by the ends.

As Jack Foley emphasises, 'The whole point of Mailer's essay is to *provide a way of empowering Mailer, and, by extension, other white people, particularly white males*'.[30] But Mailer's tendency to solipsism was not negative. It gave his work a personal, almost vulnerable quality that spoke to many people. As Gaylord maintains,

> 'Mailer's thesis might smack of witch doctory and amount to a program of personal and/or public salvation, dependent on the resurrection of the myth of the noble savage, but it also tapped deep well-springs of anxiety and projection in the American social consciousness'.[31]

Mailer's incantatory and hallucinatory tract was manna for a generation seeking direction while wayward on taking substances.

In arguably a different kind of self-adulatory form, the same was true for Kerouac. And what is certainly true is that Mailer and Kerouac shared the need to mine the black American experience. Mailer never entertained the idea of becoming black, or to marry white and black, but rather, as Foley points out, to use them 'as metaphors of selfhood which he is playing out. This is also true of Kerouac'.[32] Understandably, these stances by educated, articulate, white heterosexual men drew scorn from members of the Afro-American community, such as James Baldwin, who branded their positions as 'nonsense' and 'offensive'.[33] Others defended the use of the Afro-American, as it served as a rightly provocative exit strategy from simpering social 'squareness'.[34]

In the adaptation of 'black', the equivalent popular figure of the time was Elvis, a white man who, in the early stages of his career, controversially expressed a 'primitive', 'black' sensibility in all its libidinal terror. But it was a 'romance', as Foley observes, that had in essence nothing to do with African Americans.[35] Where Mailer and Kerouac diverge is in only degree, not in kind. Mailer was more extreme and philosophical, while Kerouac was more openly hedonistic. Kerouac was a French-Canadian who spoke French as well as English. He was aware, and did play upon, the transposition of 'Beat' into *Béat* ('blessed'), which made

explicit in the magazine *Beatitude* founded in 1959.[36] Mailer would have judged such an association as effete and coy. For him the Hipster has already tasted damnation, and in a very Mailerian macho twist with its characteristic pop pathos, somehow withstands it.

If it is true that Mailer tried to give some kind of unity to the concept and the persona of the hipster, with all the generalizations of the Beats aside, their literary work was far from coherent. As Stephen Petrus observes, 'Different writers presented a variety of interpretations, which contradicted each other and undoubtedly confused readers'.[37] Yet there was some perceptible overlap. But the idea of a group was given more concrete when the key members began, as Petrus points out, to feature on the pages of magazines such as *Esquire* and *Playboy*. This does tend to support Mailer's contention. The Beats, it seems, were anti-establishment, but within the somewhat decorous confines of media representation, although not always sympathetic (but sympathy is not always the best approach for notoriety). The first article on the Beats to appear in *Playboy* in February 1958 was written by the literary critic Herbert Gold, who contended that the Beats were a more violent extension of the Mailerian hipster. He cited a penchant for heroin and the disregard for responsibility as among the Beats' least desirable traits.[38] Another article appeared in *Esquire* at around the same time written by John Clellon Holmes, which painted the Beats in a far better light. While conceding that they were prone to erratic behaviour, Holmes also defended their spirituality and their capacity for care.[39] Writing shortly after Holmes , Kerouac jumped to the Beat Generation's defence by stating that there were two kinds of hipsters, one 'cool', the other 'hot'. The former, probably of the kind belonging to Mailer, is unfriendly, while the latter, the group to which he belonged, was vibrant and highly social.[40] Irrespective of these views, whether heart-felt or cavil, by now there had been enough discussion stirred in the media to stake out a firm place in the public imagination. But by and large the majority of the public were hostile to Beats and what they represented, one often-cited factor being the disrespect for parental authority.[41] But this did not seem to stop the popular appeal. 'If the initial response was like a wave', 'writes Petrus, 'the second was a tsunami. From approximately the end of 1958 through 1960, popular magazines, newspapers, television shows, and even comic strips bombarded Americans with images of the Beat Generation'.[42] The disturbed individual played by James Dean had officially been replaced by a more unruly and eccentric figure, the beatnik.

The language of the hipster and the beatnik had, as one would expect, a great deal in common, but there were, to the specialist ear, supposedly some finer differences. In 'The White Negro', Mailer comments on

> the cunning of their [hipster's] language, the abstract ambiguous
> alternatives in which from the danger of their opposition they learn

to speak ('Well, now, man, like I'm looking for a cat to turn me on...'), add even more the profound sensitivity of the Negro jazzman who was the cultural mentor of the people, and it is not too difficult to believe that the language of Hip which evolved was an artful language, tested and shaped by an intense experience and therefore different in kind from white slang, as different as the special obscenity of the soldier, which in its emphasis upon 'ass' as the soul and 'shit' as circumstance, was able to express the existential states of the enlisted man.[43]

With the invocation of the depredations of the black American experience, Mailer, energetically but tenuously, advances the notion of a need for a countercultural language, that, while still rooted in English, was rooted in resistance and subterfuge ('different in kind').

Whether or not people who saw themselves as belonging to one as opposed to another group, one observed such distinctions readily, the beatnik's way of talking was grounded in laxity and 'cool', with 'cool' being one of the most popular words. The retinue of words are now part of the historical reserve of hippie diction: 'groovy', 'wild', 'dig', and the all-purpose copula 'like', which still has an unfortunately tenacious afterlife to this day. The dishevelled appearance, together with this way of speech, quickly began to find its way into the popular media, with beatniks featuring in such television shows as *The Many Loves of Dobie Gillis, 77 Sunset Strip, Route 66*, and *San Francisco Beat*.[44] Only a few years after the first few tumultuous responses to the Beats, when the language and, by degrees, appearance began to seep into popular life, and especially with the prominent place within the media, the beatnik had evolved into a popular figure, either to emulate or to ridicule. As Petrus again explains,

> Beatnik clothing also turned into a hot commodity. The Young Individualist Shop, a boutique in Manhattan on Fifth Avenue, noted the *New York Times*, sold a variety of fake furs and a black wool dress with a sleeveless tunic of mock leopard designed to appeal to the 'on-beat chicknik'. College stores throughout the nation, as shown in *Life* magazine, offered loose sweaters, tight black trousers, skirts, and leotards items that beat chicks consider 'the end'.[45]

Although the beatniks were suspect of vagrancy and delinquency, their ad hoc style in both manner and dress had, in the space of only a few years, significantly penetrated American life, and the ways in which it viewed itself.

What is hard to neglect is the vehemence and sincerity with which both Mailer and the Beats, especially Kerouac and Ginsberg, set about validating and reflection on their understanding of a new social condition.

As Foley remarks, the entry of the Beat Generation into American society at the end of the 1950s was often referred to as an 'explosion'. So too, Mailer's manifesto and his subsequent sallies had explosive import, and the more so as they gathered momentum. The explosion in American culture was a mass reflex to the explosion of the atomic bomb and the consciousness that what had been visited on others might be visited on the home shore. But if laced in fear, it was also an explosion of exultation.[46]

Hipster Style

There are roughly two points of origin of the hipster. The first, as mentioned in the introduction, is with jazz and bebop culture in the 1940s, the second are the 'white negroes' and the Beat Generation beginning in the late 1950s. The earliest hipsters centred around the club scene and with jazz musicians like Thelonius Monk, Dizzy Gillespie, Cab Calloway (Figure 3.1), and Charlie Parker who liked to differentiate themselves from the 'square' exponents of swing music such as Guy Lombardo

Figure 3.1 Cab Calloway in Zoot Suit Performing on Stage. The New York Public Library.

or Lawrence Welk. But from the very start, whiteness would encroach on Afro-American territory, since many White jazz musicians, including Benny Goodwin, Gerry Mulligan, and Mezz Mezzrow numbered among those associated with hip. Others, such as Bing Crosby, were consecrated as an epitome to hipness. In a comment made in 1992, the clarinettist Artie Shaw pronounced Crosby as 'the first hip white person in the United States'.[47] True or false, the statement certainly highlights the brisk watershed of hip from blackness to whiteness.

The alliance between jazz and hip was far from a calculated one, but emanated from the many social strictures placed on society in the middle of the twentieth century, and the gatekeeping between classes and high and low cultural Institutions. Jazz had no venerable historic tradition, and if anything was likened to the troubadours, who were also thieves, journeymen, and confidence tricksters. Jazz's emphasis on improvisation was seen as an indication of its unruliness (conveniently the forgetting the role of improvisation in the classical music tradition). But it was thanks also to the prohibition that made jazz 'the theme-song of the underworld'. As Mezzrow himself explains,

> 'because, thanks to prohibition, about the only places we could play like we wanted were illegal dives. The gangsters had their dirty grabbers on our music too, just like they kept a death grip on everything else in this booby-hatch of a country'.[48]

The ownership of strains of jazz, such as bebop, was an issue that would be contested in the early years of the hipsters and the Beats in the 1960s, and came to a head with the Black Power movement at the end of the decade. It is a debate that would rage into the century and find itself reborn with the question of the ownership of rap music. What is true for both jazz and rap, is that both proved to be highly effective mechanisms for communicating the experience of black America, amongst themselves and more widely.[49] From the 1940s to the 1960s, jazz represented something far more than music, but a rejection of white middle-class high art, and a robust alternative to the mainstream.[50]

The hipster style of clothing had been in circulation since the 1930s with jazz musicians wearing zoot suits and dark glasses indoors. In *A Portrait of a Hipster* (1948), Anatole Broyard writes of the hipster that 'he brandished his padded shoulders... flourished his thirty-one-inch pegs like banners... his two-and-seven-eighths-inch brim was snapped with absolute symmetry ...and he always wore dark glasses, because normal light offended his eyes'.[51] Kerouac later wrote in his reflection on the Beat Generation, that 'the hipsters, whose music was bop, they looked like criminals but they kept talking about the same things I liked, long outlines of personal experience and vision'.[52] In *On the Road*, Kerouac writes of 'a great mob of men dressed in all varieties

of hoodlum cloth, from red shirts to zoot suits'.[53] Essentially the hipsters were anti-materialistic, which meant that fashion was not as important in the subculture in so much as literature or music. Kerouac was often photographed wearing baggy chino trousers and checked or plaid shirts, his hair was unkempt, and he was usually unshaven. Ginsberg was in the habit of wearing faded jeans, turtleneck sweaters, and sandals, and kept a long beard. 'The Beats' unkempt appearance', writes Linda Welters, 'became a badge of defiance in the neat, well-groomed 1950s'.[54] This unkempt, 'messy' look was a deliberate choice of style and a visual signifier adopted by the Beats to indicate a 'beaten and defeated' life in line with their credo. This style became a signifier of difference and a sign of revolt. Whilst Kerouac's style encapsulated a 'beaten' downtrodden look, the characters he describes in *On the Road* are quite the opposite, they 'sharp up for the big night' and look 'sharp in a suit'.[55] The zoot suit, with its extended lapel, baggy pegged trousers, and thigh level jacket was an exaggerated style of suit compared to the suits that were fashionable at that time.

The zoot suit soon gained a reputation for brazen, hedonistic night-life, pimping, and gangs. Although the circumstances of its resurgence remain obscure, the earliest examples of the suit have been cited in 1818, from illustrations in the St. Louis *Missouri Public Gazette and Advertiser,*[56] being a flared jacket in the style inspired after the typical eighteenth-century *habit*, which was worn over a long waistcoat. Other precedents have include the long coattails that Clark Gable wore playing Rhett Butler in *Gone With the Wind,*[57] the baggy suits of Frank Sinatra,[58] and Mexican film star Tin Tan who wore loose flowing suits in 1930s.[59] Other commentators propose the suit's origins in Pachuca, Mexico, but evidence about this is slight.[60] What we do know is that the zoot suit was a popular fashion garment worn by African Americans and jazz impresarios Dizzy Gillespie and Cab Calloway during the 1930s and appears to have its roots in jazz subculture. By the mid-1940s, when bebop became a popular form of music, the zoot suit became a fashionable garment amongst African American men. Ralph Ellison's 1952 novel *The Invisible Man* captures the language and subcultural affiliation produced by the suit.

> A group of zoot-suiters greeted me in passing. 'Hey now, daddy-o,' 'they called. 'Hey now!'...It was as though by dressing and walking in a certain way I had enlisted in a fraternity in which I was recognized at a glance – not by features, but by clothes, by uniform, by gait.[61]

The zoot suit was worn by the Jazz impresario and self-confessed hipster Dizzy Gillespie, who described himself as 'pretty dandified',[62] and attracted a cult following with his sense of dress and style. It was not so much his zoot suit that attracted the Beats, but rather his beret, eyeglasses, and long pointy 'goatee' beard that became synonymous with

beatnik sartorial style and rebellion. Ten years later the zoot suit would become associated with anti-American sentiments as *pachucos,* young Mexican men, adopted the suit as an act of defiance against white middle-class American values. These feelings of disenfranchisement culminated in the clash between sailors (which symbolically represented patriotism to white American values) and young Mexican-American youth in Los Angeles in 1943, which became known as the 'zoot suit riots' (to be discussed later in Chapter 8).

Historically the whiteness of such rebellion was all but sedimented with James Dean's role in the film *Rebel Without a Cause* (Nicholas Ray, dir. 1955). As a side reference consonant with Mailer's contention that that the hipster was a kind of psychopath, the film's title was taken from a book written by psychiatrist Robert M. Lidner titled *Rebel Without A Cause: The Hypnoanalysis of a Criminal Psychopath* (1944), although that was the limit of the derivation. Dean vividly portrayed the rudderless youth of the prosperous post-war era, a youth weighed down by a war in which they did not participate. In terms of sartorial style, Dean's faded blue jeans, white T-shirt, and red jacket became an iconic garment of rebellion (Figure 3.2). The cut of Deans red

Figure 3.2 James Dean. Billy Rose Theatre Division, The New York Public Library.

jacket was based on Marlon Brando's prototype black leather motor-cycle jacket that became synonymous with the motorcycle boys and rebellion. Released two years after *The Wild One* (Laszlo Benedek, dir. 1953) starring Marlon Brando, Dean's performance as a despondent, juvenile delinquent dissatisfied with his world imprinted a social condition of the new generation on public consciousness. A more detailed analysis of the film and the leather jacket is explored in Chapter 6 of this book.

As we have already discussed, hipness navigated its way through, in, and around the Beats, was brought into the mainstream by the hippies, and then brought into abeyance by the yuppies of the 1980s and 1990s. Hipster slowly re-emerged as a mainstream term in the late 1990s, but this time it was laced with a new kind of inner city chic, mixing the most up-to-date cell phones, fixie bikes,[63] and Che Guevara[64] T-shirts. The contemporary hipsters mixture of conformity and rebellion is neatly summarised by Philip Ford in his observations about Kurt Cobain, the lead singer of the grunge band Nirvana, who died in 1994 aged 27 (James Dean died at 24):

> Kurt Cobain rebels for us, so that we may with an easy conscience pay our bills, worry about our children, and tip our mail carrier at Christmas. If there is something multiply absurd about the idea of Cobain, who died a fabulously wealthy man, wearing a T-shirt reading 'corporate rock magazines still suck' on the cover of Rolling Stone, we resort to the tired language of 'co-optation' to explain it—or, if we wish to preserve our idealized memory of Cobain's 're-bellion,' 'we simply do not think about it too much.[65]

These contradictions are internal to the way in which capitalism absorbs and exploits subculture for its own ends. The passage also gives us pause for where rebellion is or can be situated, and the manner in which it is marketed, often at the expense of its poster-boys.

Writing on hipster cinema and the revival of the hipsterism in 1990's Los Angeles, David James agrees that

> Sometimes the term carries a derogatory implication of the fash-ionista's appropriation of the accoutrements of various post-punk and hip-hop cultures combined with the refusal or avoidance of whatever real social contestation these might have entailed. The simultaneous revival and reconstruction of the term [hip-ster] imply both a desire for some authentically real politics and the present difficulty of actually engaging them. Occupying the space between the desire and its impossibility is the spectacle, the contemporary media system in which life as it might be lived is reflected back in the form of signs of commodities and signs as commodities. Any cultural activity that engages this media system

will find its search for authenticity inhabited by irony and ambivalence. Of the myriad other social and cultural developments that separate.[66]

And even if we are to seek a less unflattering light, where today's hipster is used generically for urban, creative-minded, neo-liberal youth, James' comment is hard to refute. It is a position taken by numerous other commentators on the new-wave hipster of the new millennium, which they see as a desiccated version of the original, or a wholly new animal. According to Rob Horning, the hipster 'as an embodiment of postmodernism' is 'a spent force, revealing what happens when pastiche and irony exhaust themselves as aesthetics'.[67] The aestheticization of any cause has long been its death-knell, but it a transformation favoured by capitalism in which radicalism can be marketed as something piquant, but emptied and sanitised of its radical potential. For the radical outside posited, or imagined by Mailer and his generation, is one that has been co-opted by media and advertising,[68] and exists as little more than an aesthetic, disinfected, and nostalgic memento. The residue of the hipster is something straddling the down-and-out artist or student and cultural élite, an alignment of the rebel and the dominant classes to confusing and deleterious effect.[69] In the midst of this confusion, what is noticeable in the last few decades is the need for men to inhabit a kind of fantasy that is more of a graspable kind of character model, however much implausible.

It is maybe best to conclude with a parody of the hipster that became something of a prophecy. During the heady wave of the media's preoccupation with the new subculture, in 1960 *MAD* magazine devoted six pages to parodying beatniks in which modes of speech, clichés regarding the aversion to cleanliness, fascination with Zen Buddhism, and other sacred cows were all comedically pilloried. One scenario describes a beatnik called 'wild Harry' who unaccountably becomes a square: his friends lament his shaving his beard, taking a bath, drinking beer from a glass, aversion to espressos, and his growing interest in baseball.[70] Today's reincarnation of the hipster is all of that, wearing as a badge of honour all the trappings of political and social awareness: he is pro-gay marriage, eats organic, loves quinoa, prefers organic cotton, drinks ethically sourced tea and coffee ('fair' is the catchword), and he likes the other products he supports to be sustainable. Not that there is anything wrong with any of this, except that when ethics become a matter of fashionable posturing, then the revolutionary impetus behind the original becomes a grim caricature. The upholding of causes for the sake of aesthetics and bolstering personal image tends in the end to obscure the issue of the often, unwelcome rigors that accompany actual change. But then, in retrospect, it is still inconclusive as to how effective the original hipster was in the first place—whether the vast literature and rhetoric, grandiloquent and seductive as it was, could measure against harsh reality. Or was it, for both hipsters of then and now, a convenient politics of deferral and delusion?

Notes

1 Anatole Broyard, "A Portrait of the Hipster", *Partisan Review* (June 1948), 724.
2 Carol Tulloch, *The Birth of Cool* (London: Bloomsbury, 2016), 4.
3 Robert Farris Thompson, 'An Aesthetic of the Cool', *African Arts* 7, no. 1 (1973): 41.
4 Richard Lacayo, "If Everyone is Hip... Is Anyone Hip", *Time*, August 8, 1994, http://content.time.com/time/magazine/article/0,9171,981219,00.html. Accessed February 28, 2017.
5 Zeynep Arsel and Craig J. Thompson, "Demythologising Consumption Practices: Consumers Protect their Field-Dependent Identity Investments from Devaluing Marketplace Myths", *Journal of Consumer Research* 37, no. 5 (February 2011): 795.
6 Denny Lee, "Has Billburg Lost Its Cool?", *The New York Times*, www.nytimes.com/2003/07/27/nyregion/has-billburg-lost-its-cool.html. Accessed February 24, 2017.
7 Tim Elliot, "A Spotters Guide to the Emerging Tribes of Sydney", The Sydney Morning Herald, www.smh.com.au/nsw/a-spotters-guide-to-the-emerging-tribes-of-sydney-20140607-39qc2.html, June 7, 2014. Accessed February 27, 2017.
8 Matt Granfield, *HipsterMattic* (Sydney: Allen and Allen, 2011), 8.
9 Caroline Evans, "Dreams that Only Money Can Buy... Or, the Shy Tribe in Flight from Discourse", *Fashion Theory: The Journal of Dress, Body and Culture* 1, no 2 (1997): 172.
10 See Dick Hebdige, *Subculture the Meaning of Style* (New York: Routledge, 1979).
11 Christian Lorentzen, "Why the Hipster Must Die", *Time Out New York*, no. 609, http:/newyork.timeout.com/articles/features/4840/why-the-hipster-must-die. Accessed February 25, 2017.
12 Zeynep Arsel and Craig J. Thompson, "Demythologising Consumption Practices", 796.
13 See Philip Ford: 'But if the presence or absence of hipness in a piece of expressive culture cannot be as easily demonstrated as some more material phenomenon, it is no different in this respect from aesthetic concepts such as sublimity or beauty. One may not be able to draw up a definitive list of beautiful or unbeautiful things, but one can at least discuss how the word beautiful has been used as a term of aesthetic discourse, and how a specific idea of the beautiful can imprint itself on those works that have been fashioned by an artist's dialogue with that idea.' "Somewhere/Nowhere: Hipness as an Aesthetic", *The Musical Quarterly* 86, no. 1 (2002): 50.
14 Steve Shoemaker, "Norman Mailer's 'White Negro': Historical Myth or Mythical History?", *Twentieth Century Literature* 37, no. 3 (1991): 343.
15 Mailer, "The White Negro", 291.
16 As James Wierzbicki puts it: 'Personal rant though it may be, and by the author's own assessment 'difficult to read,' the essay is nonetheless potent, not the least because of the vocabulary with which Mailer spurs himself— and perhaps sympathetic readers—to vent frustration. The appropriate parlance, Mailer writes, includes such terms as 'man, go, put down, make, beat, cool, swing, with it, crazy, dig, flip, creep, hip, square''. *Music in the Age of Anxiety* (Illinois: University of Illinois Press, 2016), 55.
17 Ibid., 292.
18 Ibid., 292–293.
19 Ibid., 304.

20 Wierzbicki, *Jazz*, 71.
21 Ibid., 293.
22 Ibid.
23 Ibid.
24 Ibid., 294.
25 Robert Ehrlich, *Normal Mailer: The Radical Hipster* (Metuchen, New Jersey and London: The Scarecrow Press, 1978), 6.
26 See also Eugene Burdick, "The Politics of the Beat Generation", *The Western Political Quarterly* 12, no. 2 (1959), 555.
27 Mailer, "A Footnote to 'The White Negro'"', *Advertisements*, 325.
28 Ibid., 327.
29 Karen Gaylord, "Bohemia Revisited", *Social Research* 32, no. 2 (1965): 165.
30 Jack Foley, "Beat", *Discourse* 20, no. 1/2 (1998): 184. This view, but taken in a broader sense, is supported by Robert Ehrlich: 'While Mailer continues to advocate radical social change, the individual in the guise of Mailer himself of one of his male fictional personae is usually the focus and of greatest interest', *Normal Mailer: The Radical Hipster*, 6.
31 Gaylord, "Bohemia Revisited", 172.
32 Ibid.
33 James Baldwin, "The Black Boy Looks at the White Boy", *Nobody Knows My Name* (New York: Dial P., 1961), 231.
34 Gaylord writes: 'The Hip mask may have been a white fabrication designed to depict a socially demanded role, as characterologically fictitious in its fashion as ever Uncle Tom, Aunt Sally, or Sambo had been, but surely it offered more freedom to its wearer than the former constrained grimace of 'happy' submission. And most important, since this projection represented no disclaimed cast-off summarily to be rejected but rather a found treasure greatly to be rejoiced in, since it established in at least a portion of the white public consciousness a powerful heroic image, mysteriously knowledgeable, I would argue that it functioned subtly but significantly to bring to the Negro a new audience eager to learn the secret wisdom that myth had conferred upon him'. "Bohemia Revisited", 172.
35 Foley, "Beat", 184.
36 Ibid., 187.
37 Stephen Petrus, "Rumblings of Discontent: American Popular Culture and its Response to the Beat Generation, 1957–1960", *Studies in Popular Culture* 20, no. 1 (1997): 4.
38 Cit. Petrus, ibid., 5.
39 Ibid., 6.
40 Ibid.
41 Ibid., 7.
42 Ibid., 8.
43 Mailer, "The White Negro", 301.
44 Petrus, "Rumblings of Discontent", 10.
45 Ibid., 11.
46 Foley, "Beat", 195.
47 James Marcus, "The First Hip White Person", *The Atlantic*, February 2001, www.theatlantic.com/magazine/archive/2001/02/-the-first-hip-white-person/302104/. Accessed May 2, 2016.
48 Mezz Mezzrow, Bernard Wolfe, "If You Can't Make Money", in Glenn O'Brien ed. *The Cool School: Writing from America's Hip Underground* (New York: Library of America, 2003), 9.
49 See also Wierzbicki, *Jazz*, 63–68.
50 Ibid., 74.

51 Anatole Broyard, "A Portrait of a Hipster", in Charters Ann ed. *Beat Down to Your Soul: What Was the Beat Generation?* (London: Penguin, 2001), 45.

52 Jack Kerouac, "The Origins of the Beat Generation", in ibid., 129.

53 Jack Kerouac, *On the Road* (New York: Viking Press, 1957), 131.

54 Linda Welters, "The Beat Generation", in Linda Welters and Patricia A. Cunningham eds. *Twentieth Century American Fashion* (Oxford: Berg, 2005), 159.

55 Ibid., 52–53.

56 Anon. "Early Zoot Suits", *State and Local History News* 2, no. 4 (1944): 3.

57 Shane White and Graham White, *Stylin': African American Expressive Culture and Its Beginnings in the Zoot Suit* (Ithaca and London: Cornell University Press, 1998), 249.

58 Samuel Gilbert, "Schools vs. Frank Sinatra and Zoot Suits", *Journal of Education* 127, no. 5 (1944): 153–155.

59 Luis Alvarez, *The Power of the Zoot* (Berkeley and London: University of California Press, 2008), 83.

60 Edouardo Obregón Pagán, *Murder at the Sleepy Lagoon: Zoot Suits, Race, Riot in Wartime L.A.* (Charlotte: North Carolina University Press, 2003), 108.

61 Ralph Ellison, *The Invisible Man* (New York: Vintage, 1995), 485.

62 Dizzy Gillespie, *To Be, or Not....to Bob: Memoirs* (New York: Double Day, 1979), 279.

63 A fixed gear or 'fixie' bike is a bike that has a drive train and no fixed wheel mechanism.

64 Ernesto Che Guevara was an Argentinian Marxist that became a revolutionary leader during the Cuban Revolution against the right-winged authoritarian government of President Fulgencio Batista. His image, which was graphically interpreted, became a countercultural symbol of rebellion in popular culture.

65 Ford, "Somewhere/Nowhere", 71.

66 David James, "L.A.'s Hipster Cinema", *Film Qharterly* 63, no. 1, (2009): 58.

67 Rob Horning, "The Death of the Hipster", in Mark Greif, Kathleen Ross and Dayna Tortorici ed. *What Was the Hipster? A Sociological Investigation* (New York: n+1 Foundation, 2010), 84.

68 See for example Yogi Hendlin, Stacey J. Anderson and Stanton A. Glantz, "'Acceptable Rebellion': Marketing Hipster Aesthetics to Sell Camel Cigarettes in the US", *Tobacco Control* 19, no. 3 (2010): 213–222.

69 See Mark Greif: 'The hipster is that person...who in fact aligns himself *both* with rebel subculture *and* with the dominant class, and opens up a poisonous conduit between the two.' "Positions", in Mark Greif et al. eds. *What Was the Hipster?*, 9.

70 *MAD*, September 1960, 41–46, cit. Petrus, "Rumblings of Discontent", 10.

4 Sailors[1]

The mariner holds a special place of fascination in the world of fashion and in the sexual imagination of both men and women. This is perhaps attributable to the personal cost of having to spend long periods at sea, and the many rigors he was expected to withstand. In the early days of exploration, from the fifteenth century onward, seafaring was a perilous business, the high risk rewarded with the promise of new vistas and riches. Months at sea were physically and psychologically taxing, but to those who did not need to experience it, exciting and adventuresome. The difference between sailor and soldier was that soldiers undertook their business where everyone else did, on the land, whereas sailors had a life at sea, on the part to which humans did not belong. What happened from day to day at sea was also something of a mystery to the uninitiated. By the late twentieth century, the mariner and particularly the sailor as a type and idea insinuated itself into everyday life, becoming a strong signifier both of rugged masculinity and of queer identity.

In the quintessential narrative about man and the sea, Herman Melville's *Moby Dick*, there are numerous vivid descriptions of mariners. One is of the chief mate, Starbuck, a rugged and ravaged seaman, whose body bears the many traces of the elements to which he has been exposed. Those familiar with Melville will know that quotations from him are seldom inclined to be short:

> A long, earnest man, and though born on an icy coast, seemed well adapted to endure hot latitudes, his flesh being hard as twice-baked biscuit. Transported to the Indies, his live blood would not spoil like bottled ale. He must have been born in some time of general drought and famine, or upon one of those fast days for which his state is famous. Only some thirty arid summers had he seen; these summers had dried up all his physical superfluousness. But this, his thinness, so to speak, seemed no more the token of wasting anxieties and cares, than it seemed the indication of any bodily blight. It was merely the condensation of the man. He was by no means ill-looking; quite the contrary. His pure tight skin was an excellent fit; and closely wrapped up in it, and embalmed with inner health

and strength, like a revivified Egyptian, this Starbuck seemed prepared to endure for long ages to come, and to endure always, as now; for be it Polar snow or torrid sun, like a patent chronometer, his interior vitality was warranted to do well in all climates. Looking into his eyes, you seemed to see there the lingering images of those thousand-fold perils he had calmly confronted through life.[2]

Calm and solemn, his inscrutability bears the weight of hardship. In a novel that allegorically casts back to the Old Testament, Melville paints a reverential picture of a quasi-religious figure, 'the wild water loneliness of his life' disposing him to 'superstition'.[3] The mystique of such characters owes itself them not seeming quite as real others, as their time on the land on furlough becomes just the intervals between their more authentic lives on the sea.

Of a dramatically different bent is a photograph of the Rolling Stones taken in 1974 while recording their song 'It's Only Rock and Roll (But I Like It)'. They are all dressed in white pants and shirts with large collars teamed with dark ties or scarves, not too dissimilar to a sailor uniform. In trying to look past the nostalgic charm of the image, the combination has a rather unsettling effect that can best be described as camp, to use the word theorised by Susan Sontag exactly ten years before the picture was taken. The costumes give the members of the band a roguish air without in any way being threatening. In a picture taken about the same time in 1967 sees the actor Kirk Douglas, at the height of his fame, on vacation, stepping off a boat in Sardinia. He is wearing a version of a Breton sailor shirt, a long-sleeve shirt with blue and white stripes that is unmistakably nautical. These are but two examples among a great many, but they serve to show the extent of the idiom of the seaman in male identity and male style, and one that stretches to women's fashion as well. What aligns the two is that wearing a uniform gives the male figure a certain phallic impetus, an assertion of male dominance and power. But as in the Rolling Stones' image, the nature of this power is not uniform. The boyish charm is different from the straightforward brute masculinity of Douglas.

Men in Uniform

In the successful television series *Black Sails*, which is presented as a prequel to Stevenson's *Treasure Island*, there is an understandable inconsistency that is persistent in perhaps all naval period dramas, namely that the naval seamen wore uniforms. Set around 1715, the story revolves around characters that are fictional (Captain Flint) and ones based on fact (Charles Vane). Pirates are the romantically unruly and desirably undesirable who are pitted not only against themselves, but against the righteous and, by contrast, more prim British navy and marines. But at this time, the truth about uniforms on British naval vessels was that they differed

dramatically from ship to ship, with the sailors in their own clothes as the officers followedthe lead of the captain. Captains could be austere or they could be flamboyant: Admiral Sir Charles Napier, for instance, wore a bright yellow waistcoat under a cut-away coat.[4] It was not until 1748 that the British Navy resolved to have uniforms, dark blue, and then only for the officers, a measure intended to increase their authority by placing them apart from the common sailors. It is still unclear why it took so long for sailors to wear uniforms comparative to the landed military. A common-sense explanation is that land soldiers required uniforms to differentiate one another, while sailors were separated from ship to ship, except during exceptional situations when the ship was boarded. The other concern was expense. Comparative to the military, the navy had a high desertion rate owing to the isolation and brutality of sea life, and to the ease by which a sailor might take flight while stopping on a foreign port. The investment in uniforms was therefore an unattractive one.

This is not to suggest that the military at this time had had a long history of uniform. Until the mid-seventeenth century uniforms had been confined to élite guards and for ceremonies. The Knights Templar of the Middle Ages wore the same red crosses on a tunic over their chain mail, which by dint of repetition can be called uniform, but was not standard issue in the modern sense. A fresco from 1577 by Jacopo Coppi depicts the Pope Sixtus III with the Swiss guard dressed in their traditional motley uniforms. In 1626 the Swedish infantry under Gustavus Adolphus wore alternatively yellow or blue to distinguish regiments. At this time, the standard way to distinguish friend from foe was through so-called 'field signs' which could range from feathers or scarves to foliage. But commentators agree that, with isolated exceptions, the largest and most noticeable incident in the history of uniform appeared in the English Civil War (1642–1645) as a means of adding discipline and conformity to an army that had been experiencing defeat. As Jennifer Craik states, uniforms not only allowed easy differentiation from the enemy, but were also instrumental in instilling loyalty. Moreover, through uniform 'individuals learned to behave in particular ways and acquired contrived body techniques and mental attributes'.[5]

The ubiquitous blue of naval uniforms is taken to be something of a given, a continuation of colour of the sky and sea. However much as this was a happy aesthetic marriage, the explanation has far more to do with logistics. The British colonization of India and victory over France in the Seven Years' War (1756–1763) enabled the rapid expansion of the East India Company which made a great many new goods more plentiful and affordable. One of these commodities was the plant, *Indigofera tinctoria*, or indigo plant, which had been used in Europe since the thirteenth century, but now was in no short supply. As well as abundant and affordable, indigo was also markedly more colour fast than other pigments, and thus more likely to withstand exposure to salt water and the sun. The French Revolutionary Wars from 1789 onward followed by

the Napoleonic era, a period of almost perpetual conflict, created advancements in warfare at all levels, including uniforms. Naval uniforms were issued to all levels of seaman, as it was identified that it not only denoted rank but also unity. While after the Napoleonic wars, all navies mandated uniforms (the US in 1817), it was not until the mid-nineteenth century that the naval uniform became a distinct type, where the national variations became less pronounced.

And so the sailor, or Sailor, was born. His look was a variant on a set of recognizable standards such as the flap or blue jean collar, the striped shirt, the dixie cup cap, otherwise called the 'Bachi' bonnet by the French, or the square rig or pork pie hat, and bell-bottom trousers (Figure 4.1). The shoulder flap is falsely attributed to the accommodation of tarred pigtails, although these began to phase out after Napoleon's final fall in 1815. Designed for utility, the bell-bottoms were to be

Figure 4.1 Sailor (present day). George Arents Collection, The New York Public Library. New York.

easily rolled up to prevent unnecessary wear and soiling when the deck needed scrubbing. A year after men's uniforms became standardised by the British Admiralty in 1858, the French navy adopted the Breton shirt or 'marinière', the unmistakable blue and white striped shirt. The garment is so distinctive and so classic that its original justification has receded to obscurity. The stripes, wide apart, were intended to make sailors cast into the sea easier to spot. Made of knitted jersey cotton with long or three-quarter length sleeves and a boat neckline, the Breton shirt contained 21 white strips of 20mm and 20/21 blue stripes of 10 mm, as required by the French-Navy Act.

It did not take long for the sailor to be quoted in everyday dress. Once again, the reasons for this remain imprecise, and is probably a combination of the happenstance of the influence of some of the earliest instance, and the more consequential reason raised earlier that the sea was a far

Figure 4.2 Kaiser Wilhelm II in 1861. The Miriam and Ira D. Wallach Division of Art, Prints and Photographs: Print Collection, The New York Public Library. New York.

more abstract space than the land, and as a result more disposed to the changes caused by appropriation and adaptation. Of these signal early examples, which became popular and copied in their time, was the representation of Prince Albert Edward, the Prince of Wales (later Edward VII) by Napoleon III's court painter Franz-Xaver Winterhalter. Standing against a coastline, his sailor's outfit has a generous blue collar faced with white, under which springs a generously flowing black cravat. His hands are resolutely in his pockets, emphasizing the three big buttons that hold up his fly fronts. Sailor outfits of this kind would continue to have currency and growing popularity in successive decades, for both boys *and* girls. It served particularly well for photographic portraits of children, becoming an almost ceremonial uniform of dressing up for the photographic event that made them something more than just children, while still not being adults. The sailor figure, it seems, traverses a number of liminal spaces, starting with the sea, to that of gender and of age. It has a special autonomy, in fact, being used as a standard uniform for children in roles nothing to do with the sea, such as Vienna Boys' Choir (Figure 4.2).

The Seepage of Sailor into Life and Lore

Just as the sailor suit was quickly adopted as a key fixture of the elegant child's repertory at the end of the nineteenth century and beyond, by the beginning of the twentieth century the marinière came to be a popular item worn by civilians. Such a shift was perhaps the first example of military sartorial troping, as it would later become common in the use of the camouflage pattern, sharp peaked caps, and military boots. One important juncture in the sailor look was Coco Chanel, who drew inspiration from observing the sailor uniforms of the First World War. She would later wear one herself and launched her Navy Style range, which was also lauded for the use of the practicable and available jersey fabric in a time when luxury fabrics were scarce. Chanel thus started a trend that would be reprised repeatedly in different or the same ways. The elements of the sailor suit—striped of blue and white, cloth or peaked cap, anchors, and brass buttons—have been translated into nautical themes and appeared on the fashion catwalk. Jean Paul Gaultier, Givenchy, Dior, Sonia Rykiel, Prada, Michael Kors, Dolce & Gabbana, and Kenzo have all included elements or interpretations of the sailor theme in their collections. Most recently Karl Lagerfeld reprised Chanel's Navy Style with his Croisière ('cruise') collection launched in May 2015. The blue and white striped shirt's prevalence has been assured by it being worn by as diverse a group as Pablo Picasso, Jean Cocteau, John Wayne, Audrey Hepburn, Brigitte Bardot, Andy Warhol, David Bowie, and the mime artist Marcel Marceau.

But this is not to lose sight of the sailor himself, although reality does tend to mingle with fiction. Associated with youthful virility, yet forced to celibacy from long months at sea, the sailor in fiction, art, and film

became a symbol of sexual availability. The excitement of local women at news of a naval ship coming to port is a cliché that is also true. The lusty sailor promised a liaison whose excitement lay in the expression of his pent-up sexual energy and the advantages of non-committed relationships. Cole Porter sang 'What's Central Park without a Sailor?' Paul Cadmus and Charles Demuth painted sailors with a distinctly homoerotic air. In a similar vein, the sailor in his tight pants features in Tennessee Williams' *The Rose Tattoo*. What is undeniable is the very precariousness of the sailor's sexuality, especially given the covert, but highly reasonable, suggestion that while at sea, sexual frustrations evidently led them to places they might have ventured while on land. And the look of the hard-muscular sailor's body has also been appropriated by gay men and made popular in the illustrations of Touko Laaksonen, aka Tom of Finland. Laaksonen's drawings repeatedly display images of men dressed in uniform, including the sailor with hard bodies and oversised genitalia bulging the crotch of their trousers. We will return to him shortly.

A central figure in the homoerotic mythology of the gay sailor is the formidable Lietuenant Seblon in Jean Genet's *Querelle de Brest*. There is a passage of Seblon's memory of *Querelle* that is notable on a number of accounts, not least at which the sailor suit and the sailor persona are at the epicentre of the homosexual meeting point. With the sailor as a world-traveller, Genet combines an image of Oriental wonder with a primal, pre-Grecian animality, as if Querelle were the paragon of civilisation and primitivism all in one:

> The most striking memory that Seblon had of him—and it was one he often recalled—was a time in Alexandria, Egypt, one blazing noon when the crewman showed up at the foot of the ship's gangway. Querelle was smiling, a dazzling, silent smile that showed all his teeth. At that time his face was bronzed, or rather, tanned a golden color, as is mostly the case with blondes. In some Arab garden he had broken off five or six branches of a mandarin tree, laden with fruit, and, as he like to keep his hands free, to be able to swing his arms and roll his shoulders while walking, he had stuck them into the V-neck of his short white jacket, behind the regulation black satin cravat, their tips now tickling his chin. For the lieutenant, their visual detail triggered a sudden and intimate revelation of Querelle. The foliage bursting forth from the jacket was, no doubt, what grew on the sailor's wide chest instead of any common hair, and perhaps there were—hanging from each intimate and precious little twig— some radiant balls, hard and gentle at the same time.[6]

Genet is clearly having fun with the description. Brest was hit hard during the Second World War and this destruction sets up the violence rife in the book. *Querelle* literally means 'quarrel' (used as most commonly in

the 'quarrel between the ancients and the moderns'), which also sets up a sense of conflict, but can also be said to infer, for our purposes here, the inner tension within the sailor-type himself, especially with regard to homosexual culture and iconography. As Genet's biographer, Edmund White, explains, Genet drew a great deal from Herman Melville's *Billy Budd*, for in both books 'the sailor is compared to Christ and themes of murder, homosexuality and sadism are deeply intertwined'.[7] (Melville, incidentally, is widely believed to have been homosexual.) However, Genet, in his tale, inverts Billy Budd's demise for a murder he committed unintentionally: Querelle voluntarily kills a fellow sailor and escapes unpunished, while Seblon's love for Querelle involves masochistic submission. Querelle is a man, while Billy is a boy.[8] Clearly this man-boy relation as it is mobilised in the sailor type needs more unpacking.

Sailors Big and Small

At this point we have arrived at a juncture of the sailor's sexuality. Perhaps unlike any other male type, in the sailor the oscillation between hetero and homosexuality is the strongest, the borderline the most indistinct. At the same time, he can be alluringly cute and infantilised, as with the portrait of Prince Edward, or menacingly formidable, as with Melville's Starbuck. The sailor is the explorer of distant lands at great physical and psychological cost, or he is the 'cruiser', the gay male in search on the streets for anonymous sex. While still practiced today, cruising was rife at the end of nineteenth century, necessary to duck social condemnation. Cruising is dangerous with the added excitement of the fleeting, chance encounter. This is the shadier, gay version of the girls waiting to meet the sailors as the ship comes to port. As such, the sailor is a cipher for two traits: ephemerality (the traveller, the itinerant) and danger (strength, military). He is the archetype of the ephemeral sexual being.

A searching and revealing exploration of the two polarities of the sailor—the innocent and cherubic child on one hand and the roving tough guy on the other—can be found in descriptions by two very different (homosexual) authors, Thomas Mann and Edmund White. In Mann's novella *Death in Venice* (1912), Ashenbach's first sighting of the beautiful boy, Tadzio—the obsession and later his ruin—is with him clad in a sailor suit:

> No one had ever dared to cut short his beautiful hair; like that of the *Boy Extracting a Thorn* it fell in curls over his forehead, over his ears, and still lower over his neck. The English sailor's suit, with its full sleeves tapering down to fit the fine wrists of his still childlike yet slender hands, and with its lanyards and bows and embroideries, enhanced his delicate shape with an air of richness and indulgence.[9]

Mann composes a paean to what for Ashenbach is a divine creature, an atavistic sign of ancient Greek male-male love, echoing the famous Platonic texts on the subject such as the *Symposium* and the *Phaedrus*. It is worth quoting a passage a little before the one above to afford a stronger sense of the nimbus of beauty that surrounds the boy, and the allusions to ancient Greek life, mythology, philosophy, and art:

> With astonishment Aschenbach noticed that the boy was entirely beautiful. His countenance, pale and gracefully reserved, was surrounded by ringlets of honey-colored hair, and with its straight nose, its enchanting mouth, its expression of sweet and divine gravity, it recalled Greek sculpture of the noblest period...'[10]

But Mann, a writer of exceptional astuteness, is not one to make references lightly, while the ones to the Greeks are easy to identify, the fact that the boy wears a sailor suit is easy to miss. It is not simply a foil of freshness to the dress of his two sisters who are described as looking like nuns. For the sailor suit is also a modernised, vernacular symbol of Venice itself, the once great port that was a trade channel between Europe and the Orient. The boy is also in Venice temporarily with his family and with the final scene eventuating in the writer's death, is a symbol of not only the transition of travel and trade, but the vicissitudes of desire and finally, transition from life to death.

Before Aschenbach spies this paragon of effeminate male beauty, his first meeting with sailors is peremptory and abrupt, a little more in conformity with the class stereotype:

> It was an ancient Italian boat, out of date and dingy and black with soot. Aschenbach was no sooner aboard than a grubby hunchbacked seaman, grinning obsequiously, conducted him to an artificially lit cave-like cabin in the ship's interior. Here, behind a table, with his cap askew and a cigarette-end in the corner of his mouth, sat a goat-bearded man with the air of an old-fashioned circus director and a slick caricatured business manner, taking passengers' particulars and issuing their tickets.[11]

This is the sailor in all his undesirable roughness, but it is also the very roughness that is a source of homosexual titillation.

As White points out in his autobiographical novel *The Beautiful Room is Empty* (1988), about growing up as a homosexual in the 1960s: 'I'd divided the world into either philistines or aesthetes. The pretensions of the aesthetes convinced no one, me least of all, since most of the jocks who attracted me were philistines'.[12] Subsequently one of the narrator's lovers, William, is described as having things that 'were all severely, un-exceptionally masculine and patrician...He even had a monogrammed

silver hairbrush set, an old Louis Vuitton trunk and cut-glass sherry bottle'. Clearly William was more of the 'aesthete' domain, but the narrator continues: '"Such a hoot!" he shrieked when I teased him. 'Mad for High WASP camp! Only a retired English officer makes me get really hard".[13] Later the simple dualist taxonomy of homosexual desire is expanded. A later lover by the name of Lou

> divided all homosexuals into 'boys', 'men', and 'vicious old queens'. A man (laborer, truck driver, even 'high-powered exec') must lust after and love a boy, who would be 'beautiful' or at least 'cute' but given to reckless enthusiasms, usually reckless and foolish. A man was brawny, cruel, except to the boy, whom he cherished, although sometimes cruelly. The man could be forgiven if he beat someone up, the boy if he bleached his hair.[14]

While the sailor or mariner type is not mentioned in this last passage—he could easily be listed together with the labourer and truck driver, all 'rough trade'—it goes a long way to clarify the power dynamics that are staged in many homosexual relationships, but more satisfying to our purpose, where the sailor is situated. Indeed it would appear that the sailor not only conforms to both 'man' and 'boy', but could be said to enshrine both, the epitome of the divided nature, the internal rift within homosexual desire, and within homosexuality itself. The 'homo' (one) made intelligible through its internal scission. The polarities and paradoxes of the sailor figure make this manifest.

Disciplined but Naughty Boys

While at sea, ships are something of a world unto themselves, and certainly before the twentieth century subject to their own laws and ways, which effected all strata of life, including sexual practices. Extreme or unconventional behaviour, if unpunished, was either left unnoticed or remained off the record. In his essay 'Of Other Spaces', Foucault writes that 'the boat is a floating piece of space, a place without a place that exists by itself that is closed in on itself and at the same time is given over to the infinity of the sea'.[15] This highlights the contradictory nature of the seaman since he is at once in a confined space that exists in a space that passes out to infinity on all sides. Moreover, the ocean encircles the boat, making it analogous to a prison, with its discipline, its rules and routines, its hierarchies, a system of activities that generate their own climate of power that is not necessarily comparable to the written laws themselves. Such spaces also tend to redefine the sense of self and society, so that what was once shocking or undesirable is seen in a different light, whether that be systematic cruelty or wayward activities such as sodomy. As Foucault adds, 'In civilizations without boats, dreams dry

up, espionage takes the place of adventure, and the police take the place of pirates'. To put this in a different way, society needs boats, both as a reality and an idea, in order to project desire and for transgressions to be performed.

Unlike the landed soldier, who is able to drift back at periodic intervals to the world of civilian life and, in effect, seek reprieve, the sailor is subject to discipline on a continual basis. His body can be seen as a metaphor and product of discipline, it is by all accounts a 'working body', and a 'cog in the machine'. As Laura Kipnis suggests, the sailor as worker makes him a 'privileged political trope of lower social classes, and through which bodily grossness operates as a critique of dominant ideology'.[16] Foucault places privilege on the body as a site of power, the body is embroiled in a 'a political field: power relations have an immediate hold on it; they invest it, mark it, train it, torture it, force it to carry out tasks, to perform ceremonies, to emit signs'.[17] Military (and naval) institutions, schools, prisons, hospitals, and factories are those where these dynamics are in plain view. Such institutions situate the body within a network of laws, manipulations, and expectations that place individuality and subjectivity to one side, as contingent to the main process. The body is expected to be trained for certain tasks, which it must then obediently discharge.[18] Accordingly, as Foucault states, discipline produces 'docile bodies...it increases the forces of the body (in economic terms of utility) and diminishes these same forces (in political terms of obedience). In short, it dissociates power from the body'.[19] The powerful body, then, is not power in and for itself, but rather to discharge the power according to the forces that formed it.

But yet another paradox presents itself, this time in the tattoo. Long before tattoos became fashionable, the sailor was one of the key figures associated with them. They were signs of subjection to authority as the inscription of belonging to a ship, yet they could as much be read as signs of resistance. In contradistinction to what Foucault argues, disciplinary power operates differently on marked bodies. Marked bodies is to be understood both materially and metaphorically, as marked by tattoos, but then also as marked with assumption and/or aspersion, which means every individual as he or she is marked according to gender, sexuality, and race. In this way, the sailor's body can also be interpreted as a desiring body, neither straight not gay, resistant to the laws of nature. As Elizabeth Grosz asserts, 'It is problematic to see the body as a blank, passive page, a neutral 'medium' or signifier for the inscription of a text'.[20] Rather, it is important to consider 'the specific materiality of the page/body', because 'one and the same message, inscribed on a male or female body, does not always or even usually mean the same thing or result in the same text'.[21] The sailor's body and uniform are interchangeable, or mutually exclusive, representative of authority and power and invested with sexual connotations. The sexuality is one of virility and strength,

but also subservience, a boyish, naughty playfulness. His tight-fitting trousers, emphasizing is arse and crotch make him a highly homoerotic figure. He is, to quote Elizabeth Wilson, both 'butch and masculine, yet open to the lure of sex with men'.[22]

Bell Bottoms and Fly Fronts

Quentin Crisp had a special fondness for sailors, 'whose crowning aphrodisiac feature was the fly-front of their trousers. More than one of my friends has swayed about in ecstasy describing the pleasure of undoing this quaint sartorial device'.[23] Crisp was far from an isolated case. Fantasies like these reached convulsive proportions in the highly charged graphic work of Laaksonen (Tom of Finland), for whom the phallus is always a locus of aggressive, untamed animal sexuality, always threatening to burst the pants, if not already taken out. With Laaksonen, the signifiers of masculine virility including hair chest, moustache, pirate earing, tattoos (including the anchor indelibly associated with Popeye the Sailor Man), tight jeans, and combat boots are 'so overabundant', according to Susan Bordo, 'that they cannot be taken seriously'.[24] Yet she adds that these are 'not just cartoon images, they are erotic in intent; folks masturbate to Tom of Finland images'.[25] Laaksonen founded the gay utopia, or gay Olympus in which male bodies were 'pumped' and available, their bodies sculpted to hypertrophied perfection. Or to use the line from Guy Snaith, they were endowed with 'big pecs, tight abs and bubble butt'.[26] Sailors feature prominently among the pantheon of gay clones that cavort and pose throughout Tom's work. His sailors are often depicted having group sex with other sailors on board a ship or fellating or being anally penetrated by leather men. As Snaith avers, 'Tomland is a fantasy world where masculinity is held up as the highest ideal'.[27] But it is an ideal brokered according to the single condition that the most masculine ideal is deeply and unwaveringly homoerotic.

Not only are Laaksonen's illustrations highly confronting images that were empowering for gay men, but they also raise relevant questions about appropriation, power, and resistance. On the cover of *Kake 18: Pants Down Sailor*, Laaksonen's popular cartoon series, a leather man dressed in fetish gear, leather pants and jacket, bikers cap, and combat boots is kneeling in front of a burly sailor holding his large, erect penis about to perform fellatio. The sailor towers above him, pushing the leather man's torso towards his crotch. These images had powerful appeal to gay men from the 1960s onward, as they were seen as a decisive challenge to the longstanding equation of homosexuality and effeminacy. This was, in part, based on the psychological hypothesis propounded since the nineteenth century that an 'invert' (homosexual) was a woman in the body of a man. On the contrary, Laaksonen's images exploit traditional codes of masculinity and assert the desiring

homosexual body with no degree of shame or apology, depicting the homosexual act as one of empowerment and, indeed, the most privileged, exalted form of sexual congress. As Adam Thorbum affirms,

> The primary sex act in Tom's world is one of force. Forced sex and gang rape are depicted repeatedly in Tom's images. Men are tied up, spanked, handcuffed; gagged and whipped every act of violence is a sexual act in Tom's universe'.[28]

Whereas the word 'rape' once implied the male violation of a woman, it was subverted to male violation of men.

Uniforms clearly have a role in this, not just because of the historical association of the way many invading soldiers treated women since antiquity. It also has to do with the close association of uniforms with authority. It is the very homologous nature of uniforms with authority that, Craik argues, inspires the opposite. Uniforms incite unrestrained and transgressive conduct and have become an 'integral prop in licentiousness and sexual perversion'.[29] The compulsion to transgress and to despoil is something of which Laaksonen makes unsparing use, and the excitement of authority breached and authority stretched. As Justin Lorentzen remarks, Laaksonen's male menagerie are 'driven by a fear of the erotic and libidinal body [where] violence, access and delirium are the languages of the armoured body and euphoria is achieved only through orgies of destruction'.[30] Despite such 'orgies of destruction', they are oriented around pleasure, for one or both sides. Tom's bodies are insatiable and sexually predatory. The pornographic, taboo images of sailors exuberant in homosexual acts are not only aimed at gays, but by default at respectable, dominant heteronormativity. The desecration of heteronormative culture is carried out in the uniform. Uniform is government sanctioned, public property, and synonymous with 'to serve and protect'. And yet, as Marjorie Garber explains,

> Whatever the specific semiotic relationship between military uniforms and erotic fantasies of sartorial gender, the armed services attests to the complicated interplay of forces, including male bonding, acknowledged and unacknowledged homosexual identity, carnivalized power relations, the erotics of same-sex communities.[31]

But when the uniform is transgressed, the extremity of the law is exposed, and the extent to which rules and laws are constructs masquerading as natural.

Sailor Chic: From Boardwalk to Catwalk

In 1995 the Italian fashion brand Diesel, known for their controversially provocative advertising images, engaged David La Chappelle to

photograph the For Successful Living campaign. Here Chappelle superimposed an image of two sailors kissing on an original photograph, *Victory*, originally from 1945. The photograph depicts the crew of an American submarine (powered by diesel engines) returning triumphant from the war. The two men kissing directly pastiches two famous photographs: Alfred Eisenstaedt's V-J photograph of a nurse and sailor kissing in New York's Times Square, which appeared on the cover of *Life* magazine in August 1945, and Robert Doisneau's most famous photograph, *Kiss at the Town Hall* (1950).

After Chanel's foray into sailor styling, the appeal of nautical styling has remained relatively consistent up until this day. Guided in no small part by her own petite figure, Chanel was always drawn to austere styles that emphasised woman's boyish, slim silhouette. She was also fond of synthesizing men's clothes for women's fashion, a tendency she picked up from browsing the closets of her lovers. As her biographer, Rhonda Garelick, explains, 'As she had with Etienne, Coco now regularly pilfered objects from Boy [Capel]'s closet—especially sportswear items such as the polo shirts he favoured for beach weekends, English schoolboy-style blazers, and loose-fitting sweaters'.[32] Although she started with riding attire, she is best known for her nautical-style clothing. They suited her penchant for simple patterns and angular lines. In the 1920 and 1930s, with the sartorial emphasis on physical mobility and sport, Chanel made use of the sailor's pea jacket and designed flared button-front trousers, known as 'yachting pants'. Given the legacy of bloomerism at the turn of the century, for a woman to be placed in trousers was, at that time, still risqué.

Moving closer to the present, in 2006 for Kenzo's ready-to-wear collection, Antonio Marras chose a predominantly sailor theme. The synthetic trousers and jackets were clearly evocative of the French naval uniform and unmistakable in the use of braiding and shiny anchor buttons. Navy-and-white striped knits and tailored sailor suits came with matching berets. To assure that the ensemble was complete, other outfits came with pop-pom hats and bell-bottom pants.

But the true inheritor after Chanel of sailor styling is Jean Paul Gaultier for whom the marinière makes a regular appearance, such that it is something of a signature for him. In earlier years as a designer, Gaultier wore the striped shirt with a kilt, leather pants, and black blazer. Gaultier's preoccupation with the striped motif is not only because it has proven to be extraordinarily versatile, but for reasons outlined above, that the sailor has become, partly also thanks to him, a homoerotic symbol. One distinctive early example of Gaultier using sailor style was in the 'Tattoo' collection for Spring/Summer 1994. Using 'body stocking tops', models were given the appearance of having tattoos on their torsos, consisting of the universal motifs in the sailor tattoo lexicon, such as anchors,

mermaids, and ships. Gaultier's investment in the mythology and ambiguity of the sailor is explicit, for as he said himself:

> With their tattoos, sailors are also associated with the bad boy image, which I love, [they are] the Casanova on the fringes of society with a mistress or lover in every port. The uniforms are so gorgeous and can be so elegant. I particularly like sailor's pants, which I adapted in many of my men's and women's collections.[33]

Gaultier also reinterpreted the sailor-stripped sweater by giving it an open back for his *Bad Toy* menswear collection. His womenswear collections *Punk CanCan* (2011), *Les Filles de la Marine* (2008), and *The Love Boat* (2006) were also influenced by the sailor's uniform.

In 1990 Gaultier commissioned the artist duo Pierre et Gilles to design the cover of his photographic autobiography, *À nous deux la mode* ('Fashion for both of us'). The artists' work is characterised by high key colours, a liking for excessive ornamentation, and complexions with a sculpted, smooth air-brushed look, making them look like they are made of some artificial substance, such as alabaster or latex. In this style, their portrait of Gaultier has him with perfect skin and an angelic smile wearing a Breton sailor top, his hair short and bleach blond. He holds a posey of daisies against his chest while the Eiffel Tower and more daisies are discernible in the background. This marriage of styles of Pierre et Gilles and Gaultier might in retrospect seem predestined, since both shared a sensibility for distortion and opulence, and both were drawn to the sailor idiom. As they themselves testify, 'we are gay artists, therefore if we see Jean Genet in our mind's eye we also see a sailor. These are classic images that will keep coming back forever...sailors are a staple in our work, and also in Gaultier's'.[34] Sailors, alone or in pairs, appear in lurid colours and sumptuous environments redolent of a dream, the men themselves paragons of beauty. In *Havre Harbour* (1998), a blond sailor wearing a traditional French sailor's uniform with white cap and Breton shirt, is submerged to the waist in water, the spume more like bubble bath. He is surrounded by a night sky littered with stars and a factory emitting smoke. Looking toward the horizon, his stare has a tender, forlorn air, reminiscent of other images of theirs of Christ's passion.

Released to coincide with Rainer Werner Fassbinder's *Querelle* (1982), the adaptation of Genet's novel, Gaultier's Spring/Summer 1983 *Dada* collection combined corsets and sailor-style tops, two 'powerful symbols of seduction'.[35] (In homoerotic synergy, the theatrical release poster to Fassbinder's film is of a sailor in a white singlet, a white hat with a red pom-pom, leaning on a thick brick pillar in the unmistakable shape of a penis.) Gaultier has drawn heavily from maritime themes in his collections, making the image of the sailor his signature style. His 1996

Spring/Summer collection, *Pin-Up Boys,* was based on the sailor ensemble and featured garments made of neoprene and spandex, incorporating elements of fetish wear leaving no doubt as to the equation of sailor and sexualised object. The sailor reappeared once again for his Spring 2013 menswear collection. This consisted of buttoned panel trousers in denim, Breton stripes, and cape-back tops made with classic tailoring techniques and decorated with Indian craftwork. Sailor's tattoos (anchors and sirens) were embroidered into shirtsleeves and fronts, and an Indian turban replaced the white canvas 'dixie cup'.

Perhaps with Genet's matelots still in mind, in 1995 Gaultier launched his scent *Le Mâle* (created by Francis Kurkjian) that came in the now famous sailor torso bottle. The packaging was (and continues to be) a metal can. The bottle recalls Elsa Schiaparelli's perfume *Shocking* (1937), whose bottle design was modelled on Mae West's nude hourglass figure. As Schiaparelli's biographer, Meryle Secrest, continues:

> 'Where the head should have been was a bouquet of flowers, a tape measure taking the place of an impromptu scarf, hiding nothing, and, and a little belt had a button-shaped buckle with the initial S on it. It was impudent femininity and definitely a bit of a shock.'[36]

Turning the concept of Schiaparelli's perfume on its head, this was impudent homoeroticism, yet emphatically figured as masculinity itself. To ensure that the insinuation to camp remained unambiguous, Gaultier enlisted Pierre et Gilles to the first and successive campaigns, ensuring that the sailor image had persistent, tenacious homoerotic currency. In one of the advertisement images, a bare-chested sailor covered in floral tattoos and bluebirds, his white cap cocked back impudently on his head, looks back at the camera with laconic charm. As Fiona Allon comments, 'The sailor's arms are crossed in a pose suggesting masculine virility and a cheeky impertinence'.[37] Another advertisement depicts a pair of sailor's arm wrestling. The conjunction with butch masculinity and homoerotic desire is all over the image. As Gaultier himself notes, 'Le Mâle is the perfect sailor, he's the touch guy with a tender heart, Le Mâle is not afraid to show his softer side, making him both manly and sexy'.[38] The title is decisive and bears special mention, for unlike the neutrality of Guerlain's *L'Homme,* for instance, Gaultier points directly to *manhood* itself. As opposed to the more generic 'man' (*homme*), we are presented with *the* man, and to what men should aspire, which is manhood, masculinity, maleness. In the most emphatic sense, the gay man stands victorious. While at the time of its release it was associated with gay men—although it was also risqué and chic for openly straight (metrosexual) men to wear it, too—it later came to be one of the most popular male high-end scents, worn by straight and gay men alike.

More recently, in 2013, Gaultier released *Le Beau Mâle* (The Beautiful Male), its packaging only a mild variant on its predecessor, the blue

stripes on frosted glass only more pronounced because the bottle was lighter. (The French name is also ambiguous as there is not the same distinction between 'beau' and 'belle' as there is between 'handsome' and 'beautiful'.) The scent is less forceful, connoting fresh sea spray. But according to Gaultier, it is consonant with the same visual codes:

> The tattoos on the skin, the sensuality, the heart, the dragon—all of these visuals speak to traveling, more particularly to the collections I did on travelling. There is also the sailor code. He is sailor with his shirt thrown flippantly on his shoulder, and his hand rooted in the ground like a paw.[39]

These rather Baroque verbal images are fitting to those of Pierre et Gilles and they also speak to the way in which across Gaultier's entire oeuvre, the sailor recurs as the ultimate imaginary figure. All the more desire because his presence is temporary, he is also the symbol of travel and encounter.

Gaultier is the salient example in recent time of a designer to have made use of the sailor as both fact and myth. He has become a symbol of discipline and pleasure. But for those who wish to keep the heterosexual credentials intact, then his fate has been radically subverted in a different direction. While it would be presumptuous, and maybe dangerous, to identify a sailor on the street as gay, what is unshakable is that the sailor, when evoked aesthetically as an idea, is suffused in an aura that is homoerotic. The reasons for this may be attributed to chance, but they are also due to the way that gay men have been frequently forced into sexual encounters based on transience and chance. But now it appears what represented the fleeting arrangement has become, in the aesthetic imagination, something of a permanent fixture.

Notes

1 A version of this chapter is published in *The Journal of Asia Pacific Pop Culture* (JAPC). Citation: Adam Geczy, Vicki Karaminas and Justine Taylor, "Sailor Style. Representations of the Mariner in Popular Culture and Contemporary Fashion", *Journal of Asia Pacific Pop Culture* 1, no. 2, The Pennsylvania State University Press, 2016.
2 Herman Melville, *Moby Dick* (London: Dent, 1993), 97.
3 Ibid., 98.
4 John Irving, "Naval Life and Customs", 1944, www.naval-history.net/ WW2aaNavalLife-Customs1.htm#2. Accessed May 18, 2016.
5 Jennifer Craik, "Uniform and Men's Fashion: Tailoring Masculinity to Fit" in Andrew Reilly and Sarah Cosby eds. *Men's Fashion Reader* (Oxford and New York: Berg, 2009), 431.
6 Jean Genet, *Œuvres complètes*, vol. III (Paris: Gallimard, 1951–1991), 305.
7 Edmund White, *Genet* (London: Chatto and Windus, 1993), 335.
8 Ibid.
9 Thomas Mann, *Death in Venice and Other Stories*, trans. David Luke (London: Vintage,1998), 220.

10 Ibid., 219.
11 Ibid., 210.
12 Edmund White, *The Beautiful Room is Empty* (London: Picador, 1988), 14.
13 Ibid., 64.
14 Ibid., 102.
15 Michel Foucault, "Of Other Spaces", *Diacritics* 16, no. 1 (1986): 23.
16 Laura Kipnis, "(Male) Desire and (Female) Disgust: Reading Hustler", in Lawrence Grossberg, Cary Nelson and Paula Treichler eds. *Cultural Studies* (London and New York: Routledge, 1992), 376.
17 Michel Foucault, *Discipline and Punish: The Birth of the Prison* (Harmondsworth: Penguin, 1987), 27.
18 Ibid., 138–139.
19 Ibid., 138.
20 Elizabeth Grosz, *Volatile Bodies: Toward a Corporeal Feminism* (Indianapolis: Indiana University Press, 1994), 156.
21 Ibid.
22 Elizabeth Wilson, "Exhibition Review: "Camouflage and Sailor Chic", *Fashion Theory* 12, no. 2 (2008): 280.
23 Quentin Crisp, cit. Marjorie Garber, *Vested Interests: Cross-Dressing and Cultural Anxiety* (London and New York: Routledge, 1992), 57.
24 Susan Bordo, *The Male Body: A New Look at Men in Private and in Public* (New York: Farrar, Straus and Giroux, 2000), 98.
25 Ibid.
26 Guy Snaith, "Tom's Men: The Masculinization of Homosexuality and the Homosexualization of Masculinity at the End of the Twentieth Century", *Paragraph* 26, (2003): 78.
27 Ibid., 77.
28 Adam Thorbum, "Confronting Tom of Finland", www.polarimagazine.com/features/confronting-tom-finland/. Accessed June 2, 2015.
29 Jennifer Craik, *Uniforms Exposed* (Oxford and New York: Berg, 2005), 97.
30 Justin Lorentzen, "Reich Dreams: Rituak Horror and Armoured Bodied", in Charles Jenks ed. *Visual Culture* (London and New York: Routledge, 1995), 166.
31 Garber, *Vested Interests*, 56.
32 Rhonda Garelick, *Mademoiselle: Coco Chanel and the Pulse of History* (New York: Random House, 2014), 67.
33 Jean Paul Gaultier and Thierry-Maxime Loriot, *The Fashion World of Jean Paul Gautier. From the Sidewalk to the Catwalk*, Montreal Museum of Fine Arts. Exhibition Catalogue, (Abraham: Montreal, 2011), 39.
34 Pierre et Gilles cit. Jean-Paul Gaultier and Thierry-Maxime Loriot, *The Fashion World of Jean Paul Gaultier: From Sidewalk to Catwalk*, exh. Cat., (Montreal: Montreal Museum of Fine arts and Abraham, 2011), 268.
35 Ibid., 39.
36 Meryle Secrest, *Elsa Schiaparelli: A Biography* (New York: Random House, 2014), 192–193.
37 Fiona Allon, "Sailor Style. From Jack Tar to Sailor Moon", in *Sailor Style: Art, Fashion, Film*, exh cat., (Sydney: Powerhouse Museum, 2004), 55.
38 Jean Paul Gaultier, www.edgarsclub.co.za/archive/exclusive-interview-with-jean-paul-gaultier/. Accessed 24 May, 2016.
39 Ibid.

5 Cowboys and Bushmen

Adapted from a short story written by Annie Proulx, the closet[1] scene in *Brokeback Mountain* (Ang Lee, 2005) is considered to be one of the most powerful scenes of forbidden desire and lost love in contemporary cinema and an iconic moment in the history of men's fashion (another iconic moment in men's fashion was the wardrobe scene with Richard Gere in *American Gigolo* (Paul Schrader, dir. 1980), which we discussed at length in Chapter 2 of this book). On hearing of the death of his long-term lover, Ennis del Mar, played by Heath Ledger, visits Jack Twist's (Jake Gyllenhaal) childhood home. At the top of a steep staircase is Jack's bedroom containing a single bed and a narrow wardrobe with a hidden compartment. Hanging on a nail inside the wardrobe is Ennis' old shirt stained with dried blood from a nose bleed that he sustained one summer on Brokeback Mountain (stolen by Jack as a memento). Placed inside his shirt was another shirt belonging to Jack, the sleeves were carefully wrapped around each other as though they were two bodies locked in a passionate embrace. Later, Ennis buys a postcard depicting Brokeback Mountain which he pins up in his trailer wall above the two shirts that are suspended from a wire coat hanger. The scene is worth quoting in its entirety if only to highlight how clothes have the ability to invoke emotions and memories.

> In the closet hung two pairs of jeans crease-ironed and folded neatly over wire hangers, on the floor a pair of worn packer boots he thought he remembered. At the north end of the closet a tiny jog in the wall made a slight hiding place and here, stiff with long suspension from a nail, hung a shirt. He lifted it off the nail. Jack's old shirt from Brokeback days. The dried blood on the sleeve was his own blood, a gushing nosebleed on the last afternoon on the mountain when Jack, in their contortionistic grappling and wrestling, had slammed Ennis's nose hard with his knee…. The shirt seemed heavy until he saw there was another shirt inside it, the sleeves carefully worked down inside Jack's sleeves. It was his own plaid shirt, lost, he'd thought, long ago in some damn laundry, his dirty shirt, the pocket ripped, buttons missing, stolen by Jack and hidden here inside Jack's own

shirt, the pair like two skins, one inside the other, two in one. He pressed his face into the fabric and breathed in slowly through his mouth and nose, hoping for the faintest smoke and mountain sage and salty sweet stink of Jack, but there was no real scent, only the memory of it, the imagined power of Brokeback Mountain of which nothing was left but what he held in his hands.[2]

Sella Bruzzi's important text, *Undressing Cinema* (1997), proposes that film costumes function as 'iconic clothes': 'spectacular interventions that interfere with scenes in which they appear and impose themselves onto the character they adorn'.[3] In *Brokeback Mountain*, Ennis's plaid and Jack's denim shirts act as 'iconic clothes', or representations of cowboy culture and its masculine qualities of ruggedness and fearlessness. Denim shirts were first introduced in 1926 by Levi Strauss and Company as a tough and durable garment that was functional for mustering cattle and steers across the frontier. In 1946 pearl snap buttons were added to the design of the shirt by Jack A. Weil, whose company Rockmount Ranch Wear in Denver, Colorado, manufactured Western shirts. The 'iconic' Rockmount shirt, worn by Heath Ledger and Jake Gyllenhaal (as well as Clark Gable in *The Misfits*, directed by John Huston in 1961) came to represent 'a way of living that reflected the flamboyance of the rodeo riders'.[4] In those days, notes Weil, cowboys 'had two or three months pay in their pocket to raise hell with and get drunk and I got the idea that they'd buy a few fancy shirts while they were at it'.[5] Over time, the cowboy shirt became associated with romantic notions of the 'lawlessness of the Wild West' as an 'authentic' and traditional American way of life. The clothes that Ennis and Jack wear are an integral aspect of their masculinity: their broad-rimmed Stetson hats, their western cut shirts with pearl snaps and curved yokes, boot-cut jeans, bandanas, spurs, and saddles are charged with male power. In the words of Eric Patterson, 'By dressing as cowboys these American westerners signify their participation in the Western as national fantasy and especially in the traditional constructions of manliness associated with it'.[6]

As an American folk hero, the cowboy is a figure of stoic individualism and bravery that has cemented his place as an icon of masculinity in popular culture. He is the embodiment of freedom and self-reliance and is always portrayed as a renegade stirring trouble of some kind or another. But what is interesting about the construction of the cowboy (or the Australian outback bushman) is that he is rarely depicted with domestic possessions or a family, but is either an anti-social loner or he can be found in the company of other cowboys in the wilderness; simply put, his emotional attachments, aside from his horse, is played out with men (Figure 5.1). In other words, the cowboy is a queer figure, very much like the sailor (who we have discussed at great length in Chapter 4 of this book), he 'resists community; he eschews lasting ties with women but embraces rock-solid bonds with same-sex partners; he practices same

Figure 5.1 Cowboys Shooting Craps. The Miriam and Ira D. Wallach Division of Art, Prints and Photographs: Photography Collection, The New York Public Library.

sex desire'.[7] As a Hollywood Western, *Brokeback Mountain* represents, as Eric Gonzalez puts it, 'the very face of American masculinity'.[8]

For years the cowboy has been a figure in gay pornography, with many of the characters constructed through their Western clothing. By examining the gay pornographic films and photography of Colt Studio, Shaun Cole argues that the gay cowboy became an icon of masculinity that developed prior to gay and lesbian liberation. These archeytypes, and the way in which they were dressed, initially appeared in physique magazines and stag films, and later influenced gay men's fashion and identity post-liberation. Cole writes that the cowboy was a reoccurring type in the Colt Studio films and projected an image of the all-American outdoor masculinity that implied virility and was reflective of freedom from the restraints imposed by social order. The founder of Colt Studio, Jim French, portrayed cowboys removing their shirts and trousers but leaving on their hats and boots, which were often presented in scenes of sexual tension. Jockstrap underwear and jeans were essential garments of the gay clone style, so, too, denim baseball caps and denim shirts. Cole describes the opening scene of the film *Prowlers* (1981) as an example of the cowboy look in the clone-style wardrobe.

> The film opens on two pairs of work boots, one brown, one black, surmounted by the hems of denim jeans.... He is wearing classic basic clone style of boots, jeans, white t-shirt, and denim shirt, topped

off with a moustache and blue denim cap. His companion... is al-
most identically dressed... with a blue plaid rather than denim shirt
and a rip in front of his jeans. A rear view... reveals that his jeans are
Levi's 501, as the camera focuses in on the red tag label.[9]

The retainment of cowboy boots in gay pornographic films reflects 'a
fetishization of footwear and a reinforcement of the cowboy fantasy'.[10]
Cole recalls French's eight-millimetre loop films, called *Saddle Tramps*,
that featured six cowboys, semi-naked save for three 'iconic' garments,
namely hat, boots, and bandana. Cole continues: 'All except one, who is
wearing jeans, are wearing chaps that leave their genitals exposed... the
rest of their outfits vary to include waistcoats, shirts, wrists straps and
gun belts'.[11] Like that of the clothing worn by the construction worker
or the motor mechanic, the rugged cowboy attire is associated with hard
work and the great outdoors. The garments association with an eroti-
cised working-class identity and hypermasculinity is commonly known
as 'rough trade', a term that has also regular currency in pornography
in which hard labour, brute strength, and uncompromised male viril-
ity are conjoined. Within this working-class repertoire of garments and
gay fantasy archetypes, whether the cowboy, the motor cyclist, the me-
chanic, or the construction worker, denim jeans are a central garment
that gay men heavily draw on. Dressed in blue denim jeans, canvas shirt,
and sheepskin jacket, the quintessential image of rough outdoor mascu-
linity is the Marlboro Man.

Conceived in 1955, Marlboro Man, the figure used for the Marlboro
cigarettes advertising campaigns, became a symbol of rugged mascu-
linity and an archetypal American hero. Set against a mythical land-
scape of natural wilderness, the Marlboro Man embodied the virtues of
hegemonic masculinity, mate ship, musculature, and virility. Marlboro
Country was a 'man's country', an imaginary place where men worked
hard and bonded with other men and their horses. Bruce Lahof writes
that the image of the Marlboro Man consists of two elements; the
Marlboro Man himself and what John Cawelti has called 'the symbolic
landscape',[12] the larger Western myth that 'influences the character and
the actions of the hero'.[13] This symbolic landscape is neatly summed
up by the phrase, 'Come to Marlboro Country' and the Marlboro Man
personifies the landscape in which he lives. As Bruce Lahof comments,
his clothing

> reflects the competitive spirit that is exacted by the wilderness. His
> attire is not the spangled costume of dime-store Texans and back-
> lot cowboys. Rather he wears a rough spun shirt, sheepskin vest
> or coat, dungarees and chaps. Nothing is for show, and little is for
> comfort; everything is for facing down the elements. And his habits,
> like his clothing are dictated by practical considerations.[14]

This image of a muscular man of the outdoors is a particular version of manhood as sexually desirable—a rugged and tough masculinity that Susan Bordo calls 'face off'. In this type of masculinity, men are portrayed as physically superior, 'powerful, armoured, yet emotionally impenetrable'.[15] The Marlboro Man embodies the macho values of the Wild West, a rough and ready 'man's man' hero. He is often depicted with a group of cowboys mustering horses or alone in the wilderness in contemplative stance, smoking a cigarette by the campfire. David Grindstaff writes that 'the Hollywood Western has typically represented masculinity through male homosocial relationships, which remain haunted by an implicit homoerotic desire'.[16] This homoerotic desire or presence is scripted in the vast landscape of the wilderness, a space that is in opposition to the space of the city, a space within a space, a site where culture is inside, yet outside, 'simultaneously represented, contested, and inverted'.

These spaces of otherness function in non-hegemonic conditions which Michel Foucault has called *heterotopias*. A heterotopia is a space or environment whose multiple layers of meanings mirrors a utopia, a parallel space that creates an illusion that represents perfection. Foucault wrote of several types of heterotopias including: those of *crises*, such as hotel rooms or boarding schools where rites of passage take place, that of *time*, such as museums that enclose objects out of time, or spaces of *ritual* or *purification*, such as the spa or public sauna. According to Foucault, and this is of relevance to the space of the frontier or the wilderness, heterotopias create a space of illusion, a parallel world of alternative rules and regulations that offers an escape from the repression of authority and exposes and affirms difference. In the wilderness, away from the confines, regulations, and repressions of society, relationships are formed and sodomy, amongst other sexual perversions, are practiced and performed. The wilderness 'is a place without a place, that exists by itself, that is closed in on itself'[17] and at the same time is given over to the infinity of the landscape. 'Not only does the film queer its cowboys', writes Ruby Rich, 'but it virtually queers the Wyoming landscape as a space of homosexual desire and fulfilment, a playground of sexuality freed from judgement, an Eden poised to restore prelapsarian innocence to a sexuality long sullied by social shame'.[18]

No other form of popular culture best encapsulates Foucault's notion of heterotopic space than HBO's science fiction and Western thriller television series *Westworld* (Jonathan Nolan, 2016), based on the 1973 television series of the same name directed by American novelist Michael Crichton. *Westworld* is a virtual amusement park (a utopia) populated by androids that are known as 'hosts' who cater for the whims of high-paying visitors called 'guests'. The guests are free to indulge in all their sexual and murderous fantasies in this virtual parallel colony (that also serves as brothel, two extreme types of heterotopias that Foucault mentions in his article), without retaliation or oppression from the

hosts. In all the recent commentary on the high-budget series (which, among others, starred acting greats Ed Harris and Anthony Hopkins), what is missed is the world that the guests enter into is fake on several counts. For crucially the 'Wild West', as it is depicted here, is multiple simulacrum, being the West as depicted and circulated in film, not the tired and lacklustre West of historic real life. In this regard, the West of *Westworld* is something of a saturated heterotopia, where the illusion of reality only transpires by the fact that the reality it simulates is already an elaborate fiction.

Curiously, *Westworld* is not the first television series of its kind, *Fantasy Island* (Gene Levitt, dir.), aired on the American Broadcasting Company Network between 1977 and 1984, was a place somewhere in the Pacific Ocean accessible only by boat, where people came and lived out their fantasies, sexual or otherwise, at a price. The series host, Mr Roarke (played by Ricardo Montalbán), was always dressed in a white suit (a reference to his immortality) and catered for the islands 'guests' with the help of his assistant, Tattoo (played by Hervé Villechaize). *Westworld* and *Fantasy Island* are heterotopias par excellence, isolated and impenetrable spaces, yet freely available to access via a boat or a computer terminal.

Unknown Frontiers

The American frontier populated by cowboys, or the Australian outback home to the bushman, are spaces inscribed by discourses of masculinity. Even as far back as the Middle Ages, remote landscapes were depicted in medieval and Renaissance maps and religious texts as being populated by mythic creatures and monsters who terrorised explorers and lured them to their deaths.[19] Monsters and demons of all kinds, from witches, vampires, and werewolves, inhabited the forests and mountains that circled the peripheries of towns and villages. During the colonial expansion of the world beginning in the fifteenth century, in what became known as the 'age of discovery', civilisations were plundered, enslaved, and massacred for economic resources. Explorers that sought commercial gain or the lure of adventure yearned, according to Nahoko Alvey, 'to demystify and conquer the site of otherness that fulfilled dreams of masculine desire'.[20] To the explorers' colonial gaze, these vast landscapes appeared unhospitable and brutal, but, simultaneously, 'an unexplored treasure house, whose inexhaustible riches [were] symbolised as the physical beauty of the female' which they yearned to possess.[21] Discourses of exploration were bound up with the colonial desire of consumption whose language of settlement produced sets of knowledges around the conquest of unfamiliar lands. These sites of otherness were imagined as hostile and brutal 'virgin' females awaiting to be penetrated, tamed, and possessed. In her seminal study of colonial practises, Anne McClintock

writes that the male bravura of the explorer is invested with anxiety and longing for the female body in his conquering mission. At the same time, 'the female body is figured as marking the boundary of the cosmos and the limits of the known world, enclosing the ragged men, with their dreams of pepper and pearls, in her infinite ... body'.[22]

The construction and reconstruction of the American West from a wilderness wasteland to an agrarian paradise can be found in the European expansionist discourses that inscribed the territories as masculine. In settlement discourse, the West was represented as a symbol of conquest and nation-building. Mary Anne Irwin and James Brooks write that this 'mythic-historiography of the taming of the frontier was used as a way to underwrite American colonialism and to explain the nations distinctive culture and emergence as a world power'.[23] Frederick Turner suggests that American ideas of democracy were 'forest-born, emerging out of the individual (male) pioneer's struggle to subdue the wilderness – and its native inhabitants – and wrest a living from the land'.[24] The mythic figure of the cowboy emerged as a hero in the construction of the American West, a place where 'white women were civilizers, women of colour were temptresses or drudges, and men of colour were foils for the inevitable white male hero'.[25] Yet the cowboy, as a masculine hero, finds its roots in the old Castile region of twelfth-century Spain where cattle herders wore sashes; broad-brimmed hats, bolero jackets, tight-fitting trousers, and spurred boots.

It was not until the fifteenth century, with the colonisation of New Mexico by the Spaniards, that the cowboy took hold of the American borderlands. The introduction of cattle to New Mexico in 1540 by the Spanish conquistador Francisco Vásquez de Coronado as part of the Hispanic settlement resulted in the spread and growth of an important cattle industry in Texas by the mid-1700s. Although the cattle herders of the Castile region were considered lowly in social status, the cattle herder of the American borderlands, the Vanquero, became cattle barons and laid the foundations of the contemporary cowboy with his dress, style, and way of life. Cowboy gear (known as 'tack') had also been inherited from the Andalusian region in southern Spain, which was under Moorish rule for seven centuries. This included the horned saddle developed by the Moors; bridles, bits, spurs, prods, halters, and long ropes known as lariats that were used to lasso horses and cattle. Other forms of dress, such as the *armas*, an early form of chaps made from cowhide that hung from the saddle, were designed to protect the legs of cowboys from thistle bushes. The cowhide *chaparejos* (chaps) that enclosed the rider's legs were developed later.

In his ethnographic study of rancher and farmer dress in North Central Texas, George Boeck writes that the dress of the cowboy had remained consistent from 1870 until the end of the century. Items of clothing included long-sleeved full shirts, a kerchief wrapped around the neck, boots with cut-away heels, a broad-brimmed, high crowned hat, and work pants (Figure 5.2). The attached shirt collar was adopted

Figure 5.2 A Serious Problem. The Miriam and Ira D. Wallach Division of Art, Prints and Photographs: Photography Collection, The New York Public Library.

sometime in the nineteenth century and denim pants were introduced by the 1920s.[26] Cowboy hats were usually made of straw with three- or four-inch-width brim that curled on the sides. As for Western-style shirts, they tended to taper in on the waist with a pointed yoke in the front and back. The plaid two pointed shirt became popular in the 1950s and up until the late 1970s, peal snaps were commonly used instead of buttons. But it was denim that is best associated with the cowboy and his rugged type of masculinity.

Celluloid Cowboys

There is a scene in a movie, that was later used for a publicity still, where a young man is dressed as the quintessential cowboy. He is lying languidly in the back seat of a black Cadillac, his white Stetson hat pulled down over his eyes, and cigarette dangling from the corner of his mouth. He is wearing a canvas Western-style shirt with pearl snaps and vest. His legs are stretched out and his Fry boots are placed on the front seat headrest. He is looking yonder towards the distance with an expression of calm insouciance. He is James Dean wearing tight blue Lee 101Z Riders jeans. Rebel. Sex symbol

(although after his death he was revealed to have been bisexual). Freedom and the American way. James Dean is ranch hand Jett Rink. The film is George Stevens' *Giant* (1956), also starring Rock Hudson and Elizabeth Taylor, which portrayals a powerful Texas ranching family challenged by changing social values and the coming of 'the big oil'. Twenty-five years later, this same image would be used in a thirty second commercial to market traditional Levi's shrink-to-fit 501 button fly blue jeans. Except this time James Dean had been replaced by a woman. Same slouch, same pose, different gender, and this advertisement campaign was not targeting men, but women.[27] Nearly 108 years after Levi Strauss and Company introduced the XX patented model jeans in 1873, this postmodern decontextualised image became 'a floating emblem of cool'.[28]

Although denim jeans were worn by labourers in the early 1800s, it was not until 1904 when the silent, short, Western film, *The Great Train Robbery*, produced and directed by Edwin S. Porter, that jeans became an emblem of rugged masculinity and individualism. Levi Strauss and Co. were producing advertising campaigns that targeted cowboys and by 1920, Levi's jeans were a staple wardrobe garment for many actors starring in Hollywood Western films. John Wayne wore a pair of Levi's jeans in John Ford's *Stagecoach* (1939), as did Burt Lancaster in *Vengeance Valley* (1951), and Kirk Douglas in *Lonely are the Brave* (1962). Cinema helped foster the myth of the democratic ideals of the cowboy and the freedom of the American frontier that it represented. Levi's were not the only jeans manufacturer to attract the attention of the cowboy, in 1924 the workwear company Lee, founded by Henry David Lee in 1889 created the 'Cowboy Pants' which became known as '101B' or '101Z' depending on whether the fly was button or zip-fastened. In 1926 the saddle crotch was introduced to the 'Cowboy Pants' and in 1944 they were named Lee Riders. By the 1950s the rugged individualism symbolised by denim jeans and its association with the cowboy was in cultural crises. The Cold War had produced an aura of suspicion along with political tensions that manifested in subversive groups and a certain type of teenage social outcast that displayed a nonchalant defiance of social norms. James Dean, teenage disillusionment personified, appearedas the troubled Jim Stark in *Rebel without a Cause* (Nicholas Ray, dir. 1955), followed by loner Carl Trask in *East of Eden* (Elia Kazan, dir. 1955), and ranch hand Jett Rink in *Giant*. In all three films, Dean wears Lee Riders jeans. Pamela Church Gibson writes of Dean that he was 'always [an] outsider and [a] misfit, complex and problematic, moody and difficult',[29] James Dean, along with the 'sulky and antagonistic'[30] Marlon Brando in *The Wild One* (Lazlo Benedek, dir. 1953), became signifiers of blue-collar rebellion, the outsider and the disenfranchised anti-hero. But this is not the place to discuss rebels and jeans, the following chapter on leather men examines the impact of jeans as a statement of anti-establishment and its role in constructing transgressive identities.

By the 1960s jeans started to appear in urban dramas like the 1969 cult film *Midnight Cowboy* (John Schesinger, dir.), starring Jon Voight and Dustin Hofmann. Joe Buck (Jon Voight) is a Texan working as a dishwasher who packs his cowhide suitcase, quits his job, and heads for New York City in search of wealthy women to hire his services as a prostitute. Instead, dejected and out of money, he meets the small-time swindler Ratso Rizzo, played by Dustin Hofmann, and together they spend a not-so-warm winter in Ratso's apartment in a condemned derelict building. The importance of this film is two-fold; it draws attention to the performative macho cowboy myth by signalling the homoerotic undertones prevalent in the film and highlights the importance of dress and costume in constructing a visual narrative of gendered identity and sexuality. As Sarah Gilligan argues in a different context, Joe Buck's cowboy dress functions as a 'spectacular intervention that enables the spectator to revel in the visual pleasure of the objectified male'.[31] Joe Buck wears a tassled cowhide jacket, tight blue denim shirt with yolks and pearl snaps, beige Western trousers, black kerchief around his neck, and black Stetton hat. Desire is repeatedly displaced from the face and body onto the clothes themselves as the camera frequently pans from his cowboy hat to his booted feet walking along the street. The fragility of the macho cowboy myth is further compromised when Ratso exclaims, 'That great big dumb cowboy crap of yours don't appeal to nobody, except every Jackie on 42nd Street! That's faggot stuff! You want to call it by name, that's strictly for fags!'[32] Joe replies, 'John Wayne? You're gonna tell me that John Wayne's a fag?'[33] Whilst *Midnight Cowboy* signalled the queer undertones prevalent in male friendships (Ratso places Joe's needs above his own, washing and ironing his clothes, feeding and providing him with shelter), the relationship is never sexually consummated but remains ripe with possibilities. While John Schlesinger was filming *Midnight Cowboy,* Andy Warhol used the motif of the gay cowboy-hustler in his avant-garde quasi-porno film, *Lonesome Cowboys* (1968) to reach out to a queer populace and engage in debates about effeminate and flamboyant masculinities. The '60s were a period rife with social protest and political unrest and the concept of manhood, with its long-held assumptions of masculinity and heterosexual hegemony, was being challenged on all fronts by feminism, civil rights, and gay activist groups. Filmed over one long weekend on a rented movie set in Oracle, Arizona, *Lonesome Cowboys* tells the story of the erotic confrontations between an outlaw gang of five cowboys who, when not seducing the town's sheriff, who is an occasional transvestite, are ravishing each other. Throughout the film, the camp and effeminate gay cowboys subvert the hypermasculine ones: from the nurse with the high-pitched lisp and swishing gait, to the bodies who wrestle and cavort, performing fellatio on one another. Gay sex is figured, in the words of Ara Osterweil, as 'the site of camp masquerade and polymorphous perversity'.[34] As an avant-garde film produced in the

early 60s Sixties before the commercialisation of hardcore pornography in the 70s Seventies, *Lonesome Cowboy* is an experimental film that flirts and parodies the Western and soft-core porn. 'In its casual rejection of defined sexual roles', notes Osterweil,

> its deliberate confusion of homosexual and heterosexual pairings, its campy celebration of sadomasochism, and its polymorphous, floundering erotic gaze, it is both a product and a parody of 1960s sexual revolution politics.

In many ways *Brokeback Mountain*, *Midnight Cowboy,* and *lonesome cowboys* are very similar in their theme of gay sexuality, however each film differs in the ways that homosexuality is handled. Whilst *Brokeback Mountain* places gay relationships at its centre and exposes the tragedy and heartbreak that lost love between two men can entail, *Midnight Cowboy* disguises Joe and Ratso's feeling for one another as purely platonic. As for *Lonesome Cowboys*, gay sexuality is figured as a free for all celebration, a utopia where polymorphous sex and fetishistic desire reign supreme.

The Australian Bushman

America and Australia have much in common in terms of the ways in which popular culture—particularly cinema, television, and music—has shaped national identity. They are settler societies colonised by Britain that became dumping grounds for their convicts and others fleeing from their past. Their histories involve narratives of great frontier battles and genocide policies that targeted the dispossession of indigenous land that led to attempts, often successful, at their complete eradication. Along with the people, animals and diseases were imported as well. Smallpox in both countries was the pestilence that scourged the native peoples more than the gun. The nineteenth century, for both, was a bloody time of conflict and uncertainty where death always loomed.

America's mythic cowboy is rooted in the cattle drive era, so, too, are the legends and exploits of Australian bushman and drovers who rustled cattle across untold miles of barren or inhospitable terrain. The Australian bush ethos, like the cowboy myth, stresses egalitarianism and, in his abandonment to adventure, a certain disdain for authority and common law. Their identities are similarly rooted in the frontier myth as a perilous landscape where ideals of hardship and heroism were carved out by masculine heroes. The list is a roll-call of boyhood fantasy where fact and fiction are indissolubly mixed. They are metonymic of adventure, but more, the struggle necessary in nation-building: Jessie James, Billy the Kid, and bushrangers Ned Kelly (Figure 5.3), Jack Donahue, and Ben Hall. These men became symbols of emerging nations (under colonialism) packaged in contemporary folklore and

Figure 5.3 Ned Kelly in Chains. Charles Nettleton photographer. Dolia and Rosa Ribush Collection. State Library of Melbourne.

mythologies and were idealised (and cursed) in popular prose, verse, painting, and cinema.

Such cultural representations were bound by discourses and images of unhospitable places where inhabitants survived by struggle, hard work, improvisation, and comradery. Since colonisation, or even before British settlement in 1788, Australia had been constructed as an imaginary place full of oddities that incited fear and wonder in equal measure. To British—as well as Dutch and French—explorers and botanists, it was a land occupied by strange fauna and flora and populated with strange creatures and civilisations. As the early explorers struggled to make sense of the wild shores, their European gaze considered Australian land a *terra nullius*—an empty land awaiting their inscription. In their eyes, the eucalyptus and the gum trees were empty signifiers in a bleak and indeterminate landscape. The marsupials needed scientific classification and creatures such as the platypus with a bill, webbed feet, and fur instead of feathers. Bushrangers, devils, and witchdoctors lived in the bush, spirits and devils dwelt in the trees. With the transportation of convicts to its shores, the darkness of the place only deepened. Australia

'was a world of reversals, the dark subconscious of Britain. It was for all intents and purposes, the dungeon of the world'.[35] The historian Eric Hobsbawn writes that the original image of the frontier 'contained two elements: the confrontation of nature and civilization, and of freedom from social constraint'.[36] In other words, the taming of the wild was an encounter with man and nature and the lure of a life of individualistic freedom on the fringes of settlement (Figure 5.4).

The cowboy and the bushman, while grounded in solid and gritty facts, were romantic creations whose virtues and ideals served to construct the idea of egalitarian and democratic nations. They were the fighters and guardians of the Anglo-Saxon settler experience, intermediaries between the hostile forces of nature (that included 'the natives') and the building of an honest and a just civil society. By and large they opposed indigenous peoples which popular lore depicted as an ongoing threat. They and their pioneer women faced crushing isolation and extraordinary deprivation. In other words, the frontier and outback myth either misrepresents indigenous peoples or renders them completely absent. In such narratives, women were fairly one dimensional, existing for the sake of their men and for their satisfaction. This mythic idealism, bound thick with nationalist sentiments, created the frontier legend

Figure 5.4 Bushmen's camp in bush; Men and Australian stock horses at a camp by a river. Aston Wood photographer. Australian Post. Circa. 1939–1947). State Library of Melbourne. Public Domain.

whose (essentially white) cowboys and bushmen possessed the 'spirit' of the American frontier or the Australian outback.

In Australia, the bushman and the pioneering settler were depicted as mustering cattle, stock riding, shearing sheep, droving, camping under the stars with his swag, making tea from his billy can, riding horses, and fighting floods and bushfires. These were the romantic heroes of the frontier who fought and protected the rights of disenfranchised communities who were at the mercy of corrupt authorities or capitalist progress. They were chivalrous, rebellious, and brave and, in various occasions, were wronged by an ineffective justice system. This construction of a communal myth, as Hobsbawn suggests, 'cannot be entirely divorced from the reality of banditry', but is constructed from a combination of historical facts and the social imaginary. This can be said of American Jessie James and Australian Ned Kelly, who would become national legends and whose heroic escapades would appear in television series, comic books, and in films. One of the most interesting points is that the cinematic productions of *Ned Kelly* (Gregor Jordan, dir. 2003) and *The Assassination of Jessie James* (Andrew Dominik, dir. 2007) contain lead actors who are considered national icons: Heath Ledger (*Brokeback Mountain*) plays Ned Kelly and Brad Pitt stars as Jesse James.

Yet who can forget Brad Pitt in the American road movie *Thelma and Louise* (Ridley Scott, dir. 1991), whose minor character as a cowboy hitchhiker catapulted him to fame.Dressed in a denim shirt and jeans, aviator sun glasses, brown leather cowboy boots, white T-shirt, and Stetson hat, Pitt's character, J.D., is offered to the audience as an erotic object for their aesthetic appreciation. Later, when J.D. turns up at Geena Davis's Oklahoma hotel room, his clothes dripping wet and clinging to his body from being caught in the rain, he appears to be the sex symbol incarnate. Pamela Church Gibson writes that the scene is notable in the way in which the two bodies are presented to the spectator's (male and female) gaze. Acting out robbery scenes from his exploits as a small-time thief, J.D. stands topless on the bed wearing only his Stetson hat and a hair dryer that he brandishes as a pistol. 'In an inversion of Hollywood norms', writes Pamela Church Gibson, 'we see more of his body than we do hers. His perfectly proportioned, honed, toned torso fills the screen—the camera lingers lovingly upon it'.[37] Here, the cowboy appears in all his glory in a scene that could so easily be part of a gay male porn movie. This was not the last cowboy role that Pitt would play: in Ridley Scott's *The Counselor* (2013), he is Westray, a sleazy urban cowboy dressed in a custom-made brown tailored suit and vintage 80s eighties sunglasses.

Bush Wear for Bushmen

In her essay, 'Rural Dress in Australia', Jennifer Craik argues that the development of a distinctive type of male bush wear was more of an

'urban phenomenon rather than an outback consciousness'[38] and that its appearance coincided with the construction of a national identity and character. In the words of historian Richard Ward, this national character was 'a practical man, rough and ready in his manners [and] taciturn rather than talkative'.[39] Ward located these typical Australians traits in the men of the Australian bush—bushrangers, drovers, ringers, stockmen, shearers, and squatters who were part of the pastoral industry. Images of bushmen soon appeared in newspaper illustrations and oil paintings dressed in moleskin trousers, elastic sided boots, bush jackets, oil skin coats, and wide brimmed hats that, in time, became indissociable from the rural life of the outback.

In the early period of Australian colonisation, from 1788 until the mid-nineteenth century, clothing and footwear were imported from Britain and consisted of ready-made garments and fabrics. Shortages in apparel were common in the early days of settlement as goods would often arrive by ships saturated in water, or their arrival would often be delayed by bad weather. Some supply vessels came from other colonies, such as India and Shanghai in China because of trade routes. Garments could be purchased at government stores but they were of poor quality and ill-fitting. It was not until 1813 that private enterprises began producing high-quality fabrics and by 1820 small businesses were firmly established and began advertising locally, producing bush wear that included hats made of possum, rabbit, beaver, and wool that were available for purchase in country stores and city emporia. Manufacturers began to specialise in bushwear, such as boot company Baxters (established in 1850) and Blundstones footwear in 1870. Blundstones were designed as an elastic sided boot using thick leather with double stitching and a thick rubber sole that was able to withstand the harsh working conditions of the outback. In 1874 Dunkerley Hat Mills began manufacturing felted rabbit fur hats which they named Akubra (Figure 5.5).

The hat has since become imbued with symbolic meanings associated with the bushman and legends of the frontier and have appeared in a number of films that have enjoyed international acclaim. Australian comedian Paul Hogan appeared as the parodic caricature of the Australian bushman in the film *Crocodile Dundee* (Peter Faiman, dir. 1986), wearing an Akubra hat with a headband made of crocodile skin and teeth. Saturated with cowboy imagery and references, the film is set in an outback town in Australia where American journalist Sue Charlton travels to interview the 'legendary' crocodile hunter Mick Dundee. Dundee is represented as the quintessential bushman who has mastered indigenous knowledge about the outback: subduing a water buffalo, taking part in an Aboriginal tribal dance ceremony, knifing a crocodile, and killing a snake with his bare hands. He wears a crocodile skin vest and boots, jeans, and a leather thong with crocodile teeth around his neck. A leather armband completes the costume and casts Dundee as the visual

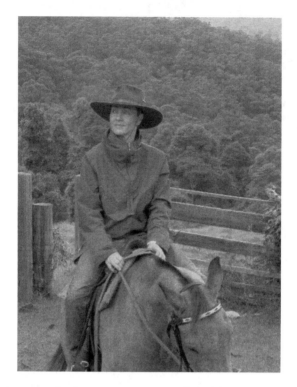

Figure 5.5 A young bushman wearing an akubra hat riding an Australian
stockhorse mare. Private Collection.

representation of the dominant (and recognisable) image of rugged, un-
compromising, unwavering Australian masculinity. These characteris-
tics of masculinity, such as the taming of the bush, the transcendence
of the limits of human abilities, and sheer brute strength are seen at the
pinnacle of Australian experience and identity.

The prime archetypal cinematic image of the 'noble' bushman that has
been etched into the consciousness of a nation is arguably that of Jim
Craig (Tom Burlinson), *The Man from Snowy River* (George Miller, dir.
1982). Drawing upon Banjo Paterson's (roughly speaking the Australia's
equivalent of Longfellow) poetic ballad of a boy's transition into man-
hood, the film occupies an iconic position in the Australian consciousness
and is synonymous with Akubra hats, Driza-Bone oil skin coats, mole-
skins, 'stirrups, horses, bare chests, sunsets [and] mountain ranges'.[40]
The costume of Jim Craig embodies national discourses of nostalgia and
anxiety for the loss of the 'high country' before the spread of urbanisa-
tion. Jim Craig's costume literally signifies, through a visual narrative,

his initiation into the world of men. Sarah Gilligan argues that cinematic costume functions within its own language that includes narrative and plot. She writes that 'this visual language may disrupt and transcend the dominant narrative through melodramatic excess, in which garments speak louder than words'.[41] The garments that Jim Craig and Mick Dundee wear construct narratives of social and national identities that are bound by discourses of national identity, its origins, and its values.

One quality that distinguishes the Australian bushman from his American counterpart is the irony that Australian identity—Australian colonial white identity—is framed in terms of the land and the landscape, and yet it is the most urbanised country in the world. It is safe to say that those who have adopted cowboy style well and truly outnumber those still operating as frontiersmen, their number steadily dwindling. In this regard cowboy style is increasingly an artefact of a time when social unity was a coherent idea, when country was country and men were men. As this history telescopes further and further into the past and with the many (happy) corruptions of the cowboy's inviolable maleness in mind, he and his identifiers are, in many ways, models of the effectiveness of cultural signifiers to solder ideas of truth and virtue, but at the same time they irrepressibly reveal how it is the signs of sacred inviolability that are more often the most fragile.

Notes

1 The closet acts as a double entendre, as Enid and Jake are secretive, hence 'closeted' about their relationship.
2 Annie Proulx, 'Brokeback Mountain. Cowboys and horses and long, lonely nights in the wilderness', *The New Yorker*, October 13, 1997. www.new yorker.com/magazine/1997/10/13/brokeback-mountain. Accessed March 6, 2017.
3 Stella Bruzzi, *Undressing Cinema: Clothing and Identity in the Movies* (London: Routledge, 1997), xv.
4 Adam Harrison Levy, "The Inventor of the Cowboy Shirt", *Design Observer*, September 30, 2008. http://designobserver.com/feature/the-inventor-of-the-cowboy-shirt/7187. Accessed March 11, 2017.
5 Ibid. "The Inventor of the Cowboy Shirt".
6 Eric Patterson. *On Brokeback Mountain: Meditations about Masculinity, Fear and Love in the Story and the Film* (London: Lexington Books, 2008), 114.
7 Chris Packard, *Queer Cowboys and Other Erotic Male Friendships in Nineteenth-Century American Literature* (Palgrave McMillan, 2006), 3.
8 Ed Gonzales, "Brokeback Mountain", *Slant Magazine*, www.slantmagazine. com/film/film_review.asp?ID=1927. Accessed March 9, 2017.
9 Shaun Cole. "Costume or Dress? The Use of Clothing in the Gay Pornography of Jim French's Colt Studio", *Fashion Theory* 18, no. 2, (2014): 140.
10 Shaun Cole, *Costume or Dress*, 137.
11 Ibid., *Costume or Dress*, 129.
12 John G. Cawelti, *Adventure, Mystery and Romance: Formula Stories as Art and Popular Culture* (Chicago and London: University of Chicago Press, 1977), 193.

13 Ibid., *Adventure, Mystery and Romance*, 143.

14 Bruce Lahof, *American Commonplace: Essays on the Popular Culture of the United States* (Bowling Green, OH: Bowling Green State University Popular Press, 1982), 15.

15 Susan Bordo, *The Male Body. A New Look at Men in Private and in Public*, 186.

16 David Grindstaff, "The First and the Corpse: Taming the Queer Sublime in Brokeback Mountain", *Communication and Critical/Cultural Studies* 5, no. 3 (2008): 236.

17 Michel Foucault, "Of Other Spaces: Utopias and Heterotopias", *Architecture/ Movement Continuité*, October 1984: Des Espace Autres, March 1967. Jay Miskowiec, trans. http://web.mit.edu/allanmc/www/foucault1.pdf. Accessed March 10, 2017.

18 B. Ruby Rich, "Hello Cowboy", *The Guardian*, Friday September 23, 2005. www.theguardian.com/film/2005/sep/23/3. Accessed March 27, 2017.

19 See Damien Kemf and Maria L. Gilbert, *Medievil Monsters* (London: British Library Publishing, 2015).

20 Nahoko Miyamoto Alvey, *Strange Truths in Undiscovered Lands: Shelley's Poetic Development and Romantic Geography* (Toronto: University of Toronto Press, 2009), 243.

21 Ibid., *Strange Truths*, 243.

22 Anne Mcclintock, *Imperial Leather: Race, Gender and Sexuality in the Colonial Contest* (London: Taylor and Francis, 2013), 23.

23 Mary Anne Irwin and James Brooks, eds. *Women and Gender in the American West* (Albuquerque: University of New Mexico Press, 2004), 185.

24 Ibid., *Women and Gender*, 185–186.

25 Sarah Lee Johnson, "'A Memory Sweet to Soldiers': The Significance of Gender in the History of the American West", in Mary Anne Irwin and James Brooks eds. *Women and Gender in the American West* (Albuquerque: University of New Mexico Press, 2004), 89.

26 George A. Boeck, Jr. "Rancher and Farmer Dress in North Central Texas, an Ethnographic History", in Peter McNeil and Vicki Karaminas eds. *The Men's Fashion Reader* (Oxford: Berg, 2009), 322.

27 Women's Levi's 501 button fly jeans became the biggest selling jeans in the fashion industry and a symbol of rebellion for third wave feminists in the 80s.

28 Claudia Springer, *James Dean Transfigured: The Many Faces of Rebel Iconography* (Texas: University of Texas Press, 2013), 110.

29 Gibson, Brad Pitt and George Clooney, 2005, 70.

30 Ibid., Brad Pitt and George Clooney, 2005, 71.

31 Sarah Gilligan, "Fashioning Masculinity and Desire", in Andrew Ireland ed. *Illuminating Torchwood: Essays on Narrative, Character and Sexuality in the BBC Series* (North Carolina and London: McFarland and Company, 2010), 153.

32 Dustin Hofmann, *Midnight Cowboy*, Directed by John Schlessinger (Los Angeles: MGM, 1969).

33 Ibid., *Midnight Cowboy*.

34 Ara Osterweil, "Ang Lee's Lonesome Cowboys", *Film Quarterly* 60, no. 3 (Spring 2007): 40.

35 Gary Turcotte, *Peripheral Fear: Transformation of the Gothic in Canadian and Australian Fiction* (Sydney: Peter Lang, 2009), 22.

36 Eric Hobsbawn, "The Myth of the Cowboy", *The Guardian*, March Wednesday 20, 2013. www.theguardian.com/books/2013/mar/20/myth-of-the-cowboy. Accessed April 2, 2017.

37 Gibson, Brad Pitt and George Clooney, 73.

38 Jennifer Craik, "Rural Dress in Australia", in Margaret Maynard ed. *The Berg Encyclopedia of Dress and Fashion*, Volume 7, Australia, New Zealand and the Pacific Islands (Oxford: Berg, 2010), 110.

39 Russel Braddock Ward, *The Australian Legend* (Oxford: Oxford University Press, 1958), 145.

40 Luke Buckmaster, "The Man from Snowy River. Rewatching Classic Australian Films", *The Guardian*. www.theguardian.com/film/australia-culture-blog/2014/may/02/the-man-from-snowy-river-rewatching-classic-australian-films. Accessed April 4, 2017.

41 Sarah Gilligan, "Fashioning Masculinity and Desire", in Andrew Ireland ed. *Illuminating Torchwood* (McFarland and Company: London, 2010).

6 Leather Men

Any description of someone wearing leather carries connotations of combat and aggression. Wearing leather—the treated hide of an animal—is the legacy, softly but unerringly applied, of warriors wearing the spoils of their hunt on their backs or incorporating their totem on their person. These images are now reserved for film and fancy but they maintain a powerful hold upon the popular imagination. The leather bomber jacket, then the gang jacket, both bearing the insignia of their particular fealties and allegiances, have become indelible displays of strength, defiance, and fortitude. To wear leather is, after all, to invoke the use of ancient armour, to suggest a need for extra endurance and resistance. For when we invoke a leather jacket what springs to mind is not a sports jacket in elegant suede but something far more rugged and utilitarian. Other leather wear, such as pants, carry far more ambiguous connotations: Bondage and Discipline, Sado-Masochism (BDSM) or gay leather men with their handlebar moustaches and military caps asserting their masculinity. It is this ambiguity that leads us to separate the two words 'leather' and 'men' in this chapter. As an ongoing theme in this book, the conjunction of leather styling and masculinity exposes the fault lines in a homogenous idea of masculinity. For the robust (straight) assertiveness of the wearing leather has tended, by the end of the twentieth century, toward sexual inclinations that fork into more than one direction. It is also the assertion of roughness in men's styling that exposes a very different pattern in the objectification of men in modern culture when compared to that of women.

This is eloquently borne out by Susan Bordo who, in her chapter, 'Men on Display', argues that women's bodies became the object of mainstream consumption through the following trajectories: first in *Playboy* magazine and the likes, then in movies, and only then in fashion. Yet the modern evolution of the objectification of the male body has been somewhat different or the obverse. Fashion has taken the lead, then lifestyle magazines, and film only later.[1] 'Hollywood may have been a chest-fest in the fifties', she writes,

> but it was male clothing designers who went south and violated the really powerful taboos—not just against the explicit depiction of penises and male bottoms, but against the admission of all sorts of forbidden 'feminine qualities' into mainstream conceptions of manliness.

When Bordo writes of 50s chest-fests, she is referring to the likes of Gregory Peck, Burt Lancaster, Paul Newman, Robert Mitchum, William Holden, and Marlon Brando. Who could forget the tight skin T-shirt and the wet-fitted jeans (Brando insisted on not wearing any underwear) that so lovingly wrapped around Brando's body in Elia Kazan's 1951 film *A Streetcar Named Desire*. (Oh dear. Oh my!) This look would become 'the style for sexual macho in many gay circles and a required uniform for many would-be teen rebels'.[2] It was also the precursor of a look that would become known as 'rough trade', a sexuality that was encoded with working class gruffness that would appeal not only to gay men, but heterosexual women alike. Pamela Church Gibson writes that in his role as the rough and often violent Stanley Kowalski in *Streetcar*, Brando was 'blue-collar sexuality personified'.[3] He was the sexually abusive king of his home. Every man is a king, Stanley tells Stella and her sister, the Southern belle Blanche DuBois, that 'I'm the King around here'[4] and king he was indeed (Figure 6.1). Stanley's raw masculinity was so potent that it spilled over into an uncontrolled ferocity against Stella (and Blanche). But Stella needs Stanley and Stanley needs Stella. She is attracted to his visceral sexuality and his childlike attachment to her. Who could forget the primal guttural moans—'Stella! Stella!'— when Stanley realises, after beating Stella, that he might lose her forever.

Figure 6.1 Vivian Leigh and Marlon Brando in the motion picture *A Streetcar Named Desire* Billy Rose Theatre Division, The New York Public Library. New York Public Library Digital Collections.

Kowalski was a 'child-man straddling the poles of neediness and man-liness'.[5] Brando embodied an overcharged masculinity that was further enhanced in his role as Johnny Strabler, the bad-boy biker in *The Wild One*, a role that made Brando into a cultural icon, cementing his place as a male rebel long before James Dean.

Reel Men

As we mentioned in Chapter 2 on the playboy, the 50s was a decade of discontent and paranoia that would pave the way for the social and po-litical shifts that would become associated with the tumultuous 60s. The post-war booms of the mid 40s and their associated economic growth in manufacture and infrustructure had created a sense of confidence and stability for many people who believed that the future would be peace-ful and prosperous. The rise in the number of births and the increase in spending on consumer goods was also a direct result of middle-class people's confidence in government support and spending on domestic services. Life, however, was not so safe and ideal for many people, in America the civil rights movement was gaining momentum with ma-jor legal victories and the fear of a communist takeover and the threat of nuclear war loomed high. Women and men felt the constraints of middle-class suburbia with its white goods, picket fences, and perfectly trimmed lawns. Sandwiched somewhere in between the facade of sub-urbia bliss and its discontent was the teenager in all its rebellious glory.

The emergence of the disaffected Cold War teenager in the 1950s was a direct result of middle-class affluence brought about in part by the post-war booms. Before the war, the category of youth was non-existent and young adults left school early to work in full-time jobs to support their families. After the war, the growth of the economy provided more leisure time and disposable income and marketers seized the opportunity to target this new young group that they coined the term 'teenager'. Like the play-boy of the 50s, the teenager was a commodified consumer identity that was constructed through advertising campaigns and mass media. Records, lifestyle magazines, radio, television, comics, and cinema, amongst other consumables (fashion, cars, and cigarettes), found a receptive audience in the teenager who yearned for freedom and a sense of identity.

Sal Mineo, who played the role of the mournful Plato alongside James Dean in *Rebel Without a Cause*—considered to be one of the great teen-age angst films—commented: 'Before James Dean you were either a baby or a man. There was nothing in between'.[6] Rightfully so. James Dean and Marlon Brando were the archetypal tortured youths whose absence of obedience and dissatisfaction with society led to their rebellion. Dean, in his role as the vulnerable Jim Stark in *Rebel*, straddled the poles of neediness and manliness, questioning the façade of 50s middle-class niceties and Marlon Brando was, well, Brando. Nonchalant. Brooding.

Sullen. In Lazlo Benedek's film *The Wild One* (1953), loosely based on the Hollister motorcycle riots in 1947,[7] Mildred asks Brando's character, Johnny Strabbler, the leader of the Black Rebels Motorcycle Club, 'What are you rebelling against Johnny?' To which he replies, 'Whatcha got?' In this simple statement, Brando's character summed up the feelings of teenage discontent brooding in post-war American families. *Rebel* and *The Wild One* were archetypal films of teenage rebellion that were created as 'a means of self -realisation, solidarity and the celebration' of a new culture. Sebastian Heiduschke writes that 'Dean and Brando, as hallmark faces of a changing American society, signalled the arrival of a cinema that sent a problematic and contested message of a liberated un-bridled youth culture'.[8] If anything, *Rebel* and *The Wild One* not only glamorised teenage rebellion and alienation, but it set in motion a style of body politics that became synonymous with protest: muffled speech, loose posture, and a withdrawn look that was practised and perfected. Another posture that was prevalent amongst young men at the time was what Susan Bordo calls 'the lean'—men that are 'almost always reclining, leaning against, or propped up against something'.[9] According to her, James Dean 'was the first 'leaner', he made it stylish for teenagers to slouch'. It was a look that became associated with the rebel teenager, that of the juvenile delinquent.

The link between motorcycles, youth culture, violence, and leather garments was a direct result of the media attention that exaggerated the Hollister Riot and demonised the bikers. Although clubs had been around since the establishment of the New York Motorcycle Club in 1903, it was not until after the Second World War that they became a popular form of entertainment, with bikers meeting at regular rallies and events. Motorbikes (and leather jackets) were used as part of the war effort on the battle front and returning servicemen, who developed a liking for the freedom and thrill associated with the motorbike, set up clubs for enthusiasts. An explosion of 'outlaw' clubs, such as The Hells Angels, which were centred on the use of Harley-Davidsons and chopper motorcycles, sprung up in 1948 in California. A biker subculture (which was often linked to criminal activities) developed with a set of allied ideals that celebrated freedom, nonconformity, and loyalty only to each other. The primary visual form of identification of these clubs was their 'colours', club specific patches, and insignia (The Hells Angels 'Death Head' for example) that were sewn onto a denim vest then worn over a leather jacket. Where once jeans were associated with hard work and cowboy culture, they now became a symbol of revolt. This look that flouted authority and became associated with the male rebel would be put in motion with the prototypical wardrobe, faded blue jeans, black engineer boots, white T-shirt, and the black leather motorcycle jacket, a style would be emulated by many young men in the following decades as the look of the outsider, the anti-hero, and the outlaw.

In Britain, the motorbike boys were known as 'coffee-bar cowboys' or 'ton-up boys', in reference to 'doing the ton' or 'burning-up rubber', an initiation rite of passage involving exceeding 100 mph to join the group. The coffee-bar cowboys hung out at remote countryside cafés where they drank coffee, showed off their motorbikes, and challenged one another to a race. Cafés such as Snitches, Ted's, or the Ace Café (the setting for the 1963 British cult film, *Leather Boys* directed by Sidney J. Furie) became so popular and notorious, writes Ted Polhemus, that the subculture was mentioned in Parliament. 'Rows of hundreds of glemming bikes', writes Polhemus, 'and constant coming and going of leather-jacketed guys (and a few girls) made it clear beyond doubt that Britain now had a fully-fledged biker-style subculture'.[10] Although *The Wild One* (1954) was banned in Britain until 1967, posters were, nonetheless, in circulation depicting Brando wearing a Perfecto jacket and dressed in all his leather finery, influencing the coffee-cowboys dress code. The coffee-cowboys differed in their dress style from their American counterparts, who wore a black leather jacket, blue jeans, white T-shirt, and black engineer boots. Instead, the coffee-cowboys wore a leather jacket over a hand-knitted sweater with jeans and a thick pair of white socks rolled over the top of their tie up military boots. A silk scarf was usually worn around the neck and tucked into the front of their leather jacket, resembling the look of an aviator.

Rebelliousness and motorcycles set aside, the Perfecto jacket was not the only military jacket to gain popularity in men's fashion. In 1931, the United States Air Corps issued the A2 leather bBomber jacket to enlisted pilots that became standard military uniform, while naval officers were issued with the M44 leather bomber jacket The A2 and the M44 were made of horsehide leather and seal skin (they are now made from cowhide leather or goat skin), contained tight front-zippered closures, extended high wrap collars, and tight cuffs with web stitching designed to keep the wind out. The actor Bob Crane wore a leather bomber jacket for his role as Colonel Robert. E Hogan in the American television series *Hogan's Heroes*, set in Luft Stalag 13, a prisoner of war camp for captured Allied airmen during World War II. But it was not until Tom Cruise wore a fur collard G1 style jacket for his role as the elite naval aviator, Maverick, in the 1986 film *Top Gun* (Tony Scott, dir), that the bomber jacket made the annals of fashion history. Unlike the motorcycle jacket that became associated with the rebel and the outsider (a direct result of the negative media reporting surrounding the Hollister Riots), bomber jackets became allied with the adventure and honour connected to the myth of the daring and chivalrous fighting pilot. A myth that continues to inform narratives concerning air force and commercial pilots.

In 1969 the Cold War between the Eastern and Western Block continued with America and its allied forces fighting in support of South

Vietnam against the communist-backed North Vietnamese army. The Vietnam War, which began in 1955 and lasted until the Fall of Saigon in 1975, was considered by many as an 'immoral' war that benefited the imperialistic goals of the United States. Opposition to American involvement was carried out on university campuses across America with regular 'teach-ins' and protest rallies demanding that the United States withdraw its troops from Vietnam. Widespread social tensions regarding women's rights, sexuality, and civil rights formed the backdrop for the anti-war movement which attracted unionists, feminists, and hippies. Slogans like 'Make Love not War' typified the counterculture movement which was gaining momentum from artists, intellectuals, and musicians. Large scale music festivals were organised, such as Woodstock and Summer of Love attracting people in search of intergenerational togetherness. Music from The Beatles, Janis Joplin, Bob Dylan, The Doors, and Jimi Hendrix drew inspiration from anti-war sentiments and penned songs of freedom and love. Men's fashion reflected the anti-authoritarian mood of the times with leather and surplus military jackets adorned with peace signs; combat fatigues, jeans, long unkempt hair, woven headbands, and colourful beads. As the era unfolded a new type of bohemian, the hippie, emerged that celebrated Eastern philosophies, alternative lifestyles, and the experimentation with sexuality, drugs, and altered states of consciousness. The hippies were a new generation of beatniks that inherited a tradition of cultural dissent from the Beat Generation. Beats like the poet Allen Ginsberg became part of the hippie and anti-war movement. Ginsberg's poem, *Howl,* which denounced capitalism and conformity, and the disaffected heroes of Jack Kerouac's *On the Road,* were early countercultural statements that called for political critique and sexual liberation. According to Susan Bordo, the civil rights movement, feminism, and anti-war politics were defining a new kind of rebel virility in men[11] that would manifest in films such as *Easy Rider* (1969).

Written by (and starring) Peter Fonda and Dennis Hopper, *Easy Rider* is a landmark counterculture film that tells the story of two motorbike riders (Wyatt, played by Fonda and Billy, played by Hopper) that travel on a road trip on their chopper motorbikes to the American South after selling a large haul of cocaine that they had smuggled from Mexico into Los Angeles. The film tackles the themes and tensions that were prevalent in the United States during the 1960s: the hippie movement, communal lifestyles, and experimentation with hallucinogenic drugs. The film's wardrobe pays homage to the themes of idealism and patriotism gone sour and the escape from conformity symbolised by Wyatt's 'Captain America' bike, named for its American flag colour scheme. Wearing a co-ordinated 'star spangled' helmet and leather jacket, Wyatt is the embodiment of the disenfranchised outlaw rebel biker that appealed not only to the anti-war protesters but to returning soldiers disillusioned by the war.

The Black Leather Motorcycle Jacket

Marvin J. Taylor writes that '*The Wild One* created three paths: the juvenile delinquent, the biker outlaw, and the gay leather man'.[12] The common denominator between these three lifestyle paths is an item of clothing that has become a stable menswear coordinate since its inception in 1928, the black leather motorcycle jacket.

In *Resistance Through Rituals*, Stuart Hall et al. use the concepts of homology and bricolage to explain why a particular subcultural style should appeal to a particular group. The answer was that appropriated objects, in this case the leather jacket, expresses and resonates aspects of group life.[13] The leather jacket is central to the ways in which the juvenile delinquent, the biker, and the leatherman embody their sense of values of rebellion reflected against conformity. Although the history of the leather jacket is tied to the United States military, when motorcycle jackets were worn by American troops in World War I, it was not until 1923 when two Russian Jewish immigrants, Irving and Jack Schott, designed the 'Perfecto' (named after a Cuban cigar) that the leather jacket secured its place as an iconic garment in subcultural style (greasers, rockers, and punks, among other groups) and fashion history. Unlike its military predecessors, the 'Perfecto' leather jacket was not buttoned but included a zipper that kept the wind out and the warmth in for its wearer. The jackets were sold at army and navy surplus retailers, but it was not until the release of *The Wild One* (Brando wore the new 'W-style' One Star jacket) that the jacket became a best seller and a new style of masculinity was created, the motorcycle rebel.

> Brando's mumbling, formidable loser [character] ...created a new kid of persona for American men...From juvenile delinquents, to bikers, to leathermen to punks, the darker, more dangerous, more volatile, hypermasculine male found a common model, swathed in a black leather motorcycle jacket.

Brando prowled in his walk, posture, and clothing. With his scuffed black leather engineer boots, tight leather pants, Perfecto jacket, and his black motorcycle cap tilted slightly on his head, he became a mythological hero; a composite screen rebel. His garments not only heralded the anti-establishment hero, but the abstraction of the myth or the ideal is played out through the interactions between the body and the his clothes. To this, the clothes that the rebel wears is the most common identifying mark of his status as a dissident. Maria Constantino writes that with the popularity of film stars Brando and Dean, the trinity of blue jeans, white T-shirt, and leather jackets became the urban uniform for young men replacing suits, shirts, and ties.[14]

Leathermen

The effect of Marlon Brando dressed in leather in *The Wild One* on Finnish artist Tourko Laaksonen cannot be underestimated. Laaksonen was attracted to Brando's physical presence, which was powerfully seductive and appealed to gay men (and women alike). He was also drawn to the overtly masculine hard-fighting (hard drinking) men that are associated with the biker subculture. A subculture that prohibited the inclusion of women, or if allowed membership to the motorcycle club it was at a lower status then men (either as sexual trophies or as prostitutes). As we argued in *Queer Style*, 'ouko dressed in leather, "becoming" Tom of Finland, and dreaming up a whole menagerie of pumped, "ripped" guys, "a gay utopia" of bikers dressed in full leather all bursting out of their tight leather pants and jackets'.[15] 'Tomland is a fantasy world in which masculinity is held up as the highest ideal'.[16] Laaksonen invented a universe in which jutting chins and pursed lips gazed longingly at biceps and pectorals that bulged with exaggerated rotundity, or to use the correct gay expression: 'big pecs, tight abs and bubble butt'.[17] Snaith goes on: 'Through his fantasy of total maleness, Tom sought to eliminate gay guilt, to correct injustices, to validate gay men, their desires and their experience, to destroy the stereotype which equated homosexuality with effeminacy'.[18] Laaksonen may have come from Europe, but his characters are definitely new world. Due to the American movie industry, American males, especially those of the working class, were seen as more virile than their European counterparts, who bore the legacy of the aesthete, the effete, pruned, and groomed dandy.[19]

Manliness and muscularity had already begun to be popular with publications such as *Physique Pictorial* that contained illustrations of buff, scantily clad men in social interaction.[20] Laaksonen did his own cover illustration for this magazine in 1968, and this time, with penises straining within the tightest of leather pants, there was little equivocation. Gay men, especially 'clones' were attracted to Tom of Finland's drawings because they represented a type of masculinity that was confident and in control. Nazi uniforms were often depicted in Laaksonen's drawings, but more than often, the swastika was replaced by a giant penis. The attractiveness of the biker look as a gay style was evident in magazines that were in circulation such as *Physical Pictorial* and the films produced by Bob Mizer's Athletic Model Guild. The all-leather look had been developing since *The Wild One* in 1953, and by the 70s it had become established in gay subculture, especially amongst Sado-Masochists (S/M) and leather fetishists. In 1977, the American disco group The Village People, who were known for their on-stage costumes depicting masculine stereotypes; the construction worker, the native American Indian, the policeman, the cowboy, and the leatherman (complete with 'handlebar' or 'horse shoe' moustache), was ere created to target gay audiences.

Hits such as 'Macho Man,' 'In the Navy,' and 'Go West' all contained gay themes of masculinity and were intended to evoke the über man clone (also referred to as a 'Muscle Mary') in gay culture. Leathermen also featured in mainstream cinema; Kenneth Anger's 1963 experimental film *Scorpio Rising* paid homage to the motor bike subculture and rebels Dean and Brando were referred to as heroes. The film also explores themes that are of interest and appeal to S/M practitioners such as Nazism, the occult, homosexuality, and religion. The Nazi Gestapo uniform and the leather-masked executioner are roles that are prevalent for dominants, also known as 'tops' in S/M pairings. Shaun Cole argues that the biker look was not necessarily a look that was regulated to BDSM subculture and gay leathermen, it was a look that also appealed to men that were attracted to bikers and their style of dress. 'Male hustlers, who were not necessarily gay', Cole writes, 'often adopted elements of the biker look, which appealed to punters looking for rough trade'.[21] Cole is referring to John Rechy's 1963 novel *City of Lights* that follows the travels of a young man working as a hustler across America. Throughout the novel the unnamed narrator has sexual trysts with other hustlers and a BDSM enthusiast. 'There's a black leather jacket with stars like a general', says the narrator of the novel, 'eagled motorcycle cap, engineer boots with gleaming polished buckles'.[22]

In 1980 the controversial crime thriller *Cruising*, directed by William Friedkin and starring Al Pacino, was released to a storm of protests. The film is loosely based on the novel of the same name by Gerald Walker about a serial killer that stalks gay men in the leather club scene in New York in the 1960s and 1970s. Steve Burns, played by Al Pacino, is a police officer who is sent undercover to track down the killer. The film was met by hostile reviews and protesters from the gay community who believed that the film stigmatised the leather and S/M community in its depiction of anonymous and rough sex that would become synonymous with the HIV/AIDS epidemic. What is of interest here is the way in which the film captures the codes, rituals, and dress of leathermen who participate in S/M subcultural practices, primarily the 'hanky code'.

The hanky code is based on the small, square coloured western style handkerchiefs, or bandannas, that have covert meanings concerned with sexual practices attached to the choice of colour or the side of the jean or leather pants back pocket that the hanky is tucked into. Known as 'flagging', the choice of hanky colour or pocket side indicates the wearers sexual preference. To begin with, the left pocket indicated dominant sexual partners (tops) and the right side for submissives (bottoms), a light blue hanky tucked into the left pocket indicates a preference for someone to perform oral sex on the wearer, a light blue hanky in the right pocket indicates that the wearer is willing to perform oral sex on another man. The code is often referenced back to the goldminers and cowboys living in San Francisco during the Californian Gold

Rush who used the hanky code to indicate whether they followed or lead when they danced. Another historical reference, and one that is portrayed in the film *Cruising,* is to the leathermen who wore a particular coloured hanky tucked into the back pocket of their jeans or leather pants (which also held their hanging keys) to indicate whether they were the dominant, or 'top', in the sexual pairing or the subservient 'bottom'. Jack Fritscher writes in his introduction to Larry Townsend's *The Leatherman's Handbook* II (2007) that queer servicemen returning from military duty during the Second World War, where men lived in the company of other men, were attracted to the power of uniforms and its rigid hierarchical codes of dominance and subservience. These men found common ground with the biker culture that provided a space of male aggression and rebellion, rather than the popular representations of effeminate and weak gay men that were in circulation at the time. The men wore full leathers, including peaked leather caps and engineer boots and gang colours on their backs (like the coloured hankies) became affiliated with gay biker clubs, like 'The Satyrs' in Los Angeles. According to Cole, there were no ready-to-wear leather sex clothes that were available and men compromised by creating garments such as harnesses from saddle shops and leather pants and jackets from Harley-Davidson.[23] Similarly, Robert Mapplethorpe's photographic images that emerged in the 1960s were in opposition to the effeminate stereotypes of gay men, but instead portrayed powerfully seductive images of muscular men in leather.

By the late 70s the leather club scene was firmly established in major cities across the world, including Amsterdam, Berlin, Sydney, New York, and San Francisco. These clubs catered to men who were attracted to leather as a fetish, or were participants of BDSM sexual practices. Leatherman (who are predominately gay) are a subset of the BDSM subculture whose dress and sexual practices are organised around leather garments and accoutrements; leather chaps, pants, jackets, vests, harnesses, and wrist cuffs. BDSM occurs within a complex setting, a theatre such as a dungeon, kitchen, or a prison in which sexual narratives can be acted out. Its props and avatars (bonds, chains, ropes, whips, blindfolds) and its scenes are what constitute its style and represent the paraphernalia of state power, public punishment converted to public pleasure. As we have noted in *Queer Style,* BDSM is so firmly entrenched in these props and its ritualistic metaphors, fetishes, and relics that it is impossible to distinguish between dress and costume for everything is a self-conscious enactment. A BDSM 'scene' is highly dependent on the garment and its accessories, whips, handcuffs, leather masks, and crops for the desired effect. Black leather, its feel, smell, and touch, as well as its associations to animal skin and its predatory impulses, induce sexual excitement with their connection to discipline and domination.[24]

Men of Rock

By the end of the 60s leather had become a popular coordinate in every man's wardrobe, for it spoke of rebellion, machismo, and a dark, hedonistic sexuality made popular by musical artists Gene Vincent, Elvis Presley, and Jim Morrison of The Doors. Morrison emerged in the Sixties as a romantic folk-rock artist with his particular blend of poetic protest songs that appealed to a generation of disaffected youth who found commonalities with his lyrics and their own experiences of political unrest, race riots, assassinations, and war. Morrison was a mesmeric figure who dressed in flowing swashbuckler-style white shirts which he wore open-to-the navel, snakeskin cowboy boots, leather pants, often teamed with an American Indian concho belt, and a leather or suede jacket. His hair was long, curly, and his overall dishevelled appearance added to his sexual appeal. He was intense, erotic, and enigmatic, adopting the moniker 'Lizard King' to herald his sexual prowess. He is described by Stephen Davis as a 'rebel poet and godhead in snake's skin and leather... shaking with rage at his world and his contemporaries'[25] Morrison established himself as a sex icon and a scandalous American rock star who decadent existence was made up of excessive drug and alcohol intake sexual orgies, and black magic invocations. Morrison successfully built an association between leather, sex, and wild, decadent behaviour that became the key ingredients to rock star status.

No other male performer in the American rock music industry is best associated with the blue-collar macho image of masculinity than Bruce Springsteen. As Rebecca Traister writes in *Entertainment*, 'Springsteen is an iconic American white guy, associated with totems-guitars and highways and leather jackets'.[26] Springsteen's wardrobe over the past forty years or so of his musical career reflects larger questions about identity, sexuality, and masculinity in the rock music industry. Simon Frith's key publication, *Sound Effects: Youth, Leisure and the Politics of Rock* (1983), argues that rock sexuality developed and defined itself against a background of permissive bohemian freedom, especially in the context of a youthful rebelliousness against family values and ideology. 'Rock sex was bohemian sex—earthly, free',[27] says Frith, 'the women's place, though, remained subordinate'.[28] The expansion of sexual opportunity in the 60s sixties occurred in the context of a hedonism that was experienced and marketed. Sex was no longer defined with reference to domestic ideology but was commodity to be consumed. Men were the sexual consumers and women were the sexual commodities. In other words, rock music was a man's world and women were subordinate.

In the 1970s, Springsteen wore a floppy hat and dressed as a troubadour poet, but following the 1975 success of his album *Born to Run,* Springsteen refashioned himself as a rocker, with a casual leather jacket, jeans, and white T-tee shirt reflecting a rough and tough rebellious masculinity.

By the time *Born in the USA* was released in 1984, almost ten years after the release of *Born to Run*, his hair was slicked back and he wore a leather jacket and head band. The album cover depicted a photograph of Springsteen cropped at the shoulders and at the knees, wearing blue jeans, a white T-tee shirt, and, to complete the all-American look, a red baseball cap tucked into the right back pocket of his jeans. Springsteen is standing in front of what is obviously the American flag. We know this because of the title of the album. Curiously enough, had the audience not known that Springsteen was heterosexual, one could be mistaken for thinking that he might be gay, given the intertextual reference of the baseball cap to the hanky code. The audience gaze is directed towards Springsteen's buttocks, which, in turn, become a fetishistic object for the consumer titillation. The eye is drawn towards the crease along his jeans that draws a line at the cleft between his buttocks, what Thomas Waugh has described as 'the dark temple of the asshole'.[29] The image brings to mind the homo-masculine men photographed by Robert Mapplethorpe, either dressed in leather or completely naked, their limbs cut off, captured by the camera's frame. The men are, quite figuratively, trapped, headless torsos whose naked backs are turned towards the audience, who may gaze longingly at the model's rear end. Melody Davies argues that photographic images that predominantly feature the male bottom 'present the male body as fetish, completely supporting the metonymic fantasy and the action ideal'.[30] Writing on Mapplethorpe's photographs of black male bodies, Kobena Mercer also argues that the male body is fragmented into micro images that 'mortify the body into a sex fetish'.[31] Let us return to Springsteen and the question of masculinity. We know, or assume, that Springsteen is heterosexual because the hegemony of rock music has its roots in patriarchal, blue-collar working-class values that are part and parcel of traditional constructions of manhood. Those of which can be read as sexist, conservative, and more often than not, homophobic. Considered the archetypal hero of traditional rock, Springsteen's America, writes Gareth Palmer, 'is a conservative land where the heroes struggle to understand the limits of their horizons'.[32]

The roots of rock belong to the bastian of traditional masculinity that considers men the breadwinners and head of the economic household and women the homemakers and the subordinates. It values competition, toughness, status, and emotional stoicism. Statements like 'men don't cry' and 'take it like a man' uphold the tenements of traditional masculinity. In this model, masculinity is an ideological construction that lays claim to power that is historically validated by reason and strength of anatomy. Given the political and cultural shifts that have occurred since the '70s traditional masculinity has been questioned, analysed, and deconstructed and posited as no longer tenable in our post-industrial and postmodern times. However, traditional masculinity is still prevalent and very much alive in rock music, the hypo-macho

posturing and performances of rock stars Jon Bon Jovi, Jim Morrison, Iggy Pop, and Aerosmith are evident, that, in the rock world at least, men still reign supreme. Simon Frith and Angela McRobbie identified a subculture of rock in the '70s that they called 'cock rock'. It became a synonym for hard rock, emphasizing an aggressive and boastful male sexuality, phallic imagery, misogynistic lyrics, and 'cock' posturing (for example, playing the electric guitar as a phallus or masculine trophy), what Frith calls 'a masturbatory celebration of penis power'.[33] According to Frith, women are excluded from this rock experience, for it speaks about the boundaries of male sexuality. Cock rocker's bodies are on 'display (plunging shirts and tight trousers, chest hair and genitals), mics and guitars are phallic symbols (or else caressed like female bodies), the music is loud, rhythmically insistent, built around techniques of arousal and release'.[34] The cock rocker is a rampant travelling man, smashing hotel rooms, snorting cocaine, drinking excessively, and partying with groupies (female fans). In the cock rockers fantasy, women are always available and sex is anonymous with no emotional strings attached.

Greasers and Punks

Film images of the black leather jacket continued to be attributed to expressions of teenage revolt throughout the 1950s. Teenagers were jolted by the liberated rhythms of rock n' roll and the sexually provocative performance style of Elvis Presley, swooning at the way he swivelled his hips and pouted his lips. Presley's songs spoke of yearning for true love and the tribulations of romance which appealed to teenage audiences. His 'ducktail' hairstyle and long sideburns became the look of the 'greeser': sharp, cool, and sexy. Hair was grown long then greased back with Brylcreem, Vaseline, or pomade, a waxy lotion that was applied to the hair and then combed back to what resembled a duck's tail. They wore dungarees, a type of jeans, white T-shirt, black leather jacket, and black leather engineer boots. A packet of cigarettes wrapped under the sleeve of a T-shirt and a plastic comb tucked into the back pocket of their jeans completed the greaser look. They spent their time hanging out on street corners or tinkering with their hot rods, Harley-Davidsons, or chopper motor bikes, which gave the impression that they were time wasters and lazy hoodlums. They listened to rockabilly music, and Elvis Presley, James Dean, and Marlon Brando were their idols. In Britain, the greasers were somewhat different from their American models, although they wore the same leather jackets, which were often sleeveless ('cutdown') over faded denim jackets, they often wore a peaked leather cap or a military helmet that covered their hair. More often than not, chains, studs, and badges such as swastikas covered their jackets. Years later, stereotyped representations of the American greaser would be reflected in the 70s television comedy series, *Happy Days,* with the character The

Fonz (played by Henry Winkler) and in the film *Grease* (Kandel Kleiser, dir. 1978), starring John Travolta as Danny Zuko. The Fonz and Zuko wear leather jackets, jeans, and white T-shirts, but it is their posturing, their 'cool stance and way of repeatedly pulling out [their] comb to smooth [their] hair into a ducktail'[35] that contained all the stereotyped hallmarks of a rebel masculinity.

In 1975 New York-based musicians were congregating in a small Bowery bar in the East Village of Manhattan called CBGB. The bar soon became a favourite venue for rock and new wave bands like The Ramones (Johnny Ramone had been wearing a black Perfecto leather jacket for many years), Talking Heads, and the proto-punk band Television. Proto-punk was rooted in rock music played by garage bands who rejected the perceived excesses of rock and favoured an anti-consumerist DIY aesthetic. Television's lead guitarist, Richard Hell, devised a new look by cropping his hair short and ripping his T-shirt and his jeans. It was about this time that Malcolm Maclaren was visiting New York to try to revive the fledgling post-glam, post-punk band, New York Dolls, when he came across Richard Hell at CBGB. Together, with his girlfriend designer Vivienne Westwood, Maclaren would recreate Hell's ripped clothes aesthetic for the newly formed punk band, The Sex Pistols that Maclaren was managing and punk would become a new style of revolt. According to Frith, punk was the first form of youth music not to rely on love songs. It rejected romantic and permissive conventions and refused to allow sexuality to be constructed as a commodity. 'They flaunted sex-shop goods in public, exposing the mass production of porno-fantasy, dissolving its humanising effects through shock-'Oh Bondage! Up Yours!'.[36] Sex and sexuality had no significance at all.

With the proliferation of punk styling, the pre-existing notions of quality were shattered. For the first time, a lack of quality, or the aesthetic of a poor quality, entered into the equation, as did clothing as a vector for ideas that challenged the very notions of wealth, class, and status that clothing had always helped to maintain. This DIY style would soon become known as punk, a style that was unerringly crude, sexually suggestive, even primitive, or primitivist in inclination. Punk was a 're-volting style' whose perverse garments and accessories; leather jacket, stove pipe pants, Dr Martins boots, dyed 'mohawk' (American Indian) hairstyle, safety pins, graffiti T-shirts and bondage gear signified chaos on every level. It was a visual and social revolution that used fashion, graphics, and behaviour as a strategy to challenge dominant ideology and capitalism.[37] as we note in *Critical Fashion Practice*,

> punk's historical and socio-political explanation lies in social disaffection is next to self-evident, but its own in-built historicism, from repurposing the old or recontextualizing visual signs, carries a strong sense of mourning that the past can never be again. With

punk the references are never nostalgic, and if they are not desecrating or denigrating, they seek to stir in the viewer not only a consciousness of the past but also the way in which relics and fragments of the past can be transformed.[38]

In this context, the black leather jacket becomes a visual signifier of protest and revolt against the establishment. Ripped and patched together with safety pins, chains, and padlocks, as well as badges and patches, the garment ceases to proclaim a macho virility, but instead becomes a political proclamation and a call to arms. A nihilistic battle cry of 'No Future'. Punks decorated their black leather jackets with the names of their favourite bands, with mini manifestoes or political slogans written in white paint. Such DIY accessories captured the essence of punk and personalises the leather jacket. When the nihilistic lead singer of the Sex Pistols, Sid Vicious, said, 'Please bury me next to my baby [Nancy Spungen] in my leather jacket, jeans and motorcycle boots',[39] it was an indication that the black leather motorcycle jacket still contained its radical and subversive status as a symbol of the outsider.

Notes

1 Bordo, *The Male body*, 168.
2 Ibid.,138.
3 Pamela Church Gibson, 'Brad Pitt and George Clooney', 72.
4 *A Streetcar Named Desire*, Elia Kazan, dir. Warner Bros. 1951.
5 Ibid., The *Male Body*, 141.
6 *Rebel without a Cause*, Nicholas Rey, dir. Warner Bros, 1955.
7 The American Motorcyclist Association sponsored a rally in California in 1947 in which four thousand motorcyclists from the Boozefighters gang descended on the rally and caused a riot that lasted for three days. When first released, *The Wild One* (1953) was banned by the British Board of Film Classification (BBFC) because of its depiction of nihilistic and anti-social behaviour. The board was concerned that the film would promote delinquency and hooliganism amongst its young audience and placed an X rating (suitable for 16 years and older) on its eventual release in the United Kingdom in 1967.
8 Sebastian Heidushschke, "Authority, Mobility and Teenage Rebellion in The Wild One (USA, 1953), Die Halbstarken (West Germany, 1956) and Berlin – Ecke Schonhauser (East Berlin, 1957)", *Seminar* 49, no. 3, (September, 2013): 282.
9 Bordo, *The Male body*, 188.
10 Ted Polhemus, *Street Style: From Sidewalk to Catwalk* (London: Thames and Hudson, 1994), 46.
11 Ibid., *The Male body*, 132.
12 Marvin J. Taylor, "Looking for Mr Benson. The Black Leather Motorcycle Jacket and Narratives of Masculinity", in H. Joseph Hancock, Toni Johnson-Woods and Vicki Karaminas eds. *Fashion in Popular Culture* (Intellect: Bristol, 2013), 129.
13 Stuart Hall and Tony Jefferson, *Resistance through Rituals*, Youth Subcultures in Post-War Britain (Hutchinson: London, 1976).

14 Maria Constantino, *Men's Fashion in the Twentieth Century: From Frock Coats to Intelligent Fibres* (Costume & Fashion Press/Quite Specific Media: California, 1997), 83.

15 Geczy and Karaminas, *Queer Style*, 89.

16 Guy Snaith, Tom's Men, 77.

17 Ibid., Toms Men, 78.

18 Ibid., Toms Men, 77.

19 Vito Russo, *The Celluloid Closet*, Revised Edition, (New York: Harper and Row, 1987), 32ff.

20 See Reed, *Art and Homosexuality*, 167–169.

21 Shaun Cole, *Don We Now Our Gay Apparel* (Oxford: Berg, 2000), 108.

22 Ibid., *Don We Now*, 108.

23 Ibid.

24 Geczy and Karaminas, *Queer Style*, 108.

25 Stephen Davis, *Jim Morrison: Life, Death, Legend* (London: Random House, 2005), ix.

26 Rebecca Traister, "Bruce Springsteen's Memoir Beautifully Dissects his Masculinity", *Entertainment*, www.aol.com/article/entertainment/2016/09/28/bruce-springsteens-memoir-beautifully-dissects-his-own-masculin/21482803/. Accessed April 27, 2017.

27 Simon Frith, *Sound Effects: Youth, Leisure and the Politics of Rock* (London: Constable, 1983), 241.

28 Ibid., *Sound Effects*, 241.

29 Shaun Cole, "Considerations on a Gentleman's Posterior", *Fashion Theory* 16, no. 2 Special Issue, Body Parts, Vicki Karaminas, ed., (June 2012), 222.

30 Melody Davies, *The Male Nude in Contemporary Photography* (Philladelphia: Temple University Press, 1991), 71.

31 Kobena Mercer, "Race, Sexual Politics and Black Masculinity: A Dossier", in Rowena Chapman and Jonathan Rutherford eds. *Male Order, Unwrapping Masculinity* (London: Lawrence and Wishart, 1988), 97–164.

32 Gareth Palmer, "Bruce Springsteen and Masculinity", in Shiela Whitely ed. *Sexing the Groove: Popular Music and Gender* (London and New York: Routledge, 1997), 116.

33 Frith, *Sound Effects*, 227.

34 Ibid.

35 Marilyn Delong and Juyeon Park, "From Cool to Hot to Cool. The Case of the Black Leather Jacket", in Andrew Riley and Sarah Cosbey eds. *Men's Fashion Reader* (New York: Fairchild, 2008), 176.

36 Frith, *Sound Effects*, 243.

37 Hebdige, *Subculture the Meaning of Style*, 68.

38 Dam Geczy and Vicki Karaminas, *Critical Fashion Practice from Westwood to Van Beirendonk* (London: Bloomsbury), 19.

39 http://dangerousminds.net/comments/bury_me_with_my_boots_on_sid_viciouss_death_wish. Accessed April 17, 2017.

7 Superheroes[1]

The status of the superhero in modernist and contemporary culture is significant and evolving at a strikingly rapid rate, so much so that it cannot go without comment. But what differentiates the figure of the superhero from the rest of those discussed here is that he is located in a different imaginary space. While men dressing in the vein of a cowboy may have no inkling of ranch-handling, and while a muscle man may actually be a coward, the only time one appears in public as a superhero is as dress-up, and the actual powers are, safe to say, limited. This may all be obvious enough but there is a nuance to all of this, which is different from saying that cowboys exist but superheroes do not, because they do, but in a more remote frontier of the imagination.[2] They are, in many ways, the modern transposition of medieval chivalry, and even the transposition of the ancient pagan gods. But they are also the embodiment of the symptom of penis envy, for in Lacanian terms, the superhero has the phallus in the way that ordinary mortals do not. It is this explanation that also helps to account for female superheroes, who are more often than not, phallic women, that is, women in possession of typically male powers. There are no female superheroes that excel in activities more germane to women, but rather are also combative and fearsome. It is also for this reason that a discussion of superheroes can concentrate on men, a bias that exposes the very lack (the phallus) for which they are the compensatory party. In tracing the nature and appearance of the superhero as he emerged in the early twentieth century, it is also curious to see a new kind of superhero. The new millennium has witnessed an exponential upsurge of superheroes in popular culture that in turn has expanded the range of characters.

There has been good deal of scholarly work done on action heroes and their relationship to classical mythology, the social subconscious, psychology, politics, and religion. Overall they stand for beliefs and aspirations, while also expressing personal fears in a highly encoded form. Batman, for instance, is the subject of considerable psychological inquiry. The victim of childhood trauma at witnessing the violent murder of his parents as a child, his mission for justice is tempered by anger, which leads to moral hesitation, reflecting a split in his consciousness.

For by becoming Batman he has withdrawn from his human identity and, in a sense, renounced the human element in whose name he was created.[3] As a modern mythology, and one that is still vigorously being rewritten, superheroes are among the most telling models for interpreting how men see themselves and how they wish to be seen. Superheroes are one of the most helpful sources in helping to mount the argument of masculinity as masquerade, an underlying concern of this book.[4] As Friedrich Weltzein argues, there are examples since antiquity of men asserting their manhood through adopting particular guises in order to perform their desired function. This can range from Odysseus returning home in the guise of a beggar to the definition of a berserker as 'the one in the bear skin'. Thus 'heroic or ideal masculinity appears not as a superior virility but as a superior ability in masking'.[5] The superhero, whose identity is based on an alternate, civilian identity is central to this concept, as he has become the modern exemplar of the ancient warrior. The construction of the 'true' male self comes as a result of the constant oscillation: It is a steady doing and undoing of two separate identities, which restlessly constructs masculinity through the act of changing costume'.[6] In many ways the dimension of fantasy that the superhero embraces exists to mask the embarrassing, unsettling, or baffling truth about male identity itself.

The Origin Stories

A central component to the superhero genre in both comics and film is the origin story: Peter Parker being bitten by a radioactive spider (Spiderman), the bestowal of a power ring and battery to Hal Jordan by a dying alien called Abin Sur (Green Lantern), or the inhalation of heavy water gas (the Flash).[7] They are not only important in grounding the narrative of a particular superhero but have, understandably, become more ingrained in popular myth with the flourishing superhero film industry, where the first film of a franchise is of how the character came to be. What is consistent throughout is the way that the transition from ordinary, often diminutive (as with Steve Rogers who becomes Captain America) to the final character is understood as a resolution that is immanent to the character. He is ontologically incomplete until the transformation takes place. It is an antiquated and perennial schema that is inscribed by the notion of manifest destiny and making the best of one's potential, both potent drivers within male narratives of combat and conquest.

Examining the genesis of the superheroes themselves proves to be a lesson in symmetries, the birth of all too many can be linked to historical upheaval, or some dramatic shift in social attitude. Dating back to the 1930s, the superhero is a child of the Great Depression, and an historical period facing the twin threat of both fascism and communism. As

Andreas Reichstein states, 'The Great Depression called for heroes who could set an example by showing how to solve the biggest problems in times of crisis and, thus, demonstrate how to cope with individual difficult situations'.[8] It is not only ironic, but fitting that Superman was created by a pair of Jewish high school students, Jerry Siegel and Joe Shuster in Cleveland, Ohio in 1933, the same year as the Nazis ascended to power. The character was then sold to Detective Comics, which became DC Comics, five years later, where he made his debut in *Action Comics* #1 in June 1938. Batman a year later (*Detective Comics* #27, May 1939), less than four months before the declaration of the Second World War. The sudden rush of heroes at this time is hard not to notice: the Flash appeared in January 1940, and the first incarnation of Green Lantern six months after that. As if anticipating historical events, Captain America was born in March 1941, and would be every boy's nationalist hero once the US entered World War Two after Japan's attack on Pearl Harbor in early December of the same year. As symbolic defensive avatars of Cold War peril, Spiderman arrived, ironically again, just three months before the Cuban Missile Crisis in October 1962 (Ant-Man was created the same year). He was followed by the troubled crusaders, Hulk and Thor, and then Iron Man the following year. These would eventually incarnate into action figures, but not before G.I. Joe who appeared on the market in 1964. The turn of the millennium and the industry of superhero films has revised or elaborated on some of the origin stories (Nolan's *Batman* trilogy) and popularised new kinds of superheroes with more ambiguous characters and allegiances, such as Deadpool, or the vampire superhero.[9]

Generally speaking, origin stories are uneven when it comes to the conception and design of the superhero outfit, which is itself telling. The most dramatic evolution in television and film is Batman's costume, which we now, in retrospect, can say that it evolved from the campy and risible worn by Adam West (1966–1968) to the sleekly monumental in *The Dark Knight Rises* (2012). Paul Zehr also charts the evolution of Batman figurines from 1940 to 2000 that chart an irrefutable passage from svelte athlete to ripped and steroid-bulging muscle man.[10] There is a common thread that then carried contemporary nuance. Similarly, the creation and subsequent improvements to the Iron Man garment are an integral part of the story, but the decisions of the character as opposed to the maker are taken as if a given. We will return to the costumes in due course, but suffice to say that the immanence of the costume, that it just comes to be that way, is of a piece to the immanence of the superhero in the character, a predetermination that echoes the same assurance we are supposed to have in the character himself. The fusion of superhero and costume is also evident in times of crisis, decline or defeat is registered in a battered costume, bloodied tears, and a ripped cape. As Barbara Brownie and Danny Graydon aver, 'since the effectiveness of many superheroes is dependent on visible projection of strength, it

is in a superhero's interest to keep his costume intact'.[11] Strength and the appearance of strength are indissoluble. In *Batman Begins* (2005), Batman declares that 'It is not who I am underneath, but what I do that defines me'.[12] Yet it is also the suit that lays claim to what it is he does and is capable of doing.

Masked Masculinity and the Phallic Hero

With the superhero, the mask presents a very special problem because it reverses its conventional logic. Masks are as old as civilisation, their origins to be seen together with the use of dolls. For both are human aliases that allow reflection back into the world itself, a process of othering that assists in socialization and personal, subject acclimatization to the expectations of society. Both allow for the play of fantasy in order to strike a balance with the fantasy that is our perceived lifeworld. And while a girl may use a doll to bring her fantasies of womanhood into reality, a mask serves the purpose of opening possibilities for action. It is the paradox of the mask that an obfuscating shield can allow the person behind it to enact desires and traits that are near unthinkable in the inhibited, unmasked state. Brownie and Graydon emphasise that there is a large amount of research to affirm the fact that when children don a superhero costume they feel 'called to action' and that the 'costume is an activation tool' that tends them to take risks that they otherwise would not take without it.[13]

Masks can be malevolent or benign, can create fear or joy. In his analysis of the mask, Mikhail Bakhtin looks at the different ways it has been used across history and the changes in cultural attitudes associated with it. He calls the mask an 'involvement' shield, protecting privacy while at the same time facilitating, lubricating interaction with others. Bakhtin affirms that 'The mask is related to transition, metamorphosis, the violation of natural boundaries...it is based on a peculiar interrelation between reality and image'.[14] The superhero identity is a bricolage of varying artefacts—horns, masks, glasses—that gesture as much to a futuristic age as one of medieval chivalry. The now universal Superman 'S' is, for instance, a reworking of a traditional heraldic shield.

With all such conventions, the civilian, 'normal' being is engaging in role play, whereas the superhero is engaging in role play when he is civilian. Hence, as Toby Wilsher states, if the role of the mask is to 'disguise, protect or transform', for the superhero, all three are active and mutually exclusive.[15] The most signal case is Superman's alter-ego, Clark Kent, which is not even his real name (it being Kal-El from the planet Krypton). Clark goes to considerable lengths to maintain this identity, such as having a C-grade average in school despite superseding all his classmates, or purposely pretending to be vague and regularly missing the morning train. To interpret such actions according to the

frameworks of masculinity, the superhero requirement to diminish himself for the sake of his 'authentic' identity is the taming of male urges, particularly sexual ones, for the sake of common civility, but also his own preservation. To be too forthright is to destabilise the status quo and become a threat, but when the situation requires it, it is desirable. On the other hand, when in costume, Captain Marvel was less worldly and more innocent than his everyday persona, which has been attributed to the innocence that America wanted to see itself as having against the nefarious forces bearing down from the Second World War.[16] A latter day paladin, his power emanates from his purity. But it is also Marvel's access to humour that singles him out from his peers, and is a sign of his moral rectitude and his pluck.[17] And in addressing the dearth of black superheroes, in recent years Milestone Comics has produced a new spate of heroes such as Black Panther, Black Lighting, and Black Goliath, all of whom combine intelligence with power.[18] A superhero is a figure with heightened attributes which he wields with skill and force.

To put this differently, the superhero possesses something special or something more than the ordinary mortal. The very superhero name, which is different from the Christian-Surname format, is metonymic of action and of dynamic, particularised activity.[19] To continue this line of thinking, if we were to classify superheroes according a particular psychological model, it might conveniently be according to the possession of the phallus. This reading is probably the least traversed in superhero studies, which is odd, as the corollaries are hard to overlook. One of Lacan's most challenging and controversial insights is that the phallus is understood as a fundamental lack. The male possession of the biological phallus is only perceived symbolically, that is, as a substitute for what they lack and to which they aspire. To the 'internal antinomy' of the 'male assumption of his sex', Lacan asks, 'why must one only assume the attributes through menace, seen from the angle of privation?'[20] He cites Freud's *Civilization and its Discontents*, arguing that such discord is 'essential to human sexuality'. Man is beset by the castration complex.[21] What makes the concept hard to grasp is because the phallus is not an object or an organ, but rather 'a signifier', where 'the phallus as signifier gives reason to desire'.[22] 'If the desire for the mother *is* the phallus, the child wishes to be the phallus in order to satisfy that desire'. It is what given the subject purpose and connection to the other, a connection that is also always partly and ultimately thwarted. The motion of desire is double: desire seeks satisfaction in a symbolic object, while also its repression, since repression is desire's cause and its catalyst.[23] The ebb and flow of desire can also be equated to the binary of self and other are always interchangeable in the superhero. It is impossible, or implausible, to be the superhero all the time, which necessitates the retreat into the masquerade of normalcy; normalcy is seen as a compromise, but also a necessary evil. The interminable spiral of the phallus is also that of the

superhero's endless striving. If the superhero is the phallic hero, someone who has 'more' of the phallus than the average being, in so having he also highlights the imperfect nature of this possession. For ultimately to solve all the world's problems is to lead to his own impotence, his redundancy. If his powers could no longer be put to use, he would be reduced to a caricature, or the ultimate masked travesty, the clown.

The symbolic castration that the superhero in costume announces is proper to any figure-wielding inordinate power, which boils down to the Hegelian Master-Slave dialectic in which the Master is nothing without the Slave who serves him. But the difference is that the superhero is at once master and slave, master in terms of extraordinary abilities, and slave to the need to protect those less fortunate than himself. In the words of Zizek:

> So what is symbolic castration, with the phallus as its signifier? We should begin by conceiving of the phallus as a signifier—which means what? From the traditional rituals of investiture, we know the objects which not only 'symbolize' power, but put the subject who acquires them into the position of effectively *exercising* power—if a king holds the scepter and wears the crown, his words will be taken as words of a king. Such insignia are external, not part of my nature: I don them; wear them in order to exert power. As such they 'castrate' me. They introduce a gap between what I immediately am and the function that I exercise (thus I am never fully at the level of my function).[24]

Even if the superhero may have more inherent powers, if these powers are increate instead of symbolic, this does not mean he is immune from the symbolic order of consensus. As Claude Lévi-Strauss also observed, the mask functions as part of a system of diacritical sings—their origin myths and the rites in which they appear—that are rendered intelligible only through the relationships that unite them. There is always a correlational value to the mask and the function assigned to it.[25] If this value falters, when the ethical rectitude is called into question. In the case of the superhero, for his powers to be spent or suspicious is to place him in an invidious position. Hence his powers always court the prospect of castration.

According to this topology of 'greater possession' of the phallus, superheroes are divided into roughly two camps, 'prosthetic' possession, and biological, or 'pathological', possession. The latter called as such because to have the phallus physically is not to assume that it works as well as a prosthetic one. Prosthetic superheroes include Batman, Iron Man, and Black Panther, while pathological superheroes range from Superman to the Hulk. The first are mortals who have trained their bodies and minds, and equip themselves with extraordinary suits or devices

that allow them to supersede average military standards. They are by degrees a match for pathological superheroes, who are either aliens (Superman), or have had their body altered in some magical way to give them powers that arise from their own body alone (the Hulk, Spiderman). In the X-men series those with superpowers are designated as 'mutants', as if their very excess makes them undesirable.

The notion of prosthetic superhero gains in meaning if one were to consider with any due seriousness if a real mortal could actually become one in real life. Iron Man is less plausible, but Batman is something worth considering. In fact, Zehr's book, *Becoming Batman,* is a hypothetical investigation on all fronts to see if such a transformation could actually take place. A scientist in neural control of human movement and himself a martial arts black belt, Zehr investigates the possibility from a physiological, neuronal, genetic, and logistical point of view. If the rare conjunction of wealth, genetics, and training were all in alignment, he concludes that it could be done. 'However, remaining as Batman is not realistic beyond a few years and a decade at the absolute maximum'.[26] This means that his own maintenance requires an elaborate system of aids and supplements. He is the apotheosis of Freud's 'prosthetic god'.

The confrontation with prosthetic and pathological occurs in the recent film, *Batman vs. Superman.*[27] Apart from them being the most original and venerable of superheroes, they are also at opposite poles. Batman is mortal with no subsequent biological adjustments (like Steve Rogers' serum for instance, that augments his powers, including the ability to heal, or the transformation of Logan's bones to adamantium to make him Wolverine). Under normal circumstances, Batman is no match for Superman's speed, strength, and special protection (excepting Kryptonite, of course). But in this film, Superman's powers have become diminished because of the diminution of the sun's rays, which are what feed his superpowers. So reduced, Batman becomes an even, if not formidable, match. In other words, Superman has possession of the phallus but is made temporarily impotent, suggesting that there are always mitigating circumstances to any superhero's power. Everyone has a weakness and no-one, man or woman, as Lacan notes, 'really' has the phallus. To see the superhero in these terms is contentious at first, but it also helps to explain why they have taken hold so strongly as parts of modern and postmodern mythology. For since ancient times, mythology has always been the receptacle for all forms of anxieties between classes and sexes.

The Costume, or the Superhero's Struggle with Fashion

The superhero costume is a specific form of dress that has become something of its own language, with a basic set of signifiers, and variants that circulate around them. The most arresting example is that of a body-hugging costume (Superman, Flash), on one hand, and purpose-made

armour on the other (Batman, Iron Man). Thanks to the developments in technology, both have become a little more plausible and, somehow, more possible. But what marks out the superhero costume is its incongruence with the conventions of everyday dress. It has the character of a uniform, although it is not one that everyone could, or would, be allowed to wear. While the everyday concept of clothing is that it covers us and we are independent agents irrespective of it, what the costume conspires to show, in an exaggerated way, the extent to which clothing is a mediator of roles, attitudes, and of possibility itself. For when the superhero is in the costume he is duty-bound to uphold particular values and to act in a certain way. Although ironic and revisionist readings of superheroes occasionally have them engaging in modest, domestic duties, it is altogether unseemly and incongruous for, say Batman, to be seen at a local café, or at the local 7 Eleven, late at night buying toilet paper and a soda. To borrow a term from Foucault, the superhero costume is 'confessional', as it is meant to communicate actively, directly, and immediately. Foucault states that 'Confession [is] the examination of the conscience, all at the insistence of the important secrets of the flesh'.[28] Similarly, even if the superhero costume is a highly-encoded form of masking, it serves a function of disclosure that is far more resonant than if the character were, say, naked. It is the graphic announcement of the character's inner being, his ethos and his very purpose.

It is this alienation from the mundane that makes them not only outsiders to the average stream of society, but situates them in a limbo outside of time. The ultimate outsider, according to Whitney Crothers Dilley, is the Hulk, who is not only a stranger to others but to himself.[29] Similarly the Gothic hero 'V' of *V for Vendetta* is brought to superhero status from being subjected to unspeakable experiments while in a concentration camp.[30] They are figures of tragedy and redemption all in one. But it also means that they are eternal foreigners to common clothes and everyday ways. As Brownie and Graydon affirms, 'In order to remain outside of time, a superhero costume must remain outside of fashion'.[31] (The Hulk cannot even manage fashion, but leaves clothes in tatters.) This has not stopped, however, designers from plundering the syntax of superhero costume, and the influence in the mainstream in fitness clothing, such as the opaque tights worn by men and women, is unmistakable. Designers have used superheroes, especially The Hulk, as a metaphor for masculine virility and sheer brute force, especially in the menswear of Walter Van Beirendonck, who is known for his graphic prints and interpretation of popular culture and his use of fashion as a tool of protest against the societal woes. 'Like most pop-culture phenomenon', Andrew Bolton writes that 'superhero comics both reflect and respond to real-world societal and political conflicts'.[32] His *Killer/Astral Travel/4D Hi-Di* Spring/Summer 1996 collection contained masks in the shape of whoopee cushions with printed slogans 'Terror Time', 'Get

off my Dick', and 'Blow Job'. Jackets contained air pockets that were inflated to symbolise an exaggerated musculature and silhouette. The collection signified the industrial strength associated with the hyper-muscular superhero body whilst responding to the HIV/AIDS epidemic that had affected the gay community and of which Van Beirendonck had lost many friends. There have also been instances in fashion where designers have directly referenced the shift from mortal to superhero personae through acts of dress. The moment when Clark Kent rips off his shirt to reveal the 'S' symbol has been literally translated by Rossela Jardini for Moschino's Autumn/Winter 2006 menswear collection. Jardini substituted the letter 'S' with the letter 'M' for Moschino to add to the playful and mischievous identity of the Italian brand. Jean-Charles de Catelbajac has also used the Superman emblem in a direct translation for his Autumn/Winter 2001 menswear collection. As we have written elsewhere, 'the superhero wardrobe has been communicating narratives through a combination of text and sequential illustration that functions within an aesthetic vocabulary of coded symbolism'.[33] The garments and their accessories, masks, armoured breastplates, epaulets, and gantlets have come to represents the wearer's identity and functions to highlight the attributes of their heroic status. In the discourse of superhero costume, the mask acts an encoding device, concealing whilst simultaneously revealing the hidden powers of the wearer. Masks and headgear proliferate in Van Beirendonk's collections. For his Autumn 1997 show *Avatar*, he asked milliner Stephen Jones 'to create 120 hats, one for each model in the show. Hats made from computer parts, kinetic hats that flew off the models' head and cartoon leaves with caricatures of insects'.[34] Designed under the label W< (Wild and Lethal Trash), a collaboration between Van Beirendonk and the German denim label Mustang from 1993 to 1999, *Avatar* was shown at the Éspace at St Denis Paris and used three parallel catwalks to display the collection's themes. Forty models wore transparent blindfolds emulating superheroes.Forty African Avatar models wore metal headframes and war make-up ready to do battle and forty Asian Avatars introduced the label's first womenswear collection. In the conflict between good and evil, superheroes act as avatars of law and order protecting the American dream.

By and large the design of the superhero costume remains fixed: if in cinema Batman has changed, Superman exists almost unaltered. Yet it is the relatively stable nature of the look that gives the superhero greater mobility in being enlisted to different causes and values that change for society over time. In the 1950s, Superman is the guardian against communism, while in the new millennium, combats social fears about ecological doom, the threat of artificial intelligence, and the continuing threat of nuclear ambitions of states unsympathetic to the West.[35] In 2004 figures such as Captain America, Daredevil, and the Hulk were recruited as 'supersoldiers' in illustrated books and sent to disarm nuclear

bombs in Iran, Iraq, and North Korea.[36] Apart from small modernizations of the fabric to safeguard against anachronism, the look of the superhero remains the same, while his actions range against historical and political demands, symptomatic contemporary concerns.

Given that the advance of superheroes in their creation since 1933/8 has regular uncanny coincidences with significant world events, their continued significance is tied up with reflecting and maintaining the national image, and in particular, the mythic narrative of the US's predestination as it gained in economic power after the Civil War in the 1860s. Although an alien, Superman's *raison d'être* is caught up in the safety of America, and therefore is no small reminder of the pride the country takes in being a multi-cultural nation, a melting pot of ethnicities and creeds. In the words of Kevin Smith, he is literally 'wrapped in the flag' and an aggressive symbol of the 'the American dream'.[37]

In equal measure, superheroes like Superman straddle different worlds but remain staunch to the America that has housed and nurtured them. Their comparison with US migrants also helps to expose how deeply everyday images and rituals are steeped in nationalist content. In *Banal Nationalism*, Michael Billig explores the wide range of instances of this, particularly in the US, where flags flutter on public buildings, over houses, in offices and classrooms. National news is dramatically coloured by domestic interests and makes a clear distinction between domestic and foreign reports. Weather forecasts reinforce awareness of the country's varied geography and its borders, while sporting heroes embody national virtues and collective loyalties. In moments of crisis, such nationalist content is particularly strong, with its rhetoric of common values and generalizations about national history.[38] Superheroes are particular embodiments of these tendencies, tendencies so prevalent and embracing that they render the superhero far more real in the mythologizing consciousness than any routine fable or tall story.

The Fabric of Superheroes

Given that superheroes themselves are an aberration of normalcy, it follows that their costumes should echo this difference. While Superman may be impervious to bullets, for some unexplained reason, his suit is as well. It is also always clean (except, as mentioned, when he is in a state of decline or injury). In the 'prosthetic' mode, as with Batman and above all Iron Man, the suit is the site of all manner of technological appendages and add-ons that are purpose-made and unique to the user.[39]

Tight, figure-hugging fabrics were introduced in the late 1950s, with synthetics such as elastic Lycra developed in 1958, with the effect of revolutionizing the superhero almost overnight. Superheroes in television and film were clad in such fabrics with resilient 'stretch and recovery' qualities that were also lightweight, colourful, and repelled moisture.

Lycra streamlined the figure's silhouette and was also suggestive of a surface that reduced friction in the high-velocity travel through water or air. In his detailed analysis of the Superman costume, Michael Carter cites three factors that shape the costume. 'The most immediate of these is streamlining—the distinction between corporeality and clothing is eliminated in favour of a condition of 'clothed nudity'. This is his 'inner form' that has fused with his outer appearance'.[40] The second aspect is functionalism, which is to be understood not as 'the fully articulated aesthetic philosophy of high art and design, instead a vague 'feeling' that certain forms—architectural, sartorial, etc.—were somehow able to achieve increased efficiency by taking on a certain look'.[41] Finally, there is the 'covert nature' between Superman's appearance and that of Clark Kent: the shift 'enacts a move from the present into the future', where Superman's costume 'violates [the] modernist sartorial aesthetic, or at least that part of the aesthetic which applied to real clothes'.[42] It is a violation that is eternally unstable, however, since Superman *qua* Superman must be tied to a cause, and therefore a relatively rigid and identifiable system of belief. If this relationship is destabilised then his very probity and purpose are called into question, and his status as a hero abruptly tips to that of criminal, as seen in *Batman vs. Superman*.

What is common to almost all superhero origin stories is that the suit simply appears, and its design, nature, and shape is on par with the ontogenesis of the character himself. But the inner reasoning of it remains a mystery, retaining an element of magic, for like the character, it is outside the realms of the circumstantial and the rational. The mystery of the superhero costume is satirised in the Pixar film *The Incredibles* (2004) where Edna Mode, the 'fashion designer to the superheroes' speaks of the future of smart-fibre technologies for the purpose of smart superhero costumes for the contemporary superhero. She tells Elastigirl that 'your suit can stretch as far as you can without injuring yourself and still retain its shape'. It is 'virtually indestructible...yet breathes like Egyptian cotton. As an extra feature, each suit contains a homing device, giving the precise global location of the wearer at the touch of a button'.[43] The fabric is highly sympathetic, implausibly so.

But her 'sell' is just an exaggeration of recent major developments in fabric technology. As with the whole-body condoms used by swimmers, and the opaque tights by runners, they reduce friction and raise performance. Nano-technology promises performance-enhancing qualities as well as control mechanisms such as vitamin, perfume, or steroid release. The aerosol spray-on Fabrican is now used in the fashion industry to produce heavy-duty street wear, while Kevlar or Tyrek-infused fabrics are used to produce light-weight, practical clothing that is also very durable. In many respects, superhero fashion conjoins fantasy with the developments in reality.

Everyone's a Superhero: Role-Play and Cosplay

At the beginning of this chapter we distinguished superheroes from the other make types discussed in this book, citing the rather self-evident fact that unlike the others, superheroes do not exist, or exist in the same way. For in their unreality they tend to expose the way in which all male types are made possible by imaginary constructs. It is the practice of co-splay that drives home this argument. To don a cowboy hat or military drills, if it may be considered dressing up, it is still to occupy a particular place in the fashion landscape, for one can still interact on everyday levels with these on. However to wear a superhero costume in public as part of the passage of everyday life is something altogether different and indeed absurd. Or was: for in the new millennium there has been a growing incidence, although still rare, of real-life superheroes.

To enter into the online community assembled under the *World Superhero Registry* is to uncover an astonishing array of superheroes with their attendant taxonomies and justifications.[44] The 'real-life' su-perheroes began largely in the US but have spread to the United Kingdom and Europe and on to Hong Kong. The characters include 'Death's Head Moth', active in Virginia, 'Ghost' active in Utah, 'Geist' active in Rochester, and 'Green Scorpion' active in New Mexico and Arizona. There is even an 'environmental activist', 'Captain Ozone' active in Belfast and Dublin. Many of them are listed together with their websites that de-tail their various affinities and activities. While highly dubious and often considered more menace than blessing to official law-enforcement, the language of superheroes, by now universal, is publicly greeted as serving the greater good. Scanning the registry will quickly reveal that the peo-ple behind these costumes are relatively ordinary people, with ordinary bodies, yet it is hard to argue the extent to which these costumes and these new constructed personas deliver to them an abstract power. As Brownie and Graydon remark, 'They have generated a lucrative industry in costume and weapon manufacture. Customized costume creators such as Atomic Hero Wear are commissioned to produce costumes with all the hallmarks of the superhero wardrobe'.[45] These costumes are made to be reminiscent but independent of those found in mainstream popular fictions, their owners assuming a seriousness to their adopted missions that they actively disassociate from cosplay.

This does not mean that the history of dressing up as superheroes should not be dismissed. In fact it does have its own small but still signif-icant history. Owing to the constraints of the Depression and the Second World War, neither of which were conducive to fantasy or fancy, the first instances of dressing up a superheroes were in the 1960s. It is a tendency that can be seen as part of the complex changes US society precipitated by the surge in its economy in the decades after the war. By the 1960s comics had their own independent cultures, which included discrete

stands in drug stores and newsstands, and ultimately whole stores devoted to them and associated memorabilia and collectables, an economy thriving today. The introduction of colour television in the 1950s created an even wider fan base in which many adherents were disposed dress as their favourite heroes: Batman in the 1960s, and in the 1970s, characters from *Star Trek* (like Dr Spock). It largely agreed that this popularity and visibility of dressing up in North America gave Japanese fans the urge in the 1980s to dress as their preferred manga heroes, while others attribute the origins of cosplay to Japan.[46]

Cosplay—costume play—comes as a translation from the Japanese, *kosupure*, by Takahashi Nobuyuki after attending World-Con, a sci-fi convention in Los Angeles in 1984. Founder of the anime publishing company Studio Hard, Takahashi was immediately struck by the number of people in fancy dress, and the sophistication and apparent authenticity of many of the costumes. Starting with 'costume play', (to distinguish the term from 'masquerade' whose Japanese equivalent translates to 'aristocratic costume party'), the term soon conjoined to become 'cosplay', and its participants became 'cosplayers'.[47] It was also around this time in the mid-1980s that manga began to have growing prominence in North American markets. Another term that the Japanese devotees like to use was *otaku*, a special devotee of a particular fictional line and aesthetic. They and their North American counterparts began to intermingle with rising frequency, with discernibly hybrid cultural effects: a hybrid manga Batgirl is now nothing new, and very much a cause for celebration, and if the outfit is good enough, veneration.

What cosplayers and so-called real-life superheroes (RLS) have in common—and this is a comparison that many of the latter will find painful—is through the analogy of dragging. Dragging can occur by various degrees, and like both cosplayers and RLS, it is a festive action, entailing the gratification of desire, or *jouissance*. In all instances, it is means of engaging in otherness so as to remake and resituate the self into a site of belonging. That belonging can be to an outside group or in order to satisfy an inner psychic model. Dragging is used in both specific and more general ways to refer to identity alteration through dressing up and masking. Masking can involve make-up as a replacement for the physical mask itself. What RLS and cosplayers also share with the drag king/queen is that they engage in measures and gestures in the attempt to bring something imaginary and non-existent into existence, and hence to give life to something different and deemed 'unnatural'. Dragging is also quite a conformist practice, dependent on consensual paradigms of appearance and deportment. It is barely conceivable, for example, for a drag queen to want to emulate a butch lesbian since it would defeat the point of the gender reversal that s/he wishes to play out. These identifiable, but still unstable, fixtures of identity and gender are conjoined to tropes that relate to narratives. These narratives, either directly alluded

to or merely suggested, supply the 'script' for the dragger's actions and tastes. The associated narratives mobilise character traits, and, indeed to mobilise the self. RLS reveal the need to complete deficiencies in their own nature by transformation, which is either a complete or supplementary identity. And although the RLS is swift to draw lines of distinction between himself and fictional heroes, the tie is always there in the language of the costume itself, in the act of transformation, and the weddedness to a narrative (origin story, tales glory, etc.)

Who Does Batman Bat For?

The discussion of dragging brings us to the hoary question of the superhero's sexual inclinations. Each superhero film results in innumerable queer parodies, so much so that these are *de rigueur*. Such reactions are normal psycho-social responses to identities that purport to sexual inclinations that are self-evident and unwavering. The radical queering of brute masculinity by Tom of Finland, discussed in Chapter 4, is a signal instance of this. Queer culture is poised to ridiculing and defiling anything that smugly and too self-evidently espouses heteronormative values. Then there is also the superhero's otherness—in terms of strength, biology, birth, or disposition—to consider. One of the countless online parodies of *Batman vs. Superman* takes a still sequence from when Clark Kent (in 'disguise') speaks to Bruce Wayne (in mufti) at a cocktail party: Clark says to Bruce, 'Technically speaking I'm an alien'. The still from camera two has Bruce's face (Ben Affleck) as solemn. Then Clark says, 'So it won't be gay sex', whereupon Bruce's face breaks into a smile.

In observing the vicissitudes of the various superheroes, their dalliances, mishaps, and falls from grace form part of the grander narrative, which is understandable, as that is what is needed to sustain interest: the hero on the physical brink is also brought to a moral threshold as well. So while it may seem given that there is never any doubt concerning the sexuality of the masked heroes—since their sexuality must perforce reflect the mainstream values that they protect and uphold—the issue is far from watertight. The first Batman played by Adam West in the television show of the late 1960s is frequently cited as high camp. It proved to have a lasting and strong effect on the image of the camp image of Batman as camp, and, outside of the good-guy-wins-all construct, as someone rather harmless as cute. But that is not where the queering of Batman ends, for to be queer is not to be an insider. Bruce Wayne's status as corporate mogul belies his psychological torment, his obsessiveness, and his isolation (in the Dark Knight version of him, at least).

For Batman's role as an outsider and the lengths he goes to keep his identity secret has made his sexuality an issue of lively contestation. In both speculation and in representation, he has wavered between the fierce and the aloof. In the earliest years of his 'life', he was as fearsome

as the villains whom he pursued, at one point he carried a gun.[48] But as Andreas Reichstein points out, the first change in Batman occurs with the entry of Robin, 'giving the thus far sinister vigilante some responsibility, as he is now a mentor and protector'.[49] They featured together in a film serial in 1949, but it was not until 1966 that Batman enjoyed widespread acclaim. But by this time, comic culture had suffered a series of setbacks, such as in the 1950s by the psychiatrist Frederick Wertham who published a book, *Seduction of the Innocent* (1954) that argued a connection between comics and juvenile delinquency. This was not limited to violence. Wertham professed to seeing through the relationship between Bruce Wayne and Dick Grayson (Robin), who lived harmoniously together in the mansion, arguing that this was no more friendship but a homosexual partnership.[50] Reichstein writes that Wertham painted the relationship as a veritable 'homosexual's dream' of cohabitation.[51] Wertham claimed not to have reached this conclusion on his own, but from confessions from homosexual patients who envisioned themselves as Robin.[52]

Views such as these exerted such a considerable influence that Robin soon vanished from the annals of the Batman, whose successive sidekicks—Bathound, Bat-mite, Batwoman, and Batgirl—were innocuous or did not put his sexuality in question.[53] The key point is not that Batman is gay per se, but that questions regarding his sexuality had surfaced at relatively early stage in his development. In his essay 'Batman, Deviance and Camp', Andy Medhurst admits that as 'Crazed as Wertham's ideas were, therireffectiveness is not in doubt'.[54] The controversy surrounding this relationship also showed how strongly invested the public was in characters that were wholly fictional.[55] After the 1960s Batman experienced what Medhurst calls a 'painstaking re-heterosexualization'.[56] But all was not over, for the entry of the Joker in the 1980s re-introduces camp, which is now represented as the queer Janus-face to Batman's heterosexuality. At the nub of their rivalry is a psychological tension that they were both born of unwonted violence. 'The Joker is Batman's 'bad twin', and part of the badness is, increasingly, an implied homosexuality'.[57] It is a perspective that proves consistent when the Joker returns most memorably in *The Dark Knight* where, as Medhurst states,

> the Joker has become the parody of the screaming queen, calling Batman 'honeypie', given to exclamations like 'oooh!' (one of the oldest homophobic clichés in the book) and pinching Batman's behind with the advice, 'loosen up, tight ass'. He also, having no doubt read his Wertham, follows the pinching by asking, 'What's the matter? Have I touched a nerve? How is the Boy Wonder? Started shaving yet?' The Bat-response is unequivocal: 'Take your filthy hands off me...Filthy degenerate!'[58]

If there be no doubt as to Batman's inclination at first, it is certainly stained by the fierceness of his homophobic response. The label of 'degenerate' is also fresh in the minds of gay men who lived through the AIDS scourge at its worst when they were branded as plague carrying 'degenerates'.[59]

Whether or not one entertains interest in queer readings is not really the issue, since there are always rogue and alternate readings offered to anyone who wants to search the Internet. What cannot be ignored is the vulnerability that superheroes have to these alternative readings, once again emphasizing the porosity of any given sexual persona, and especially those that exist at the margins of the mainstream. Nicki Phillips and Stacie Srobl take up the issue with queering of the superhero in recent years, but argue that it is still not an expanded field, the revisionist superhero is an exception, where the exceptions are largely limited to the relative goodness or badness, not his (or her) other inclinations. They see

> comic books as cultural artifacts illustrating the intersection among sexual orientation, gender, victimization, and crime fighting. This becomes particularly important given that mediums such as comic books can be considered a reflection of broader social contexts—gendered and hierarchical patterns that are particularly pronounced due to the graphic nature of the medium. Put simply, along the path of justice these characters operate in the context of the male, white, heterosexual realm, with women primarily portrayed as young, sexual objects in need of protection.[60]

They cite numerous examples of powerful and semi-powerful women of contemporary superhero comics, such as Jessica Jones or Sharon Carter, who both end up protected by dominant men (Luke Cage for Jessica and Captain America for Sharon). Infantilism is explicit when the messiah of the mutant race, baby Hope is protected by the brawny, hypermasculine hero Cable.[61] Other queer-oriented readings, such as those of the *Fantastic Four,* focus on giving birth to mutants and the odd family unit, however the gay and lesbian content is still heavily metaphoric, not to say remote.[62] Gay characters that have been written into stories in recent years, such as Green Lantern's assistant, is 'not met without resistance'. For as Phillips and Strobl contend, 'Though the presence of these characters arguably represents a certain degree of acceptance of diversity, there remains a tension around the portrayal of gay characters as crime fighters'.[63] When gay characters are at the centre of the story, such as the cowboy comic *Rawhide Kid: Slap Leather*, the reactions are largely negative owing to what is seen as a limp-wristed stereotype of homosexuality.[64] It is as if the superhero genre, as a language with its accepted diegetic and formal attributes, cannot manage overt queer content, much as an action movie cannot be arthouse at the same time.

In many ways this brings us back full circle to the beginning of this chapter, where we stated that notwithstanding the exceptions, the superhero and the genre is primarily a male domain. When women appear, they are there for combat (which have also led to corollaries about the women's movement),[65] but the struggle is with an undeniably male script, and without violence one's career as a superhero is apt to be over.[66] Yet it is also this very primacy that exposes it to aberrations, and which make the aberrations—within the genre or in rogue and random parodies—all the more conspicuous. For it is in this ostensible impassibility that the slippages, such as camp or overcompensation (as for those RLS), rise to the fore.

Notes

1 See also Vicki Karaminas, "Übermen: Masculinity, Costume and Menaing in Comic Book Superheroes", in Peter McNeil and Vicki Karaminas eds. *The Men's Fashion Reader* (Oxford and New York: Berg, 2009), 179–186.
2 This notwithstanding that Batman and Iron Man are 'mere' mortals.
3 "A Psychoanalysis of Bruce Wayne", www.youtube.com/watch?v=eRlbV8t NILg. Accessed 23 May, 2016.
4 See Friedrich Weltzein, "Masque-ulinities: Changing Dress as a Display of Masculinity in the Superhero Genre", *Fashion Theory* 9, no. 2 (2005): 229–250. Weltzein states that the first association of masculinity with masquerade was by Paul Hoch, *White Hero—Black Beast. Racism, Sexism, and the Mask of Masculinity* (London and New York: Pluto Press), 1979.
5 Ibid., 242.
6 Ibid., 246.
7 Heavy water is water that contains a larger amount of 'heavy hydrogen' or hydrogen isotope deuterium. An earlier version of the Flash origin story has the substance as hard water vapour, water made from calcium and magnesium carbonates.
8 Andreas Reichstein, "Batman–An American Mr Hyde?", *Amerikastudien/American Studies* 43, no. 2 (1998): 329.
9 Lorna Jowett, "Not Like Other Men'?: The Vampire Body in Joss Whedon's 'Angel'", *Studies in Popular Culture* 32, no. 1 (2009): 37–51.
10 Paul Zehr, *Becoming Batman* (Baltimore: Johns Hopkins University Press, 2008), 9.
11 Barbara Brownie and Danny Graydon, *The Superhero Costume: Identity and Disguise in Fact and Fiction* (London and New York: Bloomsbury, 2016), 49.
12 *Batman Begins*, dir. Christopher Nolan, DC Comics, 2005.
13 Ibid., 23.
14 Mikhail Bakhtin, *Rabelais and His World*, trans. Helene Iswolsky (Indianapolis: Indiana University Press, 1984), 40.
15 Toby Wilsher, *The Mask Handbook: A Practical Guide* (London and New York: Routledge, 2006), 12. See also Ibid., 27.
16 Brian Cremins, "'What Manner of Man is He?': Humor and Masculine Identity in Captain Marvel's World War II Adventures", *Studies in American Humor* 27, no. 3 (2013): 34.
17 Ibid., 41ff.
18 See Jeffrey Brown, "Comic Book Masculinity", in Charles Hatfield, Jeet Heer and Kent Worcester eds. *The Superhero Reader* (New Orleans: University

Press of Mississippi, 2013), 274: 'Rather than espousing the reductionist hypermasculine might-makes-right norm of the Image books, Milestone's series continually depict heroism as a matter of intelligence first and power second, showing that, in fact, intelligence *is* the greatest power of them all. For black readers, and for nonblack readers sensitive to minority concerns, the alternative depiction of *black* masculinity bearing the attributes of both mind and body is, as one fan declared, 'progressive, realistic, radical, and a much needed reworking of the African American image in the media.' although it is clear how the static tale recounted here stresses the reincorporation of 'a brain ... and a plan' as more significant than muscles and brute force, its typical comic book superhero*ish* narrative might seem to undercut any claims made about it representing new forms of masculine ideals. It is, after all, still a relatively straightforward comic book story about two superpowered, costumed characters fighting it out'.

19 Stefano Predelli, "Superheroes and Their Names", *American Philosophical Quarterly* 41, no. 2 (2004): 107–123.

20 Jacques Lacan, "La signification du phallus", *Écrits II* (Paris: Seuil, 1971), 103–104.

21 Ibid., 104.

22 Ibid., 112.

23 Ibid., 114.

24 Slavoj Zizek, *Less than Nothing: Hegel and the Shadow of Dialectical Materialism* (London and New York: Verso, 2012), 596.

25 Claude Lévi-Strauss, *The Way of the Masks*, trans. Sylvia Modeleski (Seattle: University of Washington Press, 1988).

26 Zehr, *Becoming Batman*, 263.

27 *Batman v Superman: Dawn of Justice*, dir. Zack Snyder, RatPac-Dune and DC Entertainment, 2016.

28 Michel Foucault, *Politics, Philosophy, Culture: Interviews and Other Writings, 1977–1984* Lawrence Krtitzman ed. (London and New York: Routledge, 1990), 153.

29 Whitney Crothers Dilley, "The Ultimate Outsider: Hulk", in *The Cinema of Ang Lee* (New York: Columbia University Press, 2015), 134–146.

30 Markus Oppolzer, "Gothic Liminality in V for Vendetta", in Matthew Green ed. *Alan Moore and the Gothic Tradition* (Manchester: Manchester University Press, 2013), 103–117.

31 Brownie and Graydon, *The Superhero Costume*, 98.

32 Andrew Bolton, *Superheroes. Fashion and Fantasy*, The Metropolitan Museum of Art (New York, New Haven and London: Yale University Press, 2008), 47.

33 Vicki Karaminas, "Übermen: Masculinity, Costume and Meaning in Comic Book Superheroes", in Peter McNeil and Vicki Karaminas eds. *The Men's Fashion Reader* (Oxford: Berg, 2009)pp 169-210.

34 Tim Blanks, "Walter and the Bears", *Dream the World Awake*, Exhibition Catalogue (Belgium: Lanno Publishers, 2011), 97.

35 See Danny Fingeroth, *Superman on the Couch: What Superheroes Really Tell Us about Ourselves and Our Society* (London and New York: Bloomsbury, 2004), 17.

36 S. Botzas, "Biff! Bang! Pow! Captain America Enlists to Fight for Bush in Iraq", *Sunday Herald* London, 14 November, 2004.

37 Kevin Smith, "A Superman for All Seasons", *TV Guide*, USA, 8 December, 2001, 24.

38 Michael Billig, *Banal Nationalism* (London: Sage, 1995).

39 See also Jon Hogan, "The Comic Book as Symbolic Environment: The Case of Iron Man", *Review of General Semantics* 66, no. 2 (2009): 199–214.

40 Michael Carter, "Superman's Costume", *Form/Work: An Interdisciplinary Journal of Design and the Built Environment* 4 (2000): 31.
41 Ibid.
42 Ibid.
43 *The Incredibles*, dir. Brad Bird, Walt Disney Pictures, 2004.
44 www.worldsuperheroregistry.com/world_superhero_registry_gallery.htm.
45 Brownie and Graydon, *The Superhero Costume*, 123.
46 Theresa Winge, "Costuming the Imagination: Origins of Anime and Cosplay", *Mechademia* 1 (2006): 66. See also M. Bruno, "Cosplay: The Illegitimate Child of S F Masquerades", *Glitz and Glitter Newsletter* Millennium Costume Guild. October, 2002; http://millenniumcg.tripod.com/glitzglitter/1002articles.html. Accessed September 2015.
47 Winge, Ibid., 66–67.
48 Bob Kane, *Batman & Me* (Forestville: Eclipse Books, 1989), 45. See also Reichstein, "Batman–An American Mr Hyde?", 331.
49 Reichstein, "Batman–An American Mr Hyde?", 332.
50 Frederic Wertham, *Seduction of the Innocent (1954)* (Port Washington, NY: Kennikat Press, 1972).
51 Reichstein, "Batman–An American Mr Hyde?", 333.
52 Wertham, *Seduction of the Innocent*, 192.
53 Reichstein, "Batman–An American Mr Hyde?", 333.
54 Andy Medhurst, "Batman, Deviance and Camp", in Charles Hatfield et al. eds. *The Superhero Reader* 241.
55 Ibid., 240.
56 Ibid., 247.
57 Ibid., 248–249.
58 Ibid., 249.
59 Ibid.
60 Nickie Phillips and Staci Strobl, *Comic Book Crime* (New York: NYU Press, 2013), 141.
61 Ibid., 143–144.
62 Ramzi Fawaz, *The New Mutants: Superheroes and the Radical Imagination of American Comics* (New York: NYU Press, 2016).
63 Ibid., 154.
64 Ibid., 154–155.
65 For an account of female action heroes and the Women's Movement, see Mollie Gregory, *Stuntwomen: The Untold Hollywood Story* (Louisville: University Press of Kentucky, 2015).
66 In the words of Noah Berlatsy: 'A superhero can spend an issue chatting with teammates in the pursuit of character development rather than villains. Superheroes such as Wonder Woman or Grant Morrison's Animal Man2 may prefer to settle conflicts without bloodshed when they can. But a superhero who eschews violence in every case is in serious danger of ceasing to be a superhero—either diegetically or through the extranarrative doom of cancellation'. *Wonder Woman: Bondage and Feminism in the Marston/Peter Comics, 1914–1948* (New Brunswick: Rutgers University Press, 2015), 75.

8 Gangstas

In the year 2000 there appeared an article the journal disseminated by the Council for Exceptional Children of the US entitled "'Gangstas' in Your Classroom: How to Recognize Them and What Teachers Should Know".[1] The sense of alarm in the title reads like a warning against some primal contagion, or the onset of some congenital condition. For the decorous and law-abiding teacher, the gangsta is a seen a scourge. The article clearly maps out the attributes of this particular postmodern subculture. Gangs confine themselves to their own race—be it African-American, Hispanic, Southeast Asian, or white/caucasian, and grow out of particular neighbourhoods, or *barrios*. Insurance to their loyalty to one another is through the ritual of '63', a number devised after six sides of a star and three prong of a pitchfork, where members of the gang all take turns to beat an initiate for 63 seconds. The ritual is completed once the initiate completes some criminal act, such as snatching a bag, stealing from a store, a joy ride, or a random act of violence.[2] For the physical signs of a gangsta the authors compile a neat summary:

> Gang members may use hand signs, clothing, shoelaces, shoes, jewelry, tattoos, or hat/cuff/sleeve/belt/tongue of shoe/bandanna/glove/earring with a right or left-side orientation, and designs or symbols cut into or painted into their hair. Slang language is used to identify their own gang members in contrast to rival gangs. Usually these symbols/identifiers are openly displayed, but in school or at home, these items may be covertly displayed. Graffiti, gang nicknames, or symbols may be written inside hats or clothing, even under the lining of the rim of a hat. Tattoos may be on arms, legs, back, between the thumb and forefinger or even the face....
>
> The Star of David is used as a symbol, in graffiti and jewelry to honor David Barksdale, a drug dealer and founder of the Black Gangster Disciples, who was known as King David. Other signs such as crosses, crowns, wine glasses, stars, hearts, pitchforks, canes, moons, pyramids, and numbers are used as symbols to identify specific gangs. These signs and symbols may change over time.[3]

To any member, aficionado, or student of subculture, these signs share some commonalities with punk, especially in their brutality, but there are also clear differences, which, if anything, boil down to race, as the predominant gangsta is black or Hispanic. While both punks and gangstas were born of economic disenfranchisement and urban disillusion, the majority of gangstas were also subject to the multi-generational depredations of racial discrimination as well. And because gangsta culture is clan related, their identifiers, from clothing, to body markings, to gestures are highly encoded, ceremonialised, and stylised.

According to Tasha Lewis, rap music, also known as hip-hop, emerged as part of African American and Latino gangs in the Bronx, New York, during the 1950s and 1960s.[4] (Note the presence of the word 'hip' which is taken from 'hipster'.) It eventually spread to Brooklyn and across the United States, and with it came its music, style diatribe, and fashion. By the 1980s, hip-hop had diversified in its style and had become a global phenomenon. At first, hip-hop style included sports labels such as Adidas, Reebok, Puma, Timberland, and Converse. It would later draw from 'preppy' designer label Tommy Hilfiger's collegiate garments, such as chinos and polo shirts. Baggy jeans, puffer jackets (oftentimes customised with gang names and insignia), baseball caps, sneakers, and hooded jerseys were all popular garments that blended together to form the early hip-hop style. As hip-hop music diversified in the 1990s, brands such as Phat Farm, Sean John, and Rocawear, became allied to it. As branded clothing became popular in the '80s, Harlem tailor Dapper Dan reappropriated luxury European fashion brands Louis Vuitton, Gucci, and Fendi with his own trademark, what he called 'a macho type of ethnic ghetto clothing'.[5] Using expensive fabrics such as mink, chinchilla, ostrich, crocodile, and python, Dapper Dan's garments became status symbols for disenfranchised black American youth.

This chapter examines the gangsta rapper as a form of masculine style of rebellion and resistance beginning with the zoot suit as the progenitor of early gangsta fashion. Although rap and its subgenre, gangsta rap, are styles of resistance, gangsta rap is differentiated by the former, primarily by its style politics that reflect gang affiliations with impoverished urban youths, such as the Bloods and Crips of Los Angeles. It is also worth noting that this chapter is in many ways the obverse, or flipside of the previous chapter on superheroes. With the exception of the only very recent introduction of black superheroes into the film and comic genre, the superhero in his genesis and development in the mid-twentieth century, and his generic identity is pre-eminently white. Leaving aside the consideration that superheroes are more fictional than real (although as well as RLS, we also established their symbolic (phallic) significance), both identify as predominately male and straight. Both are combative and vouch for a cause without which they are diminished (castrated). Both are enlisted to causes that enshrine some kind of narrative and are linked to myths of origin and belonging.

'Ghettocentricity' and Street Cred

Like all subcultures, hip-hop and its subgenre, gangsta rap, entails the assemblages of body adornment, including accessories, hairstyles, and garments (as well as shared music, ideologies, and argot) to create an identifiable style. The relation between these elements of styling practices produces a system of signs that creates meaning, what Carol Tulloch calls 'style narratives'. Although the relationship between the objects (sign) and its meaning (signified) is arbitrary, motivated only by social convention, the meaning produced (in this case the gangsta rapper) is embedded with knowledge and power. The style practices of the African diaspora, writes Tulloch, are a form of agency that are 'part of the process of self-telling, that is to expand an aspect of autobiography through the clothing choices an individual makes'.[6] In her study of the style narratives of the African diaspora, Tulloch creates an analytical frame that she calls 'style-fashion-dress' to interpret the system of concepts that signifies the meanings and frameworks that are implicit in dress studies methodologies. Tulloch uses the term 'style' in her matrix to denote agency. When applied to the groups of people that were formed outside of Africa (due to the effect of imperialism and colonialism), a consideration of transnational spaces needs to be accommodated in order to understand the formation of new identities. Such an approach, argues Tulloch, 'can lead to a more balanced understanding of the style-fashion-dress practices of black people as a comment on a sense of self in contested situations and contested spaces'.[7] Using Tulloch's analytical framework, hip-hop extends on African and Latino precursors of style-fashion-dress by engaging in the appropriation of everyday garments and accessories (sports-wear and high end fashion brands) to produce meanings of group affiliation, visibility, and territoriality.

In the same vein, Chandler and Chandler-Smith argue that African idiomatic style maintains cultural continuities through the concept of bricolage and black fashion imagination, what they call 'things African'. They argue that 'contemporary hip-hop recirculates its own internal ethnic traditions in a wider black fashion system' to produce continuity of memory and a sense of shared space and belonging.[8] Gangsta attire signals affiliation and territoriality across Afro-Latino imaginary spaces, particularly spaces of poverty and neglect, such as the ghetto, what Chandler and Chandler-Smith call 'the underworld womb of hip-hop'.[9] This transgressive space of transcultural urban identities uses music, language, and dress codes to articulate social resistance by producing new meanings of style (read *agency* here) whilst maintaining links to African prototypes of costume and performance, what Chandler and Chandler Smith describe as 'ghettocentricity'. Ghettocentricity and *pachuco* culture 'got into the dress codes of white male status and normality, playing with the images of an Anglo popular culture's own masculine

'outsiders' – the Southern dandy, the Western gambler, the *modern urban gangster*.... and ruptured their structures of Otherness'.[10]

Since the establishment of cable television and MTV (music television) in the 1980s, hip-hop subculture has been co-opted by the media, fashion, and marketing industries to mass produce the violent and negative aspects of ghetto life: poverty, drugs, crime, and institutional incarceration. Hip-hop performers such 50 Cent, Snoop Dog, Eminem, and the promotion of their dress code as 'players'—oversized white T-shirts and baseball jerseys, baggy pants, reversed baseball caps, and coloured bandannas—have come to represent a visual language that is bound up with notions of 'street cred'. Stereotyped masculine roles including the 'player' or the 'pimp' are promoted through stylised dressing and sexualised body language, 'in which Armani and Gucci suits, alligator shoes and custom-designed hats and jewelry'[11] come to signify conspicuous consumption, status, and affluence. It represents a call to leisure and lubricious hedonism that is an outward fillip to austere, white Protestant values.

Early Gangstas Style: Pachucos and the Zoot Suit

Anyone with some familiarity with early film noir will know that there were no consistent determinate factors for the gangster and the criminal. He was dressed either in a different shade to distinguish him from the good guy (something more or less required in black and white films), or was more dishevelled, to reflect his dissolution. However, at the same time as the emergence of film noir in the 1940s, there arose a particular and unmistakable fashion among Latino men in California who called themselves *pachucos*. Originating in Texas and Mexico, the *pachuco* appeared as a kind of streetwise playboy who prided himself in his careful grooming and flamboyant appearance. Wearing a pork pie hat, baggy trousers, brogue shoes that were more often than not duo-tone black and white, the most noticeable and lasting feature of their appearance was the zoot suit, a long, flared coat gathered at the waist, originally discussed in Chapter 3. The female counterpart was the *pachuca,* who has received relatively little attention,[12] for the main reason that the *pachuco* was not irreducible to a suit, but rather participated in acts of social subversion that were either reactions to victimisation or just plain crime.

In the war years of the 1940s, the suit ceased to be linked to a person or character, but rather assumed a universal status for those who wore them. In days of austerity following the First World War and then the Depression, to wear an excessive amount of cloth was to make a very recognizable comment about one's own entitlement and the position toward authority. The zoot suit, as Eduardo Deanagán remarks, 'was a fad that pushed at the edges of social convention, playing on fashion mores by mixing gender styles and flaunting consumption beyond the unspoken

limits of tolerance'.[13] With its distinctive silhouette that inched toward resembling a dress, it was a rebarbative garment that enshrined more than a style, it represented a socio-political assertion of the need for proper recognition. It was also not uncommon for suits to be cut from cloth with vivid colours, such as bright blue or purple, or be of dramatically dazzling patterns, from unmissable plaids to strong stripes.[14] Visibility was at a premium since an eccentric, and to many, undesirable form of dress was also to ensure that one was unquestionably inserted into the culture that wanted the opposite, which was (and is) conformity and silence. This means that dress and personal identity are central to the performative values of resistance on a day-to-day level.[15] To understand the zoot suit is thereby to understand other sartorial phenomena, such as 'bling' (ghetto fabulous), all of which are not just adornments or adjustments, but are worn as emblems and a form of armour whose violence is figurative rather than literal, but whose threat is still very real.

The zoot suit came to mean more than sartorial decadence and exhibitionism, it became the first, most uniform example of what we now refer to as subcultural street style, in which clothes are enlisted to express urban discontent and cultural defiance. In the words of Stuart Cosgrove:

> The zoot-suit is more than an exaggerated costume, more than a sartorial statement, it is the bearer of a complex and contradictory history. When the nameless narrator of Ellison's Invisible Man confronted the subversive sight of three young and extravagantly dressed blacks, his reaction was one of fascination not of fear. These youths were not simply grotesque dandies parading the city's secret underworld, they were 'the stewards of something uncomfortable', a spectacular reminder that the social order had failed to contain their energy and difference.[16]

The zoot suit became the sartorial signifier of this difference, expressing the ambivalence of the *pachuco*, a class of men of Mexican origin in North America. Deracinated from their heritage, but not fully admitted into the present culture, the zoot suit was a way of registering their unease and their non-submission. In the words of the essayist and poet Octavio Paz, the zoot suit was

> 'the only way he can establish a more vital relationship with the society he is antagonizing. As a victim he can occupy a place in the world that previously ignored him; as a delinquent, he can become one of its wicked heroes'.[17]

The suit zoot was a mechanism of struggle and defiance, which meant that it did not take long for it to become associated with crime.

Such associations were not without substance. With America's involvement in the war in 1942, those not born into white privilege were in for a harder than normal time. Many Japanese Americans, for instance, were locked away on the grounds of mere suspicion. But the range of severe and extreme measures only heightened the atmosphere of racial foment. And as Luis Alvarez explains, the body as a tool and a signifier of resistance played a particularly salient role:

> Despite racial, regional, and gender differences among zoot suiters, their struggles for dignity linked them to class, where class functioned not just as a predefined group of people identified by similar relations of subordination or exploitation to capital but also as a group based on members' *insubordination* to domination.[18]

The zoot suit was therefore a kind of pan-racial uniform that stressed the need to place the wearer at odds with a repressive and blinkered status quo, and a reminder that power relations were unjust and unequal. 'Zoot suiters', Alvarez remarks, 'were not simply metaphors for the political agendas of others; rather they practiced their own cultural politics that, if examined carefully, can teach us a great deal about how seemingly powerless populations craft their own identities and claim dignity'.[19] In many ways zoot-suiters belonged to a special masonic code that was public rather than private, and underprivileged rather than privileged.

The climax of these tensions occurred in Los Angeles on 3 June 1943. While the city was experiencing a blackout, 50 sailors from the naval Reserve Training School ripped through Mexican American neighbourhoods, stripping off the zoot suits worn by young male civilians. Their actions sparked what came to be called the Zoot Suit Riot. Eventuating in a week of chaos, the occasion escalated as thousands of military personnel flooded into Los Angeles. The authorities made no effort to stop the servicemen, instead jailing hundreds of young men, the offended parties who were mostly Mexican Americans. Both parties, sailors and zoot-suiters, viewed themselves as the victims of the riots, whose chief effect was to drive an even thicker wedge between racial groups.[20] In the words of Pagán, 'The vast majority of scholarship since that time has followed suit in de-scribing the Zoot Suit Riot as a pogrom against the Mexican American community and attributing the riot to negative reporting, anti-Mexicanism, or wartime anxieties'.[21] The problems had been gestating for many years and were exacerbated by the Great Depression. From at least the 1930s onward, young Mexican Americans were referred to as simply 'Mexicans' or '*Pachucos*'. At the time, '*Chican*' was reserved for recently arrived Mexican immigrants in barrios.

It was more than just a riot. It brought to a head competing sensibilities, races, and, in a more abstract but powerful way, ways of life. In the

longer term it led to more concerted examination of Mexican communities in the US and the racial intolerance to which they were the brunt, a problem that is just as bad, if not worse, today. Even the Mexican government demurred to take action immediately after the event, suggesting that they, too, viewed the purportedly offending Mexican American subcultures as unworthy of recognition.[22] At the time, neighbourhoods that bore the brunt of the violence were populated by segregated communities where Mexican American and African Americans interacted, and who had, as a result of this forced separation, began to show visible signs of culture distinct from their white counterparts. They were all scarred by traumatic memory of some kind: the ongoing suppression that African Americans continued to feel despite the abolition of slavery, while many of the Mexican American youths were the progeny of refugees from the Mexican Revolution. While their parents still cherished their Mexican heritage, these youths consumed a heady diet of jitterbug and swing, played by Jewish and African American musicians.[23] They even spoke a distinctive dialect, *Calo*, an inventive combination of English and Spanish. 'Undoubtedly', adds Richard Griswald del Castillo, '*pachuquismo* had its origins in poetry and racism, and Pachuco gangs were bound to territories as much by discrimination as by love of the barrio'.[24] The mixture of 'poetry and racism' plus the 'love of the barrio' goes a long way to help understanding of the power of performative language, dialect, idiolect, and neologism in gangsta culture, as well as the fealty to the 'hood'.

Naturally, the racial male-to-male violence also brought sexual relations to the fore, especially with regard to the treatment of women. As Pagán explains, 'Both white and Mexican American men repeatedly challenged each other's manhood status in challenging the other's ability to protect 'their' women, while reserving for themselves the prerogative to harass and abuse women of their own racial group'.[25] Mexican Americans would cruise other neighbourhoods in search of white females, while servicemen sought out casual sex with Mexican girls. Such encounters helped to maintain tensions but they also shed light on the more recent gangsta epithets used for women, such as the unmuffled and unhesitating use of terms like 'hoes' and 'bitches'. In its time, the zoot suit was a multivalent symbol that was also taken for sexual predatoriness that was easily conflated with African American sexual rapaciousness.

What is also undeniable is that the zoot suit was also stigmatised by presumptions about Latino cultures that were centuries old. Rosa Linda Fragoso presciently traces a genealogy of questionable, ambivalent, or down right derogatory connections relating to Latino masculinity that date back to the early dark days of European colonization. The *Conquistadores* were unscrupulous thugs, the *Indians* were 'bloodthirsty' Aztecs, *Greasers* were 'violent revolutionaries', *Latin Lovers* were 'sexually virile', while *Gangstas* was a 'fusion of the above attributes'. All

the terms are tarred with some negative brush culminating in the now commonplace and unquestioned term *machismo*: 'The negative positioning of Chicanos and more broadly of Latino culture as the negative manifestation of hegemonic masculinity is clearly evident in the replacement of the term sexism with the Spanish word, *machismo* in common English-usage'.[26] It is also within the language of aggression that the zoot suit also becomes an agent of both deracination and nationalism. Fragoso goes on to analyse Luis Valdez's 1981 film, *Zoot Suit*, created after a successful stage show.[27] By this time, the zoot suit was more of an historical artefact, although the film did much to reveal the positive side of gangster culture, especially as a site of brotherhood and belonging.[28]

Leave Political Correctness at the Door: Gangsta's Paradise

Traumatic events experienced on a mass scale evolve into historical symbols, metamorphosing into innumerable aspects of culture, both at the time and into the future. The zoot suit very rapidly came synonymous with social subjection and revolt, which naturally meant that it was used by other quarters of society, particularly African Americans. As Cosgrove graphically explains,

> From the music of Thelonious Monk and Kid Creole to the jazz-poetry of Larry Neal, the zoot-suit has inherited new meanings and new mysteries. In his book *Hoodoo Hollerin' Bebop Ghosts*, Neal uses the image of the zoot-suit as the symbol of Black America's cultural resistance. For Neal, the zoot-suit ceased to be a costume and became a tapestry of meaning, where music, politics and social action merged.[29]

'Merging' is a concept that is crucial here, as it underscores the way in which music, poetry, linguistic expression, diction, gesture, and clothing all conspired to create character. Including notions and language into the equation also serves to emphasise how the zoot-suiter and later the hip-hop and gangsta identities cannot be described as conventional dressing up. Rather inner being and outer appearance assume a reciprocal relationship, analogous to race itself, in which personal identity conjoins self-perception with the perception of others. Yet gangsta style pushes presumptions and prejudices of race back on the audience, while also being sure that it is of a kind that is displaced from white traditions of fashion and appearance. (This also accounts for the uncomfortable response of some African American hip-hop artists with the appearance of white gansta rappers, most notably Eminem in the late 1990s.)

With the increasing divisions between rich and poor, the gangsta figure enjoys a stable, if not growing currency. Contemplating the legacy of

the zoot suit as it permeated into hip-hop, Alvarez gives a comprehensive overview:

> For young hip-hoppers, much as for zoot suiters in a bygone era, gender, the body, the public space have often been the terrain on which interracial relationships have formed. Many young men, in particular, have responded to the devastation of the postindustrial city, criminalization, and well-known patterns of police brutality and inflated incarceration rates by articulating and fetishizing a hypermasculinity that is evident, for instance, in rap lyrics that denigrate women, gays, and lesbians, while they critique the state by mocking or cursing political tactics. Hip-hoppers have also embodied style, in the form of the exaggerated fashion of baggy pants, retro sports jerseys, gold chains, and oversized jackets, and they occupy public space, in the form of graffiti on public walls or subway trains and the pounding bass of car stereos in city streets, as strategies to make themselves seen and heard in a time when the economic, political, and social mainstream encourage their invisibility and silence.[30]

Alvarez paints a familiar picture to almost all of us. The rap gangsta style, although rooted in Chicano and Afro-American culture, has become appropriated by youths all over the world, from Uruguay to Uzbekistan. It is characterised by being overwrought on a sartorial, linguistic, and sexual level. It is a self-conscious kitchiness that renounces the conventions of white classic elegance, while it also disregards canons of respect to women, gays, and lesbians that were established as social norms from the protest era onward.

It is the essence of the gangsta to tread upon the taboos that are now grouped under the embattled term of political correctness (PC). (Note how Donald Trump made PC one of his targets in his 2016 Presidential campaign, especially as an alibi to his patent misogyny.) Eithne Quinn affirms that 'black culture protest models come uncomfortably close to the practice of 'PC bashing''.[31] Yet PC is also fertile and much-tilled soil for the onslaught on comfortable liberal white society. It is a transgressive stance that speaks 'to genuine frustrations, resentments, and desires, but they also help reinforce polarized positions in the black community'.[32] She cites Dr. Dre who denigrates positive liberal positions to give force to his own individual outsider position.[33]

The kind of license with aggressive codes of masculinity is already signalled, self-evidently perhaps, in the moniker of 'gangsta'. Like the superheroes that exist on the other side of the pole, the gangsta is permanently at war and on his guard, and for that, liable to be defensively aggressive. Imbibing criminal instincts, the gangsta is free to turn circumstances to his whim, and is liable to disregard laws and mores of social acceptability. Gangsta rap culture emerged in the 1980s and 1990s,

beginning in West Coast USA and spread as force of Black Nationalism, eventuating in a national rivalry between East and West Coast. In its cultural osmosis across gangs, *barrios*, and religious groups (which included Islam), it 'thus created', as Antonia Randolph relates, 'a group standard of Black masculinity to which rappers could be held accountable'.[34] In other words, while developing naturally as culture of black resistance in the last decades of the twentieth century, it also became an operative standard, a credo for living and acting.

The tension between the organically, naturally evolved gangsta and one created wilfully as a commodity image is graphically embodied in rapper-cum-actor Ice Cube. Born in 1969, his original name is O'Shea Jackson, although not born into wealth, he came from a stable family background (his mother was a hospital clerk and his father a machinist and groundsman at the University of California Los Angeles). Yet he created himself into a man with tempestuous life and a violent sensibility, playing up to the stereotype of the immoderate behaviour of blacks and their predisposition to criminality. This was only driven home by calling himself 'The Nigga You Love to Hate' and 'The Wrong Nigga to Fuck With'. He and other members of N.W.A. ('Niggaz Wit Attitudes', which included other key figures such as DJ Yella and Dr. Dre), as Randolph put it, 'staged their Blackness and masculinity through their clothes and expressions; they were usually pictured sneering or unsmiling, in all black clothes'.[35] But with the gangsta striking these poses raised important questions regarding authentic and rhetorical resistance, social engagement as opposed to play-acting. Yet as Randolph continues, 'the rhetoric of authenticity erased the gap between what gangsta rappers talked about versus who they were'. This was probably because of the sheer ferocity of many of their statements. The extremity of their positions, tended to warn off critical questioning'.[36]

But they were prone to be exposed, and exposed they were. Ice Cube was revealed not to have belonged to the seedy 'hood' he rapped about, not to have 'gang-banged', and was accused of 'never doing half the shit he rapped about'.[37] He replied that no-one 'could have pulled off all that shit and still have a record career'.[38] This, and comments like them, when rumours spread, only emphasised the way that gangstas wore their personas as entertainers, their authenticity belonging more to what responses they could elicit and whom they could convince over their so-called real experience. Their contradictory binary of identity construction presages what is mainstream today between 'real' and cyber identities. And like all arbitrary identities, they can easily be pushed too far, and the gangsta persona is frequently cited as upholding and even inciting antagonisms between black men and creating a custom where violence is expected, respected, and rewarded.[39]

The Tyranny of Masculinity

It is a sad and well-known fact that racial hatred is most ruinous and hard to curtail when it is exacted from within. As Coolio said in his greatest hit, 'Gangster's Paradise' (1995), 'Why don't we just try to see that the ones we hurt are you and me'. For the assertion of masculinity amongst gangsta cultures is as much an effect of pride as it is of self-hatred and disrespect—hence the common use from one African American to another of 'nigga' and 'black motherfucker'. (The more innocuous appellation is 'homie or 'homeboy', whose origins are not derogatory but rather relates to underprivileged or victimised social groups whose families are forced to regroup and migrate.)[40] It is because of this duality that the common use in contemporary culture of what is now called 'the *n* word' among African American men is hard to situate from an ethico-historical point of view. In his study of youth culture in schools, Edward Morris reflects that 'the *n* word, along with other social mechanisms, defined boundaries and provided pathways for the localized constructions of race. In addition to expressing racial solidarity, it was meant to make white people feel uncomfortable'.[41] It is therefore a linguistic tactic to show fealty and to facilitate what he calls 'the achievement of blackness'.[42] In this campaign of socialization, it is important for African American youths of certain (usually underprivileged) schools and communities to achieve gangsta status and to avoid being 'lame'. To be lame is show signs of vulnerability, not to have the right dress, or to have conflicting attitudes of the group, especially as it applies to the combative male culture. As opposed to the gangsta, which appropriated for itself the realities and the myths of black criminality, to be lame was to comply with rules and, by extension, to affiliate with the oppressive status quo. As Morris notices, 'boys in particular felt a pull to enact this hard streetwise image'.[43] The gangsta image is a powerful and seductive concept as it is far from confined to an urban condition, but is caught up in the fantasies circulated by representation and narrative. Thus 'the gangsta image in popular culture intoxicated boys, promising the 'glamour and romance' of unapologetic masculinity'. But what also remains to be emphasised is that the gangsta persona is distinct from crime, and for many was more a gesture about authority as opposed to committing actual misdemeanours.[44]

Bridging the divide between the individual gangsta and the gangsta's representation in all forms of media is the ways in which gangsta groups also manage and curate their own reputations in their 'hoods' and beyond. In short, gossip and hearsay are important if not essential to a gang's collective identity.[45] Violence is a constant in these discussions, but the truth of the acts is a different matter. But it is the constant storytelling within and between gangs that is also an important modulator in violence. As Timothy Lauger concludes,

Legitimacy in the intergang environment is not static; gang members continuously develop reputations for violence by telling stories or gossiping about peers. The intergang environment is host to an endless stream of information designed to both build and undermine reputations. Violent or potentially violent events become distorted as they are reconstructed to fit the agendas of the storyteller. Some self-defined gang members are labelled as weak, while others are labelled as strong. This constant flow of information pressures gang members to perform in front of their peers.[46]

This also suggests that the violence, while ostensibly against the white establishment, is just as, if not more, internecine, that is, enacted on one another. The role of perception and aesthetics is also striking: violence is a way of looking good. Even signs of violence, such as scars, can be worn alongside 'bling' as just another trophy. Indeed the sartorial signs of gangsta-dom—bandanas, baggy pants, sportswear, and so on—are so intertwined with the act of violence that rap venues are known to forbid people from wearing them, in an effort to keep concerts and clubs safe. Promotional flyers might even stipulate 'no headgear, no jerseys', although these have been hard to police and proven easy to circumvent by subtle changes in clothing.[47]

While it is hard to measure, it is nonetheless undeniable that the evolution of gangsta hyper-masculinity is an after effect of the deep and pervading social anxieties of white society regarding African American sexual prowess and appetite. This is visible on all levels of society from pornography to literature—and is also evident in the conduct of adolescent children. In a case study analysis of a ritual in an American high school, River High, C.J. Pascoe reveals how ingrained the mentality is. 'Mr Cougar' is the title awarded to the most popular senior boy of the high school. To earn the title, six candidates play out a variety of skits in the school gym, which are then voted upon by the audience. Two candidates are handsome, Aryan water polo players, Brent and Greg. In the skit in question, they are assailed by a group of (white) students dressed as gangstas complete with bandannas, bling, and baggy clothing. They assault the pair who flee, allowing the 'capture' of their girlfriends. The 'happy ending' is when Craig and Brent succeeding in overcoming the gangstas and retrieving their 'women'. As Pascoe explains,

> The Mr Cougar competition clearly illuminates the intersecting dynamics of sexuality, gender, social class, race, bodies and institutional practices that constitute adolescent masculinities in this setting. Craig and Brent are transformed from unmasculine nerds who cannot protect their girlfriends into heterosexual, muscular men. This masculinizing process happens through a transformation of bodies, the assertion of racial privilege, and a shoring up of heterosexuality.[48]

This masculinity is negotiated at the expense of the formidable odds (as the myth has it) or confronting black sexuality as embodied by the gangsta. The above anecdote also serves as a reminder that the complex forces foisted on both black and *chicano* culture with regard to myths of primal sexuality. As Pancho McFarland notes that "As a result of economic exclusion and social marginalization, black and brown men have been forced to adopt the 'phallic norm'".[49] These are enforced concepts that these subjugated cultures unwittingly propagate. The issue of choice is therefore highly moot.

Foregrounding sexual behaviour and the exploitation of women, the subclass of gangsta known as the pimp, situates black urban sexuality at an extreme point that replicates the darkest aspect of their history, namely slavery. However there is also a less scurrilous historical dimension to the pimp, which resides in the trickster. Pimps and tricksters are both 'mackers', drawing from the older definition of 'pimp', which is to try to convince someone in a persistent and flamboyant way. It is this flamboyance that is carried over to the unambiguous and extravagant appearance of the pimp, both in life and in music video and film, with his wide-brimmed hat, copious jewellery, fat belt buckle, and long flowing fur coat. In the words of Eithne Quinn,

> The affluent 'pimp daddy' is preoccupied with the conspicuous display of material wealth ('drop-top Caddy', 'clothes', and 'riches'). The commodification of women ('hoes', 'top-notch bitches') by the supersexual pimp is recounted in the lewd vernacular. The dandified spectacle foregrounds the importance of impression management: naming ('a pimp named Shorty'); reputation ('ain't fell off'); and recognition ('throw a peace sign').[50]

The pimp is the 'aristocrat' of gangsta culture 'who is admired and recognized', wearing on his body all the signs of 'reputation, appearance, and leisure'.[51] Amongst his plentiful possessions, he makes no distinction between money, status, and women. Quinn goes on to write that 'The pimp constitutes an icon of upward mobility for black working-class males, spectacularly refusing, through their heightened style politics, the subservient type casting that has historically been imposed by the dominant social order'.[52] His onslaught on the history of black material deprivation is to turn himself into a living, breathing avatar of consumption, in which conspicuousness is an understatement. Quinn argues that 'the pimp figure has, probably most fully, resisted the dynamics of mainstream incorporation, market co-optation, and white imitation'.[53] Least contestable is white imitation, since such efforts end as parodic of a figure that already harnesses chaos and parody to his own ends.

To combat the corrosive stereotypes that persist about male black culture, scholars of music and popular culture have looked closely at the

subtleties of self-expression in rap music lyrics over more than a decade, especially to see beyond the wall of hyper-masculinity, violence, and misogyny. Matthew Oware has found that many black musicians wish to project a 'decent daddy' to combat 'popular notions of Black male parental irresponsibility, rhyming about providing, protecting, and loving their mothers and children'.[54] While he concedes that it is difficult to make strong assessments due to amount of material and to the differing ways of obtaining it, a pattern emerges where the rappers evince a sincere love and admiration of their mothers, and in some cases, siblings and fathers.

> Specifically, they are displaying a range of human emotions—anger, disdain, sadness, love, happiness—that goes unrecognized by critics and many times, defenders, of this genre of music in hip hop research. In relation to research on Black males and the family, these rappers are seemingly 'taking care of their kids'.[55]

Evidently the mother is a both a real and a symbolic figure that underpins the nature of belonging and personal passage—notions central to black urban culture.

But a broader study of rap does not absolve gangsta rap, the specific version that rose up in the 1990s. Charis Kubrin claims that a broad survey of gangsta rap reveals that almost 65 percent involve violence of some sort.[56] He contends that while such music is a potent political tool of political resistance, he questions its effectiveness, as it benefits only the few, namely the gangsta and his 'peeps', and perpetuates a dominant framework that is not necessarily representative of a more nuanced and comprehensive image of rap music or black culture. 'This is not to say that the lyrics are inaccurate. But as a cultural force, gangsta rap music offers a particular characterization of urban life'.[57] Taken in larger relief, such observations raise questions as to the mission and future of gangsta culture, the cause that they fight, and the way that they fight it. The political missteps of gangsta discourse are traceable to mistakes made by the Black Panthers and the subsequent valorisation of 'thug life'.[58] It is also important to consider the degree of havoc and complications that 'bad niggers' wreak on black society. As Anthony Pinn makes plain, while '"Badness" became a defining characteristic of many African American folk heroes and of black manhood in general since the nineteenth century',[59] the gangsta's immersion in such activity is self-destructive.[60] The gangsta's very mimesis of identity—the explicit playing out of being a gangsta, and the historical echo of badness to give his action legitimacy—can make him feel distracted and perhaps even absolved of the very real effects of his behaviour.

Perhaps the first step to begin answering this question is to look at the foil to the black gangsta, the white gangsta.

White Gangstas

Judith Butler's much-cited qualification of the way gender is not essential, but a performance, is with the example of the drag queen (there are also drag kings, but drag queens are far more prevalent). The drag queen wears the signs of femininity in the most dramatically overstated way, yet it is only through such overstatement that the transformation from man to woman can be made, insofar as the performer drowns out, as it were, the 'original' gender with the adopted one.[61] To apply this insight to the topic at hand: it is through exaggeration to the point of satire that the central traits, in the fold of the external and the interiorised qualities, can be made evident.

The 'real' and iconic gangstas and rappers within the now historic pantheon pose their own variants on the shifting but still recognizable model. This model, amplified to what in the film *Spinal Tap* is '11' (out of ten), is the fictional character Ali G, invented in 1998 by the British comedian Sasha Baron Cohen. Revived at various times until 2014, Ali G dresses in loose fitting, brightly coloured, mostly customised, sportswear, a colour coordinated skull cap, thin goatee, yellow wrap sunglasses, and a large quantity of ostentatious jewellery. He is a caricature of the boorish, undereducated rapper with a narrow outlook of the world, who bridles at nothing and is never tentative about racist or sexist remarks. His language is thick with pseudo-streetwise slang and figurative expressions. In the preamble to his 2006 interview with Posh Spice and David Beckham, for instance, he replaces concern over famine in Africa for concern over the shape of poor African women's breasts, and says that 'Africa ain't just a country that gave us Bob Marley'.[62]

What is remarkable is not only Baron Cohen's adoption of the 'blackness' without the use of any colouring, but that many of his neologisms have filtered back into the culture that he is pastiching and parodying. As Mark Sebba affirms,

> 'The 'Ali G' persona is interesting in itself: without using 'black' make-up, but by choosing the right clothing and adopting the right language, 'Ali G' is able to present himself as a black person conforming to the stereotype of a gang leader or 'don''.[63]

One of the hallmarks of the character is that at the time of his heyday, Baron Cohen refused interviews except in the persona, creating an aura of veracity that almost pushed the alter-ego into some kind of actualised existence. Ali G's overwrought version of gangsta language, a hybrid of Creole, South-East British English, with Americanisms from South Central L. A. thrown in, spawned lively online communities that undertook their own imitations of his speech and expressions.[64] Sebba also comments that 'His willingness to break taboos and to exploit

uncertainties (and hypocrisies) relating to ethnicity has guaranteed him a high profile for several years'.[65] His speech is more than just send-up, but proves an example of 'new ethnicities' employing mimicry with invention that are no less organic and authentic than their more conventional counterparts.[66] The figure of Ali G, as a construction and invention, exposes the self-conscious investment that any real gangsta has in shaping and curating his persona.

Uncontestably the most famous white gangsta rapper is Eminem, aka Marshall Mathers, who received mainstream attention with his second LP *The Slim Shady LP* in 1999.[67] But while not comedy, his, too, is a carefully crafted image. With three, not two, personas (Slim Shady being the other), the public alter-egos have been viewed as an aggressive front to the more vulnerable Mathers.[68] His Eminem demeanour, with a self-excoriation that is matched by his expressions of violence, intolerance of homosexuals, and misogyny, has been referred to as 'masculine protest'.[69] Here masculinity is nourished through regular tempestuous outbursts and reminders of intemperance and intolerance, where encounters with the world are understood as vendettas.[70] 'Masculine protest is a performance with conservative gender construction as its objective', observes James Keller, 'the creation of masculine identities through the public rejection of the feminine'.[71] This is clearly objectionable posturing, and in an effort to combat the many (legitimate) criticisms levelled at him, Eminem has sought to put forward the prickly Slim Shady persona as the face of 'abject white America'.[72]

His highly successful movie debut, *8 Mile* (Chris Hanson, dir. 2002) was widely hailed as speaking on behalf of the contemporary white man and the 'white man's burden'.[73] The main character, known to his friends as 'Rabbit' has grown up in a trailer park and is therefore an easy candidate for 'white trash'. He grows up in the inner city dominated by black youth, whose customs and lingo he absorbs. His redemption comes from his skill at 'freestyling', the word for rap improvisation whose displays take on the form of a duel, or combat, between competitors. But in the end, as Roy Grundmann argues, 'Given its agenda, it is no surprise that *8 Mile* comes off as one big orgy of black hands patting a white back'.[74] Rabbit triumphs in a rap stand-off with 'Lotto' resulting in him leaving his 'hood' for bigger and better things, leaving his black friends and the black community that nurtured him to the dupes of his success, which we cannot help suspect is in some part due to his whiteness. Grundmann makes the tenable point that the popularity of the film, and of Eminem himself, is not reducible to his own evident talents, but has to take sizeable account of the liberal pluralism of the 1990s and the proliferation of minority politics, at least in theory. This made assertive male heterosexuality something dishonourable, and Eminem became its valiant crusader.[75] White straight maleness wins in the end. And worse, there is more than enough evidence in his lyrics to suggest that Eminem poses himself as a latter-day rap evangelist, a white Christian saviour.[76]

How near or far we are to Mailer's typecasting of the 'White Negro' is hard to say. But both take recourse in black experience and black history, through rhetoric and philosophy and in with Eminem/Slim Shady, the building of his persona(s), and the attitudes attendant to it/them. But the net effect is unconvincing and ultimately untenable. As Keller concludes:

> Eminem has a very grandiose image of his impact on American youth, imagining himself to be the fountainhead of dissolute adolescent culture. While he certainly is a phenomenon, selling ten million albums and starring in a hit movie all in 2002, I wonder to what extent he understands the very conservative role that his lyrics play in the consolidation of traditional power, and not just because his petty rebellions are an impetus for the dominant culture's displays of hegemony by repressing dissent, but conservative in a much more direct fashion. Masculine protest is an exaggeration of traditional masculine attributes; it is not revolutionary. Eminem's abuse of women and gay men reinforces the social processes that attempt to guarantee women's continued subordination and objectification and gay men's ostracism and forced conformity to binary gender norms.[77]

Keller's withering appraisal of Eminem's masculine protest serves as an enlightening corrective to all related stances, that is, belonging to 'authentic' African American gangstas. Just as Ali G offers us a clarion clear example of the gangsta stereotype, Eminem, as his own white-black amalgamation (the white man playing black but still staying white), shows that the hatred of women and gays in gangsta lyrics cannot be discounted as an aesthetic stance, as if the genre requires it. An analogous argument is that of cartoon and film violence, that it is not really violence. But to apply this logic to the slurs in gangsta lyrics is disingenuous and noxious. The stock names of disapproval to one male gangsta to another is 'bitch' and 'faggot', used with such habitual regularity that it ensures that the prejudices remain deep and intact. Some figural language cannot be equivocated upon, for racial and gender intolerance is what it is.

What, then, is the future of the gangsta? With widening social demographics and with generational unemployment, one can only conclude that it is a male phenomenon that will only accelerate. In the report with which we began this chapter, there is also a detailed matrix that comprises a semiology and taxonomy of gangster styling. For example, the gang called the 'Bloods' wore an earring in the left ear, have the hat turned to the left, wear either red or green sneakers, and bore five kinds of tattoos including a Playboy bunny head and a crescent moon. Meanwhile for the 'Crips', the earring was in the right ear, their symbol was a six-point star (as opposed to the Bloods' five-point star), their sneakers could be either black or blue, and their signature tattoos included a winged heart and

a Playboy bunny head with a bent ear.[78] This short litany gives a strong sense of the intricacy of the signs and the wearers' devotion to them. Such identities have proven crucial for personal survival in the group articulation of difference, belonging, and defiance. Unfortunately it comes at a great cost of credibility, as it perpetuates stereotypes of delinquency and prides itself in derogatory relationships to those weaker than, and different from, them.

Notes

1 Sandra DeHotman, Amanda Hughes and William Green-Burns, "'Gangstas' in Your Classroom: How to Recognize Them and What Teachers Should Know", *Beyond Behavior* 10, no. 2 (2000): 24–27.
2 Ibid., 24.
3 Ibid.
4 Tasha Lewis, 'From Fabulous to Glamorous. Fashion Change in Hip-Hop Culture', paper presented at the Popular Culture Association Conference, San Antonio, TX, March 2004.
5 Dapper Dan the Hip-Hop Tailor of Harlem, www.sneakerfreaker.com/features/dapper-dan-the-hip-hop-tailor-of-harlem/. Accessed February 2, 2017.
6 Carol Tulloch, *The Birth of Cool. Style Narratives of the African Diaspora* (London: Bloomsbury, 2016), 5.
7 Ibid., 5.
8 Robin M. Chandler and Nuri Chandler-Smith, "Flava in Ya Gear: Trangressive Politics and the Influence of Hip-Hop on Contemporary fashion", in Linda Welters and Patricia A. Cunningham, eds. *Twentieth Century American Fashion* (Oxford: Berg, 2005), 236.
9 Ibid., 237.
10 Sanchez-Tranquilino, Marcos and John Tagg, "The Pachuco's Flayed Hide: Mobility, Identity, and Buenas Garras", in, Lawrence Grossberg, Cary Nelson and Paula Treichler, eds. *Cultural Studies* (New York: Routledge, 1992), 559.
11 Chandler and Chandler-Smith, *Flava in Ya Gear*, 243.
12 See Catherine Ramírez, "Crimes of Fashion: The Pachuca and Chicana Style Politics", *Meridians* 2, no. 2 (2002): 1–35.
13 Ibid., 107–108.
14 Ibid., 109.
15 See also Daniel Belgrad, "Performing Lo Chicano", *MELUS* 29, no. 2 (2004): 249–264.
16 Stuart Cosgrove, "The Zoot-Suit and Style Warfare", *History Workshop* 18 (1984): 77–78.
17 Octavio Paz, *The Labyrinth of Solitude* (London: Grove Press, 1994), 8.
18 Alvarez, *The Power of the Zoot*, 78.
19 Ibid., 7.
20 Ibid., 247.
21 Edouardo Obregón Pagán, "Los Angeles Geopolitics and the Zoot Suit Riot, 1943", *Social Science History* 24, no. 1 (2000): 224.
22 Richard Griswald del Castillo, "The Los Angeles 'Zoot Suit Riots' Revisited: Mexican and Latin American Perspectives", *Mexican Studies/Estudios Mexicanos* 16, no. 2 (2000): 385–391.
23 Obregón Pagán, "Los Angeles Geopolitics", 231.
24 Griswald del Castillo, "The Los Angeles 'Zoot Suit Riots'", 369–370.

25 Ibid., 238.

26 Rosa Linda Fregoso, "Representations of Cultural Identity in 'Zoot Suit'" (1981), *Theory and Society* 22, no. 5 (1993): 661.

27 See also Shakina Nayfack, "Que le watcha los cabrones: Marking the 30th Anniversary of Louis Valdez's 'Zoot Suit'", *TDR* 53, no. 3 (2009): 162–169.

28 Ibid., 670.

29 Cosgrove, "The Zoot-Suit and Style Warfare", 89.

30 Alvarez, *The Power of the Zoot*, 242.

31 Eithne Quinn, "Black British Cultural Studies and the Rap on Gangsta", *Black Music Research Journal* 20, no. 2 (2000): 213.

32 Ibid.

33 Ibid.

34 Antonia Randolph, "'Don't Hate Me Because I'm Beautiful': Black Masculinity and Alternative Embodiment in Rap Music", *Race, Gender, Class* 13, no. 3/4 (2006): 208.

35 Ibid.

36 Ibid.

37 Ibid.

38 Ibid.

39 Charis Kubrin, "Gangstas, Thugs, and Hustlas: Identity and the Code of the Street in Rap Music", *Social Problems* 52, no. 3 (2005): 360–378.

40 Gregory Kannerstein, "Slang at a Negro College, 'Home Boy'", *American Speech* 42, no. 3 (1967): 238–239.

41 Edward Morris, *Learning the Hard Way: Masculinity, Place and the Gender Gap in Education* (New Brunswick: Rutgers University Press, 2012), 103.

42 Ibid., 104.

43 Ibid., 113.

44 Ibid., 115.

45 Timothy Lauger, *Real Gangstas: Legitimacy, Reputation, and Violence in the Intergang Environment* (New Brunswick: Rutgers University Press, 2012), 147.

46 Ibid., 158.

47 As Geoff Harkness writes: 'Some Chicago venues enacted policies specifically designed to forbid gang members from entering or flaunting their gang affiliation. This included the prohibition of hats, bandanas, hoodies, baggy pants, sportswear, and other garb that might be associated with gangs. Those wearing such items when trying to enter the venue were told to leave them in their cars or be denied entry. Promotional flyers for concerts would sometimes include these regulations: 'No headgear, no jerseys,' read one. Such prohibitions, however, were easy to circumvent through subtle uses of garb, such as the side of the body which an item of clothing was worn or the color of one's T-shirt. Small items such as jewelry or bandanas could be stuffed into a pocket and then donned inside the club. Moreover, venues dedicated primarily to gangsta- rap concerts seldom featured such policies, or did not enforce them strictly. Some venues required that all patrons be patted down or frisked for weapons before entering; others had no such regulations'. *Chicago Hustle and Flow* (Minnesota: Minnesota University Press, 2014), 163.

48 Cheri Jo Pascoe, "Becoming Mr Cougar: Institutionalizing Heterosexuality and Homophobia at River High", *Counterpoints* 367 (2012): 145–157.

49 Pancho McFarland, *The Chican@ Hip Hop Nation: Politics of a New Millennial Mestizaje* (Detroit: Michigan State University Press, 2013), 177.

50 Eithne Quinn, "'Who's the Mack?': The Performativity and Politics of the Pimp Figure in Gangsta Rap", *Journal of American Studies* 34, no. 1 (2000): 121–122.

51 Ibid., 122.
52 Ibid., 123–124.
53 Ibid., 136.
54 Matthew Oware, "Decent Daddy, Imperfect Daddy: Black Male Rap Artists' Views of Fatherhood and the Family", *Journal of African American Studies* 15, no. 3 (2012): 328.
55 Ibid., 343.
56 Kubrin, "Gangstas, Thugs, and Hustlas", 375. See also Leslie Baker-Kimmons and Pancho McFarland, "The Rap on Chicano and Black Masculinity: A Content Analysis of Gender Images in Rap Lyrics", *Gender and Class* 18, no. 1/2 (2011): 331–344.
57 Ibid., 376.
58 As V. P. Franklin that the members of the Hip Hop generation 'need to be made aware that one of the most important radical black organizations in the 20th century was crippled internally by the thugs who were recruited to the organization. Hip Hop culture has developed both positive and negative beliefs and practices, some of them traceable to the Black Power era. Hopefully, understanding the mistakes made by the Panthers and other black organizations in the Black Power era can serve as a positive message to those in the Hip Hop generation interested in advancing the movement for black liberation in the 21st century'. "Introduction: New Black Power Studies: National, International, and Transnational Perspectives", *The Journal of African American History* 92, no. 4 (2007): 465.
59 Anthony Pinn, "'Getting Grown': Notes on Gangsta Rap Music and Notions of Manhood", *Journal of African American Men* 1, no. 4 (1996): 31.
60 Ibid., 34.
61 'As much as drag creates a unified picture of 'woman' (what its critics often oppose), it also reveals the distinctness of those aspects of gendered experience which are falsely naturalized as a unity through the regulatory fiction of heterosexual coherence. *In imitating gender, drag implicitly reveals the imitative structure of gender itself—as well as its contingency*, Indeed, part of the pleasure, the giddiness of the performance is in the recognition of a radical contingency in the relation between sex and gender in the face of cultural configurations of causal unities that are regularly assumed to be natural and necessary'. Judith Butler, *Bodies That Matter* (New York and London: Routledge, 1993), 235.
62 "Ali G Interviews Posh Spice and David Beckham", www.youtube.com/watch?v=P842Tmi6lrc. Accessed 18 September, 2016.
63 Mark Sebba, "Will the Real Impersonator Please Stand Up? Language and Identity in the Ali G Websites", *AAA: Arbeiten aus Anglistik und Amerikanistik* 28, no. 2 (2003): 280.
64 Ibid., 280–281ff.
65 Ibid., 300.
66 Ibid., 301.
67 'His second album with Dre, The Marshall Mathers LP, was the fastest-selling rap album ever, selling nearly two million copies in its first week. To date, Mathers is the only Caucasian rapper to attain and maintain international significance over the course of many years and several albums'. Marie Dallam, "Eminem: The Best Emcee Since Jesus", *Studies in Popular Culture* 29, no. 2 (2007): 87.
68 James Keller, "Shady Agonistes: Eminem, Abjection, and Masculine Protest", *Studies in Popular Culture* 25, no. 3 (2003): 14.
69 Ibid., 13–14.

70 Ibid., 14.
71 Ibid., 21.
72 Ibid., 22.
73 Roy Grundmann, "White Man's Burden: Eminem's Movie Debut in *8 Mile*", *Cinéaiste* 28, no. 2 (2003): 30–35.
74 Ibid., 32.
75 Ibid., 35.
76 See Marie Dallam, "Eminem: The Best Emcee Since Jesus", whose assessment, however, is alarmingly uncritical.
77 Keller, "Shady Agonistes", 23.
78 DeHotman et al., "'Gangstas' in Your Classroom", 27.

Conclusion
Men Without Qualities

The Man Without Qualities is the title of the great, unfinished book by the Austrian writer, Thomas Musil, set during the twilight years of the Austro-Hungarian Empire. The main protagonist, 'the man without qualities' is the thirty-two year old mathematician, Ulrich, a man who is happy to be defined by the decisions, perceptions, and pressures of the environment around him, stumbling between the rational and mystical in his quest for a deeper meaning in life. One problem is that he adopts too many positions, and places in store in too much, an indecisiveness that reflects and feeds his spiritual impoverishment.[1] His confusion mirrors the socio-political chaos around him. To use the language of this book, Ulrich simply did not go far enough in adopting the trappings of the outside world. In his obsession to be true to himself, he finds himself unmoored, as he labours under the false presumption that there is some spiritual kernel to be found. Paradoxically, one can best navigate one's own subjectivity if one navigates it through the persona of another.

By late modernity, classes and ethnicities opened with a diversity that had hitherto never been seen. The effects of migration, tourism, travel, and the circulation of information and images, created cultures that were not limited to geographic boundaries, and still less, class. That is not to say that class remains an important determining factor in the shaping of character, it can also be mimicked. For both men and women, the passage of formation from adolescence to adulthood is through role models that are not only parental, but mythological and symbolic. But, with the concession of many overlaps and exceptions, how men and women then take possession of adulthood is different. A traditional feminist binary places male 'determinacy' to female "indeterminacy"; man is shaped subject and woman is the amorphous object. The passage to such determinacy is precisely through the image of a particular type, each of which enjoy a set of accompanying narratives and sartorial signs.

If we were to argue that the determination of male subjectivity is facilitated by a particular diegetic and aesthetic symbolic order, we would have to ask why it has become so evident and diverse since the mid-to-late twentieth century. There is no single answer to this, except to cite the larger variety of resources available to him. The options are not just

between chivalry (the knight) and piety (the priest), but the dandy, the playboy, rough trade, the gangsta, and even the superhero. These models of being have their own rich genealogy of dress and custom. These personas can change over time, they might also be in combination with one another, but the constant is that they are social signifying systems, tied to mythology and constructed through communication practices such as media and advertising.

The list of male types, or icons, explored here is not meant to be exhaustive, although it does cover comprehensive ground. The case studies are not only historic and fashionable templates of 'male being,' but they are also resources for insight into the narratives to which contemporary fashion is constantly alluding, in its unremitting recreation and reassertion of male identity.

The reader will also notice that a common tendency to push these identities into the realms of queerness—perhaps with the notable exception of the gangsta. This was not a prior strategy on our part, far from it. Rather, it is the logical outcome of stretching the limits any definition that purports to monolithic coherence. While these male types are recognizable and discrete, like the human psyche itself, they are all eminently porous and labile. It is also bracing to see how types are inhabited, then twisted and reformed in the interests of resistance, and the assertion of complex alternative identities—the dandy is a cardinal example of such ambiguity. And the queering of these types also exposes the speciousness of the division between form and content, especially when we see the way that the hyper-masculine man can be either straight or gay, or where it is hard to see whether the playboy has become the dandy, or the obverse. Such instability, while liberating for some, also means that in the male quest for security through the adoption of a particular identity is itself only a desire. The icon is only that, an image. Men may aspire to them, and 'be' them, to make him complete. Yet the end result is the very opposite, it is through this want to be complete that the male subjective incompleteness is exposed. This is not a cause for worry, though, as it is the salutary alternative to being at subjective sea, to be without qualities.

Notes

1 Robert Musil, *Der Man Ohne Eigenschaften* (Hamburg: Rowohlt, 1978).

Bibliography

Adams, James Eli. *Dandies and Desert Saints, Styles of Victorian Masculinity.* Ithaca and London: Cornell University Press, 1995.

Allon, Fiona. "Sailor Style: From Jack Tar to Sailor Moon", in *Sailor Style: Art, Fashion, Film.* exh cat., Sydney: Powerhouse Museum, 2004.

Alvarez, Luis. *The Power of the Zoot.* Berkeley and London: University of California Press, 2008.

Anon. "Early Zoot Suits". *State and Local History News*, 2.4, 1944, 3.

Arsel, Zaynep and Thompson J. Craig. "Demythologising Consumption Practices: Consumers Protect Their Field-Dependent Identity Investments from Devaluing Marketplace Myths". *Journal of Consumer Research*, 37.5, February 2011, 791–806.

Attwood, Feona. "Tits and Ass and Porn and Fighting: Male Heterosexuality in Magazines for Men". *International Journal of Cultural Studies*, 8.1, 2005, 83–100.

Baker-Kimmons, Leslie and Pancho McFarland. "The Rap on Chicano and Black Masculinity: A Content Analysis of Gender Images in Rap Lyrics". *Gender and Class*, 18.1/2, 2011, 331–344.

Bakhtin, Mikhail. *Rabelais and His World.* trans. Helene Iswolsky, Indianapolis: Indiana University Press, 1984.

Baldick, Chris. *In Frankenstein's Shadow*, Oxford: Clarendon, 1987.

Baldwin, James. *Nobody Knows My Name.* New York: Dial P., 1961.

Barber, Paul. *Vampires, Burial and Death: Folklore and Reality.* New Haven and London: Yale University Press, 1988.

Barbey D'Aurevilly, Jules. *Du Dandisme et de George Brummel.* Paris: Éditions Balland, (1897), 1986.

Baudelaire, Charles. *Œuvres completes.* Paris: Gallimard Pléiade, 1954.

Baudelaire, Charles. *The Painter of Modern Life and Other Essays.* trans. and ed. Jonathan Mayne, London: Phaidon, 1970.

Belgrad, Daniel. "Performing Lo Chicano". *MELUS*, 29.2, 2004, 249–264.

Berka, Sigrid. "'Das Bissigste Stück der Saison': The Textual and Sexual Politics of Vampirism in Elfriede Jelinek's *Krankheit oder Moderne Frauen*". *The German Quarterly*, 68.4, Autumn, 1995, 372–388.

Berlatsky, Noah. *Wonder Woman: Bondage and Feminism in the Marston/Peter Comics, 1914–1948.* New Brunswick: Rutgers University Press, 2015.

Billig, Michael. *Banal Nationalism.* London: Sage, 1995.

Blythe, Martine. "Vampire Poetics: George Sand and her Lovers", *Emergences* 10, no.1, 2000: 127-135.

Boeck, George A. Jr. "Rancher and Farmer Dress in North Central Texas, an Ethnographic History", in Peter McNeil and Vicki Karaminas eds. *The Men's Fashion Reader*, Oxford: Berg, 2009, 320–330.

Bolton, Andrew, ed. *Superheroes: Fashion and Fantasy*, The Metropolitan Museum of Art, New York. New Haven and London: Yale University Press, 2008.

Bordo, Susan. *The Male Body: A New Look at Men in Private and in Public.* New York: Farrar, Straus and Giroux, 2000.

Botzas, S. "Biff! Bang! Pow! Captain America Enlists to Fight for Bush in Iraq". *Sunday Herald*, London, 14 November 2004.

Brite, Poppy Z. *Lost Souls.* Harmondsworth: Penguin, 1992.

Brookner, Anita. *Romanticism and Its Discontents.* Harmondsworth: Penguin, 2001.

Brownie, Barbara and Danny Graydon. *The Superhero Costume: Identity and Disguise in Fact and Fiction.* London and New York: Bloomsbury, 2016.

Broyard, Anatole. "A Portrait of the Hipster". *Partisan Review*, 15.6, June 1948, 721–727.

Broyard, Anatole. "Portrait of a Hipster", in Charters Ann ed. *Beat Down to Your Soul: What Was the Beat Generation?* London: Penguin, 2001, 43–49.

Bruno, M. "Cosplay: The Illegitimate Child of S F Masquerades". *Glitz and Glitter Newsletter*, Millennium Costume Guild. October, 2002; http://millen niumcg.tripod.com/glitzglitter/1002articles.html. Accessed September 2015.

Bruzzi, Stella. *Undressing Cinema: Clothing and Identity in the Movies.* London: Routledge, 1997.

Buckmaster, Luke. "The Man from Snowy River. Rewatching Classic Australian Films". *The Guardian,* www.theguardian.com/film/australia-culture-blog/2014/may/02/the-man-from-snowy-river-rewatching-classic-australian-films. Accessed April 4, 2017.

Burdick, Euege. "The Politics of the Beat Generation". *The Western Political Quarterly*, 12.2, 1959, 553–555.

Butler, Judith. *Bodies That Matter.* New York and London: Routledge, 1993.

Carlyle, Thomas, and Giacomo Leopardi, *Moral Tales*, vol. 1, trans. Patrick Creagh, Manchester: Carcanet New Press, 1982.

Carmargo, Eduardo G. "The Measurement of Meaning: Sherlock Holmes in Pursuit of the Marlboro Man", in Jean Umiker-Sebeok ed. *Marketing and Semiotics. New Directions for the Study of Signs for Sale*, Berlin: Mouton de Gruyter,1987, 463–483.

Carter, Michael. "Superman's Costume". *Form/Work: An Interdisciplinary Journal of Design and the Built Environment*, 4, 2000, 26–41.

Castronovo, David. "Norman Mailer as Midcentury Advertisement". *New England Review (1990–)*, 24.4, 2003, 179–186.

Cawelti, John G. *Adventure, Mystery and Romance: Formula Stories as Art and Popular Culture.* Chicago and London: University of Chicago Press, 1977.

Chandler, Robin M. and Chandler-Smith Nuri. "Flava in Ya Gear: Trangressive Politics and the Influence of Hip-Hop on Contemporary Fashion", in Linda Welters and Patricia A. Cunningham eds. *Twentieth Century American Fashion*, Oxford: Berg, 2005.

Church Gibson, Pamela. "Brad Pitt and George Clooney, the Rough and the Smooth", in Rachel Moseley ed. *Fashioning Film Stars: Dress, Culture, Identity*, London: Bfi, 2005.

Cohan, Steven. "So Functional for its Purposes: Rock Hudson's Bachelor Apartment in Pillow Talk', in Joel Sanders ed. *Stud. Architectures of Masculinity*, New York: Princeton Architectural Press, 1996.

Cole, Shaun. *Don We Now Our Gay Apparel.* Oxford: Berg, 2000.

Cole, Shaun. "Considerations on a Gentleman's Posterior". *Fashion Theory*, Vol. 16, No.2 Special Issue, Body Parts, Vicki Karaminas ed., June 2012, 211–234.

Cole, Shaun. "Costume or Dress? The Use of Clothing in the Gay Pornography of Jim French's Colt Studio". *Fashion Theory*, 18.2, 2014, 123–148.

Conekin, Becky. "Fashioning the Playboy: Messages of Style and Masculinity in the Pages of Playboy Magazine 1953–1963", in Peter McNeil and Vicki Karaminas eds. *The Men's Fashion Reader,* Oxford: Berg, 2009.

Constantino, Maria. *Men's Fashion in the Twentith Century: From Frock Coats to Intelligent Fibres*, Costume & Fashion Press/Quite Specific Media: California, 1997, Cosgrove, Stuart. "The Zoot-Suit and Style Warfare". *History Workshop*, 18, 1984, 77–91.

Cook, Pam and Hines Claire. "'Sean Connery is James Bond': Re-fashioning British Masculinity in the 1960s", in, Rachel Moseleley ed. *Fashioning Film Stars: Dress, Culture, Identity,* London: Bfi Publishing, 2011.

Cosgrove, Ben. 'The Luckiest Generation. LIFE with Teenagers in 1950s America', with http://time.com/3544391/the-luckiest-generation-life-with-teenagers-in-1950s-america/. Assessed April 15, 2017.

Cotkin, George. "The Photographer in the Beat-Hipster Idiom: Robert Frank's *The Americans*". *American Studies*, 26.1, 1985, 19–33.

Craik, Jennifer. *Uniforms Exposed.* Oxford and New York: Berg, 2005.

Craik, Jennifer. "Rural Dress in Australia", in Margaret Maynard ed. *The Berg Encyclopedia of Dress and Fashion*, Volume 7, Australia, New Zealand and the Pacific Islands, Oxford: Berg, 2010, 107–112.

Cremins, Brian. "'What Manner of Man Is He?': Humor and Masculine Identity in Captain Marvel's World War II Adventures". *Studies in American Humor*, 27.3, 2013, 33–62.

Crew, Ben. *Representing Men: Cultural Production and Producers in the Men's Magazine Market.* Oxford: Berg, 2003.

Crothers Dilley, Whitney. *The Cinema of Ang Lee.* New York: Columbia University Press, 2015.

Cryle, Peter and Lisa O'Connell, eds. *Libertine Enlightenment: Sex, Liberty and License in the Eighteenth Century.* Hampshire and New York: Palgrave McMillian, 2004.

Dallam, Marie. "Eminem: The Best Emcee Since Jesus". *Studies in Popular Culture*, 29.2, 2007, 83–97.

Davies, Melody. *The Male Nude in Contemporary Photography.* Philadelphia: Temple University Press, 1991.

Davis, Stephen. *Jim Morrison: Life, Death, Legend.* London: Random House, 2005.

de Castella, Tom. "Whatever Happened to the Term New Man", *BBC News Magazine*, 30 January 2014, www.bbc.com/news/magazine-25943326. Accessed January 15, 2017.

DeHotman, Sandra, Amanda Hughes and William Green-Burns. "'Gangstas' in Your Classroom: How to Recognize Them and What Teachers Should Know". *Beyond Behavior*, 10.2, 2000.

DeJean, Joan. *Libertine Strategies: Freedom and the Novel in Seventeenth-Century France*. Columbus: Ohio State University Press, 1981.

Delon Michel, ed. *The Libertine: The Art of Love in Eighteenth-Century France*. New York and London: Abeville Press, 2013.

Delong, Marilyn and Park Juyeon, "From Cool to Hot to Cool. The Case of the Black Leather Jacket", in Andrew Riley and Sarah Cosbey eds. *Men's Fashion Reader*, New York: Fairchild, 2008.

Dolansky, Fanny. "Playing with Gender: Girls, Dolls, and Adult Ideals in the Roman World". *Classical Antiquity*, 31.2, October 2012, 256–292.

Easton Ellis, Brad. *American Psycho*. New York: Vintage Books, 1991.

Edwards, Tim, "Sex, Booze and Fags: Masculinity, Style and Men's Magazines", in Bethan Benwell ed. *Masculinity and Men's Lifestyle Magazines*, Oxford: Blackwell Publishing, 2003, 132–146.

Ehrlich, Robert. *Normal Mailer: The Radical Hipster*. Metuchen, New Jersey and London: The Scarecrow Press, 1978.

Eldridge, David. "The Generic American Psycho". *Journal of American Studies*, 42.1, 2008, 19–33.

Elliot, Tim. "A Spotters Guide to the Emerging Tribes of Sydney", The Sydney Morning Ellison, Ralph. *The Invisible Man*, New York: Vintage, 1995.

Evans, Caroline. "Dreams that Only Money Can Buy... Or, the Shy Tribe in Flight from Discourse". *Fashion Theory: The Journal of Dress, Body and Culture*, 1.2, 1997, 169–188.

Faisst, Julia. "'Delusionary Thinking, Whether White or Black or in Between': Fictions of Race in Philip Roth's *The Human Stain*". *Philip Roth Studies*, 2.2, 2006, 121–137.

Faludi, Susan. *Stiffed: The Betrayal of the American Man*. New York: Morrow, 1999.

Fawaz, Ramzi. *The New Mutants: Superheroes and the Radical Imagination of American Comics*. New York: NYU Press, 2016.

Fingeroth, Danny. *Superman on the Couch: What Superheroes Really Tell Us about Ourselves and Our Society*. London and New York: Bloomsbury, 2004.

Fisk, Deborah Payne, ed. *Four Restoration Libertine Plays*. Oxford and London: Oxford University Press, 2005.

Foley, Jack. "Beat". *Discourse*, 20.1/2, 1998, 182–197.

Ford, Philip. "Somewhere/Nowhere: Hipness as an Aesthetic". *The Musical Quarterly*, 86.1, 2002, 49–81.

Foucault, Michel. "Of Other Spaces: Utopias and Heterotopias". *Architecture/ Movement Continuité*, October 1984: (Des Espace Autres, March 1967. trans. Jay Miskowiec), http://web.mit.edu/allanmc/www/foucault1.pdf. Accessed March 10, 2017.

Foucault, Michel. "Of Other Spaces". *Diacritics*, 16.1, 1986, 22–27.

Foucault, Michel. *Discipline and Punish: The Birth of the Prison*. Harmondsworth: Penguin, 1987.

Foucault, *The History of Sexuality*, Vol. I, London: Vintage Books, 1978.

Foucault, Michel. *The History of Sexuality*, Vol. II, Harmondsworth: Penguin, 1988.

Foucault, Michel. *Politics, Philosophy, Culture: Interviews and Other Writings, 1977–1984*. Lawrence Krtitzman, ed. London and New York: Routledge, 1990.

Franklin, V. P. "Introduction: New Black Power Studies: National, International, and Transnational Perspectives". *The Journal of African American History*, 92.4, 2007, 463–466.

Frateriggo, Elizabeth. *Playboy and the Making of the Good Life in Modern America*. Oxford, New York: Oxford University Press, 2009.

Fregoso, Rosa Linda. "Representations of Cultural Identity in 'Zoot Suit'" (1981). *Theory and Society*, 22.5, 1993, 659–674.

Frith, Simon. *Sound Effects: Youth, Leisure and the Politics of Rock*. London: Constable, 1983.

Garber, Marjorie. *Vested Interests: Cross-Dressing and Cultural Anxiety*. London and New York: Routledge, 1992.

Garelick, Rhonda. *Mademoiselle: Coco Chanel and the Pulse of History*. New York: Random House, 2014.

Gaultier, Jean Paul. www.edgarsclub.co.za/archive/exclusive-interview-with-jean-paul-gaultier/. Accessed May 24, 2016.

Gaultier, Jean Paul and Thierry-Maxime Loriot. *The Fashion World of Jean Paul Gautier: From the Sidewalk to the Catwalk*, exh. cat., Montreal: Montreal Museum of Fine arts and Abraham, 2011.

Gaylord, Karen. "Bohemia Revisited". *Social Research*, 32.2, 1965, 163–179.

Geczy, Adam. *The Artificial Body in Fashion and Art: Mannequins, Models and Marionettes*. London and New York: Bloomsbury, 2016.

Geczy, Adam and Vicki Karaminas. *Queer Style*. New York and London: Bloomsbury. 2013.

Gelder, Ken ed. *Reading the Vampire*. London and New York: Routledge, 1994.

Genet, Jean. *Œuvres completes*. Vol. III, Paris: Gallimard, 1951–1991.

George, Sam and Bill Hughes, eds. *Open Graves, Open Minds: Representations of Vampires and the Undead from the Enlightenment to the Present Day*. Manchester and London: Manchester University Press, 2013.

Gibson, Matthew. *The Fantastic and the European Gothic: History, Literature and the French Revolution*. Cardiff: The University of Wales Press, 2013.

Gilbert, Samuel. "Schools vs. Frank Sinatra and Zoot Suits". *Journal of Education*, 127.5, 1944, 153–155.

Gillespie, Dizzy. *To Be, or Not....to Bob: Memoirs*. New York: Doubleday, 1979.

Gilligan, Sarah. "Fashioning Masculinity and Desire", in Andrew Ireland ed. *Illuminating Torchwood: Essays on Narrative, Character and Sexuality in the BBC Series*. North Carolina and London: McFarland and Company, 2010.

Godfrey, Sima. "The Dandy as Ironic Figure". *SubStance*, 11.3, 1982, 21–33.

Gonzales, ed. "Brokeback Mountain", *Slant Magazine*, www.slantmagazine.com/film/film_review.asp?ID=1927. Accessed March 9, 2017.

Granfield, Matt. *HipsterMattic*. Sydney: Allen and Allen, 2011.

Green, Matthew, ed. *Alan Moore and the Gothic Tradition*. Manchester: Manchester University Press, 2013.

Gregory, Mollie. *Stuntwomen: The Untold Hollywood Story*. Louisville: University Press of Kentucky, 2015.

Greif, Mark Kathleen Ross and Dayna Tortorici, eds. *What Was the Hipster? A Sociological Investigation*. New York: n+1 Foundation, 2010.

Grindstaff, David. "The First and the Corpse: Taming the Queer Sublime in Brokeback Mountain". *Communication and Critical/Cultural Studies*, 5.3, 2008, 223–244.

Griswald del Castillo, Richard. "The Los Angeles 'Zoot Suit Riots' Revisited: Mexican and Latin American Perspectives". *Mexican Studies/Estudios Mexicanos*, 16.2, 2000, 367–391.

Grossberg, Lawrence, Cary Nelson and Paula Treichler, eds. *Cultural Studies*. London and New York: Routledge, 1992.

Grosz, Elizabeth. *Volatile Bodies: Toward a Corporeal Feminism*. Indianapolis: Indiana University Press, 1994.

Grundmann, Roy. "White Man's Burden: Eminem's Movie Debut in *8 Mile*". *Cinéaiste*, 28.2, 2003, 30–35.

Haining, Peter, ed. *The Vampire Omnibus*. London: Orion Books, 1996.

Halberstam, David. *The Fifties*. New York: Fawcett Columbine, 1993.

Hall, Stuart and Jefferson Tony, eds. *Resistance through Rituals*. Youth Subcultures in Post-War Britain, London: Hutchinson, 1976.

Hall, Steve, Simon Winlow and Craig Ancrum, "Radgies, Gangstas, and Mugs: Imaginary Criminal Identities in the Twilight of the Pseudo-Pacification Process". *Social Justice*, 32.1, 2005, 100–112.

Halperin, David. *How to Be Gay*. Cambridge, MA: Harvard University Press, 2012.

Hancock II, Joseph, H. and Karaminas Vicki. "The Joy of Pecs: Representations of Masculinities in Fashion Brand Advertising". *Clothing Cultures*, 1.3, 2014, 269–288.

Harkness, Geoff. *Chicago Hustle and Flow*. Minnesota: Minnesota University Press, 2014.

Hatfield, Charles, Jeet Heer and Kent Worcester, eds. *The Superhero Reader*. New Orleans: The University Press of Mississippi, 2013.

Hebdige, Dick. *Subculture the Meaning of Style*. New York: Routledge, 1979.

Heidushschke, Sebastian. "Authority, Mobility and Teenage Rebellion in The Wild One (USA, 1953), Die Halbstarken (West Germany, 1956) and Berlin – Ecke Schonhauser (East Berlin, 1957)". *Seminar*, 49.3, September 2013, 281–299.

Hendlin, Yogi, Stacey J. Anderson and Stanton A. Glantz. "'Acceptable Rebellion': Marketing Hipster Aesthetics to Sell Camel Cigarettes in the US". *Tobacco Control*, 19.3, 2010, 213–222.

Hobsbawm, Eric. *Bandits*. New York: The New Press, [1969], 2000.

Hobsbawn, Eric. "The Myth of the Cowboy", *The Guardian*, Wednesday 20 March 2013. www.theguardian.com/books/2013/mar/20/myth-of-the-cowboy. Accessed April 2, 2017.

Hoch, Paul. *White Hero—Black Beast: Racism, Sexism, and the Mask of Masculinity*. London and New York: Pluto Press, 1979.

Hogan, Jon. "The Comic Book as Symbolic Environment: The Case of Iron Man". *Review of General Semantics*, 66.2, 2009, 199–214.

Holte, James Craig. "Not All Fangs are Phallic: Female Film Vampires". *Journal of the Fantastic in the Arts*, 10.2, 1999, 163–173.

Irving, John. "Naval Life and Customs". 1944, www.naval-history.net/WW2aaNavalLife-Customs1.htm#2. Accessed May 18, 2016.

Irwin, Mary Anne and Brooks James, eds. *Women and Gender in the American West*. Albuquerque: University of New Mexico Press, 2004.

James, David. "L.A.'s Hipster Cinema". *Film Qharterly*, 63.1, 2009, 56–67.

Jeffords, Susan. *Hard Bodies: Hollywood Masculinity in the Reagan Era*. New Brunswick and New Jersey: Rutgers University Press, 1994.

Jenks, Charles, ed. *Visual Culture*. London and New York: Routledge, 1995.

Johnson, Sarah Lee. "'A Memory Sweet to Soldiers': The Significance of Gender in the History of the American West", in Mary Anne Irwin and James Brooks eds. *Women and Gender in the American West*. Albuquerque: University of New Mexico Press, 2004.

Jones, Ernest. *On the Nightmare*, London: Hogarth Press, 1931.

Jowett, Lorna. "'Not Like Other Men'?: The Vampire Body in Joss Whedon's 'Angel'". *Studies in Popular Culture*, 32.1, 2009, 37–51.

Kane, Bob. *Batman & Me*. Forestville: Eclipse Books, 1989.

Kannerstein, Gregory. "Slang at a Negro College, 'Home Boy'". *American Speech*, 42.3, 1967, 238–239.

Karaminas, Vicki. "Übermen: Masculinity, Costume and Menaing in Comic Book Superheroes", in Peter McNeil and Vicki Karaminas eds. *The Men's Fashion Reader*. Oxford and New York: Berg, 2009, 179–186.

Keller, James. "Shady Agonistes: Eminem, Abjection, and Masculine Protest". *Studies in Popular Culture*, 25.3, 2003, 13–24.

Kelso, Sylvia. "The Feminist and the Vampire: Constructing Postmodernist Bodies". *Journal of the Fantastic in the Arts*, 8.4, 1997, 472–487.

Kemf, Damien and Maria L. Gilbert. *Medieval Monsters*. London: British Library Publishing, 2015.

Kerouac, Jack. *On the Road*. New York: Viking Press, 1957.

Kimmel, Michael S. "Masculinity as Homophobia: Fear, Shame and Silence in the Construction of Gender Identity". in Tracy Ore ed. *The Social Construction of Difference and Inequality*, 4th ed., New York: McGraw Hill, 2008.

Kubrin, Charis. "Gangstas, Thugs, and Hustlas: Identity and the Code of the Street in Rap Music". *Social Problems*, 52.3, 2005, 360–378.

Lacan, Jacques. *Écrits II*. Paris: Seuil, 1971.

Lacayo, Richard. "If Everyone id Hip... Is Anyone Hip", *Time*, August 8, 1994, http://content.time.com/time/magazine/article/0,9171,981219,00.html. Accessed February 28, 2017.

La Ferla, Ruth. "From Film to Fashion, a Trend with Teeth", *The New York Times*, https://mobile.nytimes.com/2009/07/02/fashion/02VAMPIES.html. Accessed February 16, 2017.

Lahof, Bruce. *American Commonplace: Essays on the Popular Culture of the United States*. Bowling Green Ohio: Bowling Green State University Popular Press, 1982.

Latham, Robert. *Consuming Youth: Vampires, Cyborgs and the Culture of Consumption*. Chicago: University of Chicago Press, 2002.

Lauger, Timothy. *Real Gangstas: Legitimacy, Reputation, and Violence in the Intergang Environment*. New Brunswick: Rutgers University Press, 2012.

Lee, Denny. "Has Billburg Lost Its Cool?", *The New York Times*, 27 July, 2003, www.nytimes.com/2003/07/27/nyregion/has-billburg-lost-its-cool.html. Accessed February 24, 2017.

Lee, Benjamin. "Avant-Garde Poetry as Subcultural Practice: Mailer and Di Prima's Hipsters", *New Literary History*, 41.4, 2010, 775–794.

Lévi-Strauss, Claude. *The Way of the Masks*. trans. Sylvia Modeleski, Seattle: University of Washington Press, 1988.

Levine, Andrea. "The (Jewish) White Negro". *MEUS*, 28.2, 2003, 59–81.

Levy, Adam Harrison. 'The Inventor of the Cowboy Shirt", *Design Observer,* September 30, 2008, http://designobserver.com/feature/the-inventor-of-the-cowboy-shirt/7187. Accessed March 11, 2017.

Lewis, Tasha. "From Fabulous to Glamorous. Fashion Change in Hip-Hop Culture", paper presented at the Popular Culture Association Conference, San Antonio, Texas, March 2004.

Mailer, Norman. *Advertisements for Myself* (1961). London: Harper Collins, 1994.

Mann, Thomas. *Death in Venice and Other Stories.* trans. David Luke, London: Vintage, 1998.

Marcus, James. "The First Hip White Person". *The Atlantic,* February 2001, www.theatlantic.com/magazine/archive/2001/02/-the-first-hip-white-person/302104/ accessed 21 February, 2017.

Marx, Karl. *Capital.* New York: Appleton, 1889.

McAllister, Matthew, Edward Sewell and Ian Gordon, eds. *Comics and Ideology.* Pieterlen and Bern: Peter Lang, 2001.

McCann, Andrew. "Rosa Praed and the Vampire-Aesthete". *Victorian Literature and Culture,* 35.1, 2007, 175–187.

Mcclintock, Anne. *Imperial Leather: Race, Gender and Sexuality in the Colonial Contest.* London: Taylor and Francis, 2013.

McFarland, Pancho. *The Chican@ Hip Hop Nation: Politics of a New Millennial Mestizaje.* Detroit: Michigan State University Press, 2013.

McGann, Jerome, ed. *Byron.* Oxford and New York: Oxford University Press, 1986.

McInerney, Jay. "How Bond Saved America", in Jay McInerney, et al. *Dressed to Kill. James Bond the Suited Hero,* Paris and New York: Flammarion-Pere Castor, 1996.

McNeil, Peter and Vicki Karaminas eds. *The Men's Fashion Reader,* Oxford: Berg, 2009.

Melville, Herman. *Moby Dick.* London: Dent, 1993.

Mercer, Kobena. "Race, Sexual Politics and Black Masculinity: A Dossier", in Rowena Chapman and Jonathan Rutherford eds. *Male Order, Unwrapping Masculinity,* London: Lawrence and Wishart, 1988, 97–164.

Morris, Edward. *Learning the Hard Way: Masculinity, Place and the Gender Gap in Education.* New Brunswick: Rutgers University Press, 2012

Mortimer, John. "Byron's Greek Odyssey", *The Telegraph,* 28 September 2005, www.telegraph.co.uk. Accessed February 18, 2017.

Mukherjea, Ananya. "My Vampire Boyfriend: Postfeminism, 'Perfect' Masculinity, and the Contemporary Appeal of Paranormal Romance". *Studies in Popular Culture,* 33.2, 2011, 1–20.

Musil, Robert. *Der Man Ohne Eigenschaften.* Hamburg: Rowohlt, 1978.

Nayfack, Shakina. "Que le watcha los cabrones: Marking the 30th Anniversary of Louis Valdez's 'Zoot Suit'". *TDR,* 53.3, 2009, 162–169.

Obregón Pagán, Edouardo. "Los Angeles Geopolitics and the Zoot Suit Riot, 1943". *Social Science History,* 24.1, 2000, 223–256.

O'Brien, Glenn, ed. *The Cool School: Writing From America's Hip Underground.* New York: Library of America, 2003.

O'Conner, Stephen. "Hipster's Hopper". *Massachusetts Review,* 45.2, 2004, 218–232.

Osgerby, Bill. *Playboys in Paradise: Masculinity, Youth and Leisure Style in Modern America*. Oxford: Berg, 2001.

Osterweil, Ara. "An Lee's Lonesome Cowboys". *Film Quarterly*, 60.3, (Spring 2007), 38–42.

Oware, Matthew. "Decent Daddy, Imperfect Daddy: Black Male Rap Artists' Views of Fatherhood and the Family". *Journal of African American Studies*, 15.3, 2012, 327–351.

Owen, Susan, ed. *A Companion to Restoration Drama*. Oxford and London: Oxford University Press, 2001.

Packard, Chris. *Queer Cowboys and Other Erotic Male Friendships in Nineteenth-Century American Literature*. Palgrave McMillan, 2006.

Paglia, Camille, *Sexual Personae*, London: Vintage, 1990.

Palmer, Gareth. "Bruce Springsteen and Masculinity", in Shiela Whiteley ed. *Sexing the Groove: Popular Music and Gender,* London and New York: Routledge, 1997.

Pascoe, C. J. "Becoming Mr Cougar: Institutionalizing Heterosexuality and Homophobia at River High", *Counterpoints*, 367, 145–157.

Patterson, Eric. *On Brokeback Mountain: Meditations about Masculinity, Fear and Love in the Story and the Film*. London: Lexington Books, 2008.

Paz, Octavio. *The Labyrinth of Solitude*. London: Grove Press, 1994.

Perkin, Harold. *The Origins of Modern English Society, 1780–1880*. London: Routledge and Keagan and Paul, 1967.

Petrus, Stephen. "Rumblings of Discontent: American Popular Culture and its Response to the Beat Generation, 1957–1960". *Studies in Popular Culture*, 20.1, 1997, 1–17.

Phillips, Nickie and Staci Strobl, *Comic Book Crime*. New York: NYU Press, 2013.

Pinn, Anthony. "'Getting Grown': Notes on Gangsta Rap Music and Notions of Manhood". *Journal of African American Men*, 1.4, 1996, 23–35.

Polhemus, Ted. *Street Style: From Sidewalk to Catwalk*. London: Thames and Hudson, 1994.

Potvin, Jogn. "From Gigolo to New Man: Armani, America and the Textures of Narrative". *Fashion Theory*, 15.3, April 2011, 279–297.

Praz, Mario. *The Romantic Agony*, trans. Angus Davidson, 2nd ed. London and New York: Oxford University Press, 1970.

Preciado, Bretiz. "Pornotopia", in Beatriz Colomina, Annemarie Brennan and Jeanie Kim eds. *Cold War Hothouses*, New York: Princeton Architectural Press, 2004.

Predelli, Stefano. "Superheroes and Their Names", *American Philosophical Quarterly*, 41.2, 2004, 107–123.

Proulx, Annie. "Brokeback Mountain. Cowboys and Horses and Long, Lonely Nights in the Wilderness", *The New Yorker*, October 13, 1997, www.newyorker.com/magazine/1997/10/13/brokeback-mountain. Accessed March 6, 2017.

Quinn, Eithne. "'Who's the Mack?': The Performativity and Politics of the Pimp Figure in Gangsta Rap". *Journal of American Studies*, 34.1, 2000, 115–136.

Ramírez, Catherine. "Crimes of Fashion: The Pachuca and Chicana Style Politics". *Meridians*, 2.2, 2002, 1–35.

Randolph, Antonia. "'Don't Hate Me Because I'm Beautiful': Black Masculinity and Alternative Embodiment in Rap Music". *Race, Gender, Class*, 13.3/4, 2006, 200–2017.

Reichstein, Andreas. "Batman–An American Mr Hyde?". *Amerikastudien/ American Studies*, 43.2, 1998, 329–350.

Reilly, Andrew and Sarah Cosby, eds. *Men's Fashion Reader*. Oxford and New York: Berg, 2009.

Rich, B. Ruby. "Hello Cowboy", *The Guardian*, Friday September 23, 2005. www.theguardian.com/film/2005/sep/23/3. Accessed March 27, 2017.

Richmond, Scott. "The Exorbitant Lightness of Bodies, or How to Look at Superheroes: Ilinx, Identification, and 'Spider-Man'". *Discourse*, 34.1, 2012, 113–144.

Sanchez-Tranquilino, Marcos and John Tagg, "The Pachuco's Flayed Hide: Mobility, Identity, and Buenas Garras", in Lawrence Grossberg, Cary Nelson and Paula Treichler eds. *Cultural Studies,* New York: Routledge, 1992, 559.

Sangsue, Daniel. "Les Vampires littéraires". *Littérature*, 75, 1989, 92–111.

Savage, Jon. "What's So New About the New Man?" *Arena*, March/April, No. 8, Spring, 1988.

Schaffer, Talia. "A Wilde Desire Took Me: the Homoerotic History of Dracula". *ELH*, 61.2, 1994, 381–425.

Sebba, Mark. "Will the real impersonator please stand up? Language and identity in the Ali G websites". *AAA: Arbeiten aus Anglistik und Amerikanistik*, 28.2, 2003, 279–304.

Secrest, Meryle. *Elsa Schiaparelli: A Biography*. New York: Random House, 2014.

Serpell, Namwali. *Seven Modes of Uncertainty*. Cambridge, MA: Harvard University Press, 2014.

Shoemaker, Steve. "Norman Mailer's 'White Negro': Historical Myth or Mythical History?", *Twentieth Century Literature*, 37.3, 1991, 343–360.

Showalter, Elizabeth, ed. *Speaking of Gender*. London and New York: Routledge, 1990.

Smith, Kevin. "A Superman for All Seasons". *TV Guide*, USA, 8 December, 2001.

Smith, Jon. *Finding Purple America*. Georgia: University of Georgia Press, 2013.

Snaith, Guy. "Tom's Men: The Masculinization of Homosexuality and the Homosexualization of Masculinity at the End of the Twentieth Century". *Paragraph*, 26, 2003, 77–88.

Springer, Claudia. *James Dean Transfigured: The Many Faces of Rebel Iconography*. Texas: University of Texas Press, 2013.

Stearns, Peter N. *Be a Man! Males in Modern Society*, 2nd ed. New York: Holmes and Meyer, 1991.

Stoker, Bram. *Dracula* (1897). http://literature.org/authors/stoker-bram/dracula/chapter-02.html.

Sullivan, Nick. "Dressing the Part", in Jay McInerney et al., *Dressed to Kill: James Bond the Suited Hero*. Paris and New York: Flammarion-Pere Castor, 1996.

Taylor. Marvin J. "Looking for Mr Benson. The Black Leather Motorcycle Jacket and Narratives of Masculinity", in H. Joseph Hancock, Toni Johnson-Woods and Vicki Karaminas eds. *Fashion in Popular Culture*, Bristol: Intellect, 2013, 123–133.

Thompson, Robert Farris. "An Aesthetic of the Cool", *African Arts*, 7.1, 1973, 40–91.

Thorbum, Adam. "Confronting Tom of Finland". www.polarimagazine.com/features/confronting-tom-finland/. Accessed June 2, 2015.

Traister, Rebecca. "Bruce Springsteen's Memoir Beautifully Dissects his Masculinity", *Entertainment*, www.aol.com/article/entertainment/2016/09/28/bruce-springsteens-memoir-beautifully-dissects-his-own-masculin/21482803/. Accessed April 27, 2017.

Tulloch, Carole. *The Birth of Cool: Style Narratives of the African Diaspora*. London: Bloomsbury, 2016.

Turcotte, Gary. *Peripheral Fear: Transformation of the Gothic in Canadian and Australian Fiction*. Sydney: Peter Lang, 2009.

Ursini, J and A. Silver, *The Vampire Film*, London: The Tantivy Press, 1975.

Vattimo, Gianni. *Art's Claim to Truth*, ed. Santiago Zabala, trans. Luca D'Isanto, New York: Columbia University Press, 2008.

Ward, Russel Braddock. *The Australian Legend*. Oxford: Oxford University Press, 1958, 145.

Weiner, Robert G., Whitfield Lynn B. and Becker Jack, eds. *James Bond in World and Popular Culture*, 2nd ed., Newcastle upon Tyne: Cambridge Scholars Publishing, 2011.

Welters, Linda. "The Beat Generation", in Linda Welters and Patricia A. Cunningham eds. *Twentieth Century American Fashion*, Oxford: Berg, 2005.

Weltzein, Friedrich. "Masque-ulinities: Changing Dress as a Display of Masculinity in the Superhero Genre". *Fashion Theory*, 9.2, 2005, 229–250.

Wertham, Frederic. *Seduction of the Innocent*. (1954) Port Washington, NY: Kennikat Press, 1972.

Whannel, Gary. *Media Sports Stars: Masculinities and Moralities*. London and New York: Routledge, 2002.

White, Edmund. *The Beautiful Room is Empty*. London: Picador, 1988.

White, Edmund. *Genet*. London: Chatto and Windus, 1993.

White, Shane and Graham White. *Stylin': African American Expressive Culture and Its Beginnings in the Zoot Suit*. Ithaca and London: Cornell University Press, 1998.

Whiting, Frank. "Stronger, Smarter, and Less Queer: 'The White Negro' and Mailer's Third Man". *Women's Studies Quarterly*, 33.3/4, 2005, 189–214.

Wierzbicki, James. *Music in the Age of Anxiety*. Illinois: University of Illinois Press, 2016.

Wilde, Oscar. "Phrases and Philosophies for the Use of the Young", *Complete Works of Oscar Wilde*, London: Heron, 1966.

Williams, Rosalind. *Dream Worlds: Mass Consumption in Late Nineteenth-Century France*. Berkeley and Los Angeles: University of California Press, 1982.

Williamson, Milly. *The Lure of the Vampire: Gender Fiction and Fandom from Bram Stoker to Buffy*. London: Wallflower Press, 2005.

Wilsher, Toby. *The Mask Handbook: A Practical Guide*. London and New York: Routledge, 2006.

Wilson, Elizabeth. *Adorned in Dreams: Fashion and Modernity*. Berkley: University of California Press, 1985.

Wilson, Elizabeth. "Exhibition Review: Camouflage and Sailor Chic". *Fashion Theory*, 12.2, 2008, 277–284.

Winge, Teresa. "Costuming the Imagination: Origins of Anime and Cosplay", *Mechademia*, 1, 2006, 65–76.

Witt, Grace. "The Bad Man as Hipster: Norman Mailer's Use of Frontier Metaphor". *Western American Literature*, 4.3, 1969, 203–217.

Zehr, Paul. *Becoming Batman*. Baltimore: Johns Hopkins University Press, 2008.

Zirakzadeh, Cyrus. "Political Prophecy in Contemporary American Literature: The Left-Conservative Vision of Norman Mailer". *The Review of Politics*, 69.4, 2007, 625–649.

Zizek, Slavoj. *For They Know Not What They Do: Enjoyment As a Political Factor*. London and New York: Verso, 1991.

Zizek, Slavoj. *Living in End Times*. London and New York: Verso, 2011.

Zizek, Slavoj. *Less Than Nothing: Hegel and the Shadow of Dialectical Materialism*. London and New York: Verso, 2012.

Zizek, Slavoj. *Trouble in Paradise: From the End of History to the End of Capitalism*. Brooklyn and London: Melville House, 2014.

Internet References Not Otherwise Cited

"Ali G Interviews Posh Spice and David Beckham", www.youtube.com/watch?v=P842Tmi6lrc. Accessed 18 September, 2016.

Complex News, "Human Ken Doll Dies at 20 After Spending $50,000 on Plastic Surgery", www.youtube.com/watch?v=VjIslx2Nl1I. Accessed 25 May, 2017.

Dangerous Minds. Sid Viscious Death Wish. http://dangerousminds.net/comments/bury_me_with_my_boots_on_sid_viciouss_death_wish. Accessed 17 April, 2017.

Dapper Dan the Hip-Hop Tailor of Harlem, www.sneakerfreaker.com/features/dapper-dan-the-hip-hop-tailor-of-harlem/. Accessed February 2, 2017.

Simpson, M. 'Meet the Metrosexual', "A Psychoanalysis of Bruce Wayne", www.youtube.com/watch?v=eRlbV8tNILg. Accessed 23 May, 2016; http://www.salon.com/ent/feature/2002/07/22/metrosexual/. Accessed February 5, 2016.

"Spotter's Guide", www.smh.com.au/nsw/a-spotters-guide-to-the-emerging-tribes-of-sydney-20140607-39qc2.html, June 7, 2014. Accessed February 27, 2017.

World Superhero Registry. www.worldsuperheroregistry.com/world_superhero_registry_gallery.htm.

Filmography

8 Mile. dir. Curtis Hanson, Universal, 2002.

American Psycho, dir. Mary Harron, Edward Pressman/Muse Productions, 2000.

The Assassination of Jesse James, dir. Andrew Dominik, Warner Bros, 2007.

Batman Begins, dir. Christopher Nolan, DC Comics, 2005.

Batman v Superman: Dawn of Justice, dir. Zack Snyder, RatPac-Dune and DC Entertainment, 2016.

Bram Stoker's Dracula, dir. Francis Ford Coppola, Columbia Pictures, 1992.

Brokeback Mountain, dir. Ang Lee, Focus Features, River Road Entertainment, 2005.

The Dark Knight, dir. Christopher Nolan, Legendary Pictures/DC Entertainment, 2008.

The Dark Knight Rises, dir. Christopher Nolan, Legendary Pictures/DC Entertainment, 2012.

Fantasy Island, dir. Gene Levitt, Columbia Pictures, 1977–2004.

Giant, dir. George Stevens, George Stevens Productions, 1956.

The Incredibles, dir. Brad Bird, Walt Disney Pictures, 2004.

Lonely Are the Brave, dir. David Miller, Joel Productions, 1962.

Midnight Cowboy, dir. John Schlessinger, MGM, 1969.

The Misfits, dir. John Houston, Seven Arts Pictures, 1961.

Ned Kelly, dir. Gregor Jordan, Australian Film Commission, 2003.

Querelle, dir. Rainer Werner Fassbinder, Gaumont, 1982.

Rebel Without a Cause, dir. Nicholas Ray, Warner Bros, 1955.

Stagecoach, dir. John Ford, Walter Wanger Productions, 1939.

A Streetcar Named Desire, dir. Elia Kazan, Warner Bros, 1951.

Thelma and Louise, dir. Ridley Scott, Pathe Entertainment, 1991.

Vengeance Valley, dir. Richard Thorpe, Metro-Godwyn-Mayer, 1951.

Westworld, dir. Jonathan Nolan, HBO, 2006.

The Wild One, dir. Benedek Làszló, Columbia Pictures, 1953.

The Wild One, dir. László Benedek, Stanley Kramer Productions, 1953.

Index

AIDS 54, 128, 135
Abraham Lincoln: Vampire Hunter
 (film) 5
Adams, James Eli 9; *Dandies and
 Desert Saints* 13
Adidas (brand) 140
Aeschylus 23
aesthetic (movement), aestheticism 7, 20
Affleck, Ben 133
Akubra (hat) 99, 100
Alexander the Great 5
Alfredson, Thomas 25
Ali G 153–154, 155; See also Baron
 Cohen, Sasha
Allon, Fiona 82
Alvarez, Luis 144
Alvey, Nahoko 90
American Broadcasting Network 90
American Civil War 129
American Gigolo (film) 16–17, 85
Andress, Ursula 41
Anger, Kenneth 112
Ant-Man 122
Arena (magazine) 4, 15
Armani (brand) 16, 142
Armani, Giorgio 30 n.31, 45; See also
 Armani (brand)
armas 91
Arvanitakis, James 50
askesis 13
Aston Martin 44
Athletic Model Guild 111
Atomic Hero Wear
Attwood, Feona 37

BDSM 104, 113; See also S/M
Bakhtin, Mikhail 123
Balsick, Chris 21
Ball, Allen 20
barbaroi 26

Barber, Paul 22, 23
Barbey D'Aurevilly, Jules 3–4, 11
Barbie 2
Bardot, Brigitte 72
Barksdale, David 139
Baron Cohen, Sasha 153
Baroque 27, 83
Batgirl 134
Batman 5, 120–121, 125, 127, 128,
 129, 133–135
Batman Begins see *Dark Knight
 Trilogy*
Batman vs. Superman (film) 126,
 130, 133
Baudelaire, Charles 1–2, 9–11; *flâneur*
 1, 27, 28–29; *Painter of Modern
 Life* 1; See also dandy
Baudrillard, Jean 13
Baxters (shoe) 99
Beatles, The (band) 109
Beats, The Beat Generation, beatniks,
 The 49, 53–59, 63, 109; See also
 Boroughs, William; Ginsberg, Allan;
 Kerouac, Jack
Beckham, David 19
Belucci, Monica 43
Benedek, Laszlo 62, 93, 107
Bentley (automobile) 44
Billig, Michael; *Banal Nationalism* 129
Billy the Kid 95
Biotherm (brand) 20
Black Gangster Disciples 139
Black Goliath 124
Black Lighting 124
Black Panther 124, 125
Black Panthers 152
Black Power 59
Black Sails (TV series) 68
Blade (film) 26
bling 143, 150

Blundstones (shoe) 99
Boeck, George 91
bohemian 11, 48, 49, 53, 109, 114
Bolton, Andrew 127
bomber jacket 108
Bon Jovi, Jon 116
Bonaparte, Napoleon 5; Napoleonic
 era 70
Bond, James 6, 33, 38, 41–45; See also
 Fleming, Ian
Bordo, Susan 17, 89, 104–105, 107,
 109; *The Male Body* 17
Bowery, Leigh 11
Bowie, David 72
Boy Extracting a Thorn (sculpture) 74
Bram Stoker's Dracula (film) 26
Brando, Marlon 4, 37, 54, 62, 93, 105,
 105, 106–107, 110, 111, 112, 116
Brandweek (magazine) 49
Breton shirt 71, 81; See also marinière
Brite, Poppy Z.; *Lost Souls* 24, 28
Brokeback Mountain (film) 85–87,
 95, 101 n.1
Bronson, Charles 15
Brookner, Anita 10–11
Brooks, James 91
Brosnan, Pierce 6
Brownie, Barbara 122, 123, 127, 131
Browning, Tod 24
Broyard, Anatole 48; *Portrait of a
 Hipster* 59
Brummell, George Bryan 'Beau' 11,
 43; see also dandy
Bruzzi, Stella; *Undressing Cinema*
 44, 86
Buffalo Bill 3
Burlinson, Tom 100
Burroughs, William 49; *Naked
 Lunch* 53
bushmen 97, *100*, 85–103
Butler, Judith 153
Byron, Lord (George Gordon 6th
 Baron Byron) 11–13, *12*, 22, 23;
 'Byronic hero' 12; *Childe Harold*
 12; *Don Juan* 12; *Giaour* 7

Cable 135
Cadillac 92
Cadmus, Paul 73
Caen, Herb 53
Californian Gold Rush 112–113
Calvin Klein (brand) 18
Calloway, Cab 58, *58*, 60
camp 26, 68, 76, 82, 94, 95, 122, 133,
 134, 136

capitalism, capitalist 8, 16, 18, 21, 29
 38, 51, 62, 63, 98, 109, 117
Carlyle, Thomas 9, 14
Camus, Albert; *The Myth of
 Sisyphus* 51
Captain America 121, 122, 128, 135
Captain Marvel 124
Carter, Jimmy; Carter era 16
Carter, Michael 130
Case, Sue Ellen 24
Castelbajac, Jean-Charles 128
Castle, Cyril 45
Cawelti, John 88
Chandler, Robin 141
Chandler-Smith, Nuri 141
Chanel, Gabrielle "Coco" 72, 80
chaparejos 91
Charlton, Sue 99
Chrichton, Michael 89
Church Gibson, Pamela 37, 98, 105
Civil War, England 69
Clellon Holmes, John 56; *Go!* 53
Cobain, Kurt 62
'cock rock' 116
Cocteau, Jean 72
Cohan, Stephen 34
Cold War 7, 38, 93, 106,
 108–109, 122
Cole, Shaun 87–88, 112, 113
Colt Studio 87
communism, communist 7, 18, 38, 41,
 106, 109, 121, 128, 129
Connery, Sean 38, 41
Conquistadores 145
Constantino, Maria 110
Converse (brand) 140
Cook, Pam 45–46
Coolio; 'Gangster's Paradise' 149
Cooper, Gary 33, 41
Coppi, Jacopo 69
Coppola, Francis Ford 26
Cosgrove, Stuart 143, 146
Cosmopolitan (magazine) 15
Cosplay 132
Counselor, The (film) 98
Count Dracula (1931 film) 24
cowboy 5, 87, *92*, 85–103, 108, 131
Craig, Daniel 6
Craik, Jennifer 69, 79, 98–99
Crisp, Quentin 78
Crocodile Dundee (film) 99
Crothers Dilley, Whitney 127
Cruising (film) 112–113
Cuban Missle Crisis 122

Curtis, Tony 41
Custer, General George 3

DC Comics 122
DIY 117–118
DJ Yella 148
D'Artagnan (Charles de Batz
 Castelmore d'Artagnan) 5
dandy 1–2, *10*, 7–32, 33, 43–44, 48,
 60, 111, 161; see also vampire
 dandy
Dapper Dan 140
Daredevil 128
Dark Ages 22
Dark Knight Rises, The see *Dark
 Knight Trilogy*
Dark Knight Trilogy (films) 122–123,
 133, 134
Davis, Geena 98
Dean, James 4, 20, 37, 48, 56, *61*,
 61–2, 92–93, 106, 110, 112, 116
Deanagán, Edouardo 142–143
decadent (movement) 7, 20
Delacroix, Eugène; *Death at
 Sardanapolous* 22; *Massacre at
 Chios* 22
Delon, Alain 4
Demuth, Charles 73
Dench, Judy 43
Detective Comics see DC Comics
Diesel (brand) 79
Dines, Gail 36
Dior (brand) 72
Dole & Gabbana (brand) 72
Doisneau, Robert 80
Donahue, Jack 95
Doors, The (band) 109, 114
Douglas, Kirk 68, 93
Dr Dre 147
Dr Martins (shoe) 117
Dr No (film) 28; See also Bond,
 James; Fleming Ian
Dr Spock 132
Dracul, Vlad; See also Stoker, Bram
Dracula 8, 22, 23, 24, 26; See also
 Dracul, Vlad: Stoker, Bram
Dracula Has Risen From the Grave 24
drag, dragging 132, 153, 157 n.61
Driza-Bone (coat) 100
Dunhill (brand) 44
Dunkerley Hat Mills 99
Dylan, Bob 109

Eames, Charles 40
East of Eden (film) 93

East India Company 69
Eastwood, Clint 15
Easy Rider (film) 109
Edward VII 72, 74
Edwards, Tim 18
Eiffel Tower 81
8 Mile (film) 154
Eisenhower, Dwight; Eisenhower
 era 38
Eisenstaedt, Alfred 80
Ellen, Barbara 19
Ellison, Ralph; *The Invisible Man*
 60, 143
Eminem (Marshall Mathers) 142, 146,
 154–155; *The Slim Shady* 154
Engels, Frederick; *The Condition of
 the Working Class in England* 21
Esquire (magazine) 15, 42, 44, 56
Evans, Caroline 50
existentialism 49

FHM (magazine) 17
Fabergé (brand) 44
Fabrican 130
Faiman, Peter 99
Faludi, Susan 15
Fantastic Four 135
Fantasy Island (TV series) 90
Farris Thompson, Robert; 'An
 Aesthetic of Cool' 49
Fassbinder, Rainer Werner 81
Fendi (brand) 21, 140
Ferrigno, Lou 4, 15
fetish, fetishize 15, 38, 39, 51, 78, 82,
 88, 95, 111, 113, 115, 147
50 Cent 142
First World War 72, 110, 142
'flagging' 112
flâneur, see Baudelaire, Charles
the Flash 121, 122, 126, 136 n. 7
Fleming, Ian 36, 41, 42; *Dr No* 38,
 41; *The Hildebrand Rarity* 42;
 James Bond (novels) 36; See also
 Bond, James
Foley, Jack 55, 58, 65 n.30
Fonda, Peter 109
Ford, John 93
Ford, Philip 62, 64 n.13
Ford, Tom 45
Fortune (magazine) 49
Foster, Dylan 23
Foucault, Michel 13, 127; *Heterotopia*
 89; *History of Sexuality Volume 1*,
 14; 'Of Other Spaces' 76–77
Francis, Freddie 24

Fraterigго, Elizabeth; *Playboy and the Making of the Good Life in Modern America* 40
French, Jim 87
French Revolutionary Wars 69–70
Freud, Sigmund 25, 126; *Civilization and its Discontents* 124
Freidkin, William 112
Frith, Simon 116; *Sound Effects: Youth, Leisure and the Politics of Rock* 114
Fritscher, jack 113
From Russia with Love (film) 41; See also Bond, James; Fleming Ian
Furie, Sidney 108

GQ (*Gentleman's Quarterly* magazine) 15, 44
Gable, Clark 60, 86
gamine 1
gangsta 6, 139–159, 161
Garber, Marjorie 79
Garelick, Rhonda 80
Gaultier, Jean Paul 80–83; *Le Beau Mâle* (fragrance) 82–83; *Les Filles de la Marine* collection 81; *The Love Boat* collection 81; *Le Mâle* (fragrance) 82; *Pin-Up Boys* 82; *Punk Can Can* collection 81; See also Jean Paul Gaultier (brand)
Gaylord, Karen 54–55, 65 n.34
Gelder, Ken 27–28
Geller, Robert; Fall 2009 Collection 21
Genet, Jean 81; *Querelle de Brest* 73–74; See also *Querelle* (film)
Gere, Richard; Julian Kaye 16–17
Gestapo see Nazi
Get Smart (TV series) 38
ghettocentricity 141–142
Giant (film) 93
Gillespie, Dizzy 58, 60
Gilligan, Sarah 45, 94, 101
Ginsberg, Allan 49, 54, 57, 60, 109; *Howl* 53, 109
Givenchy (brand) 72
Godfrey, Sima 9
Gold, Herbert 56
Goldfinger (film) 41; See also Bond, James; Fleming Ian
Golden Mirror, The (fashion film) 21
Gone With the Wind (film) 60
Gonzalez, Eric 87
Goodwin, Benny 59

Grant, Cary 33, *34*, 41
Graydon, Danny 122, 123, 127, 131
Grease (film) 117
greaser 116–118, 145
Great Depression 121–122, 131, 142
Great Train Robbery, The (film) 93
Greek War of Independence 22–23
Green Lantern 121, 122, 135
Griswald del Castillo, Richard 145
Grosz, Elizabeth 77
Grundmann, Roy 154
Guadagigno, Luca 21
Gucci (brand) 45, 140, 142
Guerlain (brand); *L'Homme* (fragrance) 82
Guevara, Ernesto Che 62, 66 n.64
Gustavus Adolphus of Sweden 69
Gyllenhaal, Jake 85–86

HBO 20, 26, 89
Haberstam, David 36
Hall, Ben 95
Hall, Stuart; *Resistance Through Rituals* 110
Hamilton, Guy 41
Hancock, Joseph 36
Happy Days (TV series) 116–117
Hardwicke, Catherine 25
Harley-Davidson 107, 113, 116
Harris, Charlaine; *Dead and Gone* 20
Harris, Ed 90
He-men 15–16
Hebdidge, Dick 50
Hefner, Hugh 14–15, 35, 36, 37, 38, 42, 44; See also *Playboy*
Hgeel, G.W.F. 125
Hell, Richard 117
Hellenism, Hellenic 4
Hells Angels 107
Hendrix, Jimi 109
Hepburn, Audrey 72
Herzog, Werner 26
Hines, Claire 45–46
hip-hop 140–142, 146–147, 158 n.58
hipster 6, 65 n.34, 48–66
Hobsbawn, Eric 97, 98
Hofmann, Distin 94
Hogan, Paul 99
Hogan's Heroes (TV series) 108
Holden, William 105
Hollister Riots 107, 108
Holly, Buddy 50
Homer 23
Hopkins, Anthony 90

Hopper, Dennis 109
Horning, Rob 62
Hudson, Rock 33, *35*, 41, 93
Hulk, the 4, 15, 122, 126, 127, 128;
 See also Ferrigno, Lou
Hustler (Magazine) 4, 15
Huston, John 86
Huysmans, Joris Karl; *À Rebours* 43

Ice Cube (O'Shea Jackson) 148
Incredibles, The (film) 130
Internet 135
Iron Man 122, 125, 126, 127, 129
Irwin, Mary Anne 91

Jackson, O'Shea see Ice Cube
James, Jessie 3, 95, 98
James, Jessie 3
Jardini, Rossela 128
Jean Paul Gaultier (brand) 72
James, David 62–63
Jessica Jones 135
John Baumgarten Company 36
Joplin, Janis 109
Joker, the 134
Jones, Ernest 25
Jones, Stephen 128

Kazan, Eli 93, 105
Keller, James 154–155
Kelly, Gene 5
Kelly, Ned 3, 95, *96*, 98
Kennedy, John F. 41–42
Kenzo (brand) 80
Kerouac, Jack 49, 54–56, 57, 60; *On
 the Road* 53, 55, 59–60, 109
Kevlar 130
Kid Creole 146
Kimmel, Michael; 'Marketplace
 Man' 15
King, Martin Luther 36
Kinski, Klaus; Nosferatu 26
Kinsley Report, The 39
Kipnis, Laura 77
Kleiser, Kandel 117
Knight, Nick 18
Knights Templar 69
Kublai Khan 5
Kubrin, Chris 152
Kurkjian, Francis 82

La Chapelle, David 79–80; *Victory* 80
Laaksonen, Touko, see Tom of Finland
Lacan, Jacques 120, 124, 126

Lagerfeld, Karl; Croisière
 collection 72
Lahof, Bruce 88
Lancaster, Burt 93, 105
Latham, Rob 15, 18–19
Latin Lovers 145
Lauger, Timothy 149–150
Le Fanu, Joseph Sheridan; *Camilla* 22
Leather Boys (film) 108
leather men 104–119
Ledger, Heath 85–86
Lee, Ang 85
Lee, Christopher 24
Lee, Henry David 93; See also Lee
 (brand)
Lee (brand) 93; Cowboy Pants 93;
 101B jeans 93; 101Z jeans 92, 93;
 Riders 93
Leigh, Vivian 105
Lestat, see Rice, Anne
Let the Right One In (film) 20, 25
Lévi-Strauss, Claude 125
Levi Strauss and Co (brand) 86; 501
 jeans 93; XX model jeans 93
Levitt, Gene 90
Lewis, Tasha 140
libertine 33
Lidner, Robert; *Rebel Without a
 Cause: The Hypnoanalysis of a
 Criminal Psychopath* 61
Life (magazine) 41, 80
Lindqvist, John Ajvide; *Let the Right
 One In* (novel) 25; See also *Let the
 Right One In* (film)
Loaded (magazine) 17–18
Lombardo, Guy 58
Lonely are the Brave (film) 93
Lonesome Cowboys (film) 94–95
Longfellow, Henry Wadsworth 100
Lorentzen, Justin 79
Lotus (automobile) 44
Louis XVIII 5
Louis Vuitton (brand) 76, 140
Luke Cage 135
Lycra 129–130

MTV 142
machismo, macho 56, 89, 94, 105,
 112, 114, 118, 140, 146
MAD (magazine) 63
Mailer, Norman 51–58, 63, 64 n.16,
 65 n.30; 'The White Negro' 51–54,
 56–57, 155
Man from Snowy River, The (film) 100

Mann, Thomas; *Death in Venice* 74–75
Many Loves of Dobie Gillis, The (TV series) 57
Mapplethorpe, Robert 113
Marceau, Marcel 72
marinière 71, 72, 80; see also Breton shirt, sailor
Marlboro Man 4, 88–89
Marley, Bob 153
Marras, Antonio 80
Marx, Karl 21; *Capital* 21–22
mask 9, 65 n.34, 112, 113, 121, 123–126, 128, 132, 133
Matheson, Bruno 40
Maxim (magazine) 17
McCarthy, Joseph 38
McClaren, Malcolm 117
McClintock, Anne 90–91
McFarland, Pancjo 151
McInerney, Jay 42
McRobbie, Angela 116
Medhurst, Andt 134
Melville, Herman; *Billy Budd* 74; *Moby Dick* 67–68, 74
Men's Health (magazine) 17
Mercedes Benz 16
metrosexual 19–20
Mexican Revolution 145
Meyer, Stephanie; *Twilight* (novel) 25; See also *Twilight* (book and film series)
Mezzrow, Mezz 59
Michael Kors (brand) 72
Middle Ages 69, 90
Midnight Cowboy (film) 94, 95
Milestone Comics 124, 136 n.18
Miller, George 100
Miller, Herman 40
Mineo, Sal 106
Misfits, The (film) 86
Missouri Public Gazette and Advertiser (newspaper) 60
Mitchum, Robert 105
Mizer, Bob 111
modernity, modern 23
Monk, Theolonius 58, 146
Monroe, Marilyn 36, 42
Montalnán, Ricardo 90
Moore, Roger 45
Morris, Edward 149
Morrison, Jim 114, 116
Moschino (brand) 128
Mr Cougar competition 150

Mr Olympia contest 4
Mulligan, Gerry 59
Muscle Mary 112
Musil, Thomas; *The Man Without Qualities* 160
Mustang (brand) 128

Nabokov, Vladimir 36
Napier, Admiral Sir Charles 69
Napoleon III 72
Napoleonic Wars 70; See also Bonaparte, Napoleon
Nazi, Nazism 111, 112
Neal, Larry; *Hoodoo Hollerin' Bebop Ghosts* 146
Nelson, Gary 38
'New Lad' 7, 17–19, 34
'New Man' 4, 7, 14, 16–19, 34
New York Dolls (band) 117
New York Motorcycle Club 107
New York Tines, The 49
Newman, Paul 105
Nietzsche, Friedrich 39, 51
9/11, September 11, 23
Nobuyuki, Takanashi 132
Nolan, Christopher 122
Norman, Neil 45
Nosferatu (1979 film) 26

Observer (newspaper) 19
Odysseus 121
Old Testament 68
Oldman, Gary; Dracula 26
Originals, The (TV series) 28
d'Orsay, Comte (Alfred Grimod d'Orsay) 11
Osgerby, Bill 36, 38
Osterweil, Ara 94–95
Oware, Matthew 152
Owens, Rick 21

PC 147
pachuco 61, 142–146
Pacino, Al 112
Pagán, Obregón 145
Paglia, Camille; *Sexual Personae* 3
Palmer, gareth 115
Parker, Charlie 58
Parker, Peter see Spiderman
Partisan Review (magazine) 48
Pascoe, Cheri Jo 150
Paz, Octavio 143
Pearl Harbour 122
Peck, Gregory 105

Penthouse (magazine) 15
Perfecto (jacket) 110
Pericles 23
Perostroika 7
Petri, Pay 18
Petrus, Stephen 56–57
Phat Farm (brand) 140
Phillips, Nicki 135
Phillips, Thomas 12
Physical Pictorial (magazine) 111
Picasso, Pablo 39, 72
Pierre et Gilles 82–83; *À nous deux la mode* 81; *Havre Harbour* 81
pimp 151
Pinaud Elixir (shampoo) 44
Pitt, Brad 98
Pixar 130
Plath, Sylvia 50
Plato 23; *Phaedrus* 75; *Symposium* 75
playboy 5, 6, 11–12, 19, 33–47, 161
Playboy (magazine, brand) 4, 14–15, 34–37, 38–42, 44, 46, 56, 104, 156; See also Hefner, Hugh
Plec, Julie 20
Plummer, Christopher 5
Polidori, John; *Vampyre* 8
political correctness see PC
Pop, Iggy 116
Popeye 78
pornography 36
Porter, Cole; 'What's Central Park without a Sailor?' 73
Post-democracy 8
Powell, Dick 33
Prada (brand) 72
Praed, Rosa 27; *A Romance of Today* 27; *The Soul of Countess Adrian: A Romance* 27
Preciado, Beatriz 39, 41
Presley, Elvis 37, 114, 116
Prince Regent (later George IV) 11
Proulx, Annie 85; *Brokeback Mountain* 85–86, 100 n.1; See also *Brokeback Mountain* (film)
Prowlers (film) 87–88
Puma (brand) 140
punk 51, 62, 81, 110, 116–118, 140

Querelle (film) 81
Quinn, Eithne 151

RLS 132–133, 136, 140
Ramones (band) 117
Randolph, Antonia 148

rap music 140
Rawhide Kid: Slap Leather (comic) 135
Ray, Nicholas 61, 93
Reagan, Ronald; Reagan era 7, 16
real life superheroes see RLS
Rebel Without a Cause (film) 61, 93, 106
Rechy, John; *City of Lights* 112
Reebok (brand) 140
Reichstein, Andreas 122, 134
Renaissance 27, 90
Reserve Training School 144
Rice, Anne; *Interview with a Vampire* 25, 28; Lestat, Louis 25, 27–28
Rich, Ruby 89
Ritts, Herb 18
Robinson, Smoky 17
Rocawear (brand) 140
rockabilly 116
Rogers, Steve see Captain America
Rolex watches 44
Rolling Stones (band) 68
Romanticism 7
Ruthven, Lord 8; See also Byron, Lord
Rymer, James Malcolm; *Varney the Vampire* 21

S/M 111, 112; See also BDSM
Saddle Tramps (film) 88
sailors 70, 67–84
Saint Laurent, Yves 45
San Francisco Beat (TV series) 57
San Francisco Chronicle (newspaper) 53
Savage, Jon 16
Schaffer, Talia 22
Schiaparelli, Elsa; *Shocking* (fragrance) 82
Schlesinger, John 94
Schott, Jack 110
Schrader, Paul 16
Schwarzenegger, Arnold 15; Conan the Barbarian 15–16; *Pumping Iron* 4
Scorpio Rising (film) 112
Scott, Ridley 98
Scott, Tony 108
Sean John (brand) 140
Sebba, Mark 153–154
Second World War 2, 38, 48, 52, 53, 107, 108, 113, 122, 124, 131
Secrest, Meryle 82
Seven Years' War 69
77 Sunset Strip (TV series) 57
Sex Pistols, The (band) 117, 118

Shuster, Joe 122
Siegel, Jerry 122
Simmell, Georg 17
Simpson, Mark 19
Sinatra, Frank 60
Sinclair, Anthony 45
Sixtus III, Pope 69
Smith, Lisa Jane; *Vampire Diaries* 20;
 See also *Vampire Diaries*
Smith, Michelle 28
Snaith, Guy 78, 111
Snoop Dog 142
Sonia Rykiel (brand) 72
Sontag, Susan 68
Spectre (film) 43; See also Bond,
 James; Fleming Ian
Spiderman 121, 126
Spinal Tap (film) 153
Springsteen, Bruce 114–115; *Born in
 the USA* 115; *Born to Run* 114–115
Stag Party (magazine) 36; See also
 Playboy (magazine)
Stagecoach (film) 93
Stallone, Sylvester 15; John Rambo 15
Star Trek 132
Stearns, Peter 14
Stendhal (Henri Beyle); *The Red and
 the Black* 41
Stetson hat 86, 92, 98
Stevens George 92
Stevenson, Robert Louis; *Treasure
 Island* 68
Stoker, Bram; *Dracula* 8, 22
Stonewall Riots 5
Strain, The (TV series) 26
Streetcar Named Desire, A (film) 105
Strobl, Stacie 135
Studio Hard 132
Sullivan, Nick 44
superhero 120–138, 161
Superman 5, 122, 123, 126, 128,
 129–130
Sur, Abin see Green Lantern

Taittinger (champagne) 44
Talking Heads (band) 117
Taylor, Elizabeth 93
Taylor, Marvin 110
Television (band) 117
terra nullius 96
Thelma and Louise (film) 98
Thor 122
Thorbum, Adam 79

Timberland (brand) 140
Time (magazine) 49
Tom of Finland (Touko Laaksonen)
 4, 73, 78–79, 111, 133; *Kake 18:
 Pants Down Sailor* 78
Tommy Hilfiger (brand) 140
Top Gun (film) 108
Toro, Guillermo del 26
Townsend, Larry; *The Leatherman's
 Handbook* 113
Traister, Rebecca 114
Travolta, John 117
True Blood (TV series) 20, 26, 28
Trump, Donald 147
Tulloch, Carol 141; *The Birth of Cool*
 48–49
Turner, Frederick 91
Twilight Saga (book and film series)
 20, 23, 25, 26
Tyrek 130

Underworld (film series) 26

'*V' for Vendetta* (film) 127
Valdez, Luis 146
vampire 8; and Marx 21–22; See also
 vampire dandy
vampire dandy 7–32; See also dandy
Vampire Diaries (TV series) 20
Van Beirendonck, Walter 127–128;
 Avatar collection 128; *Killer/
 Astral Travel/4D Hi-Di* collection
 127–128
Vanquero 91
Vásquez de Coronado, Francisco 91
Vattimo, Gianni 42–43
Vengeance Valley (film) 93
Vicious, Sid 118
Vienna Boys' Choir
Vietnam War 109
Village People (band) 4, 111; 'Go
 West' 112; 'Macho Man' 1123; 'In
 the Navy'
Villechaize, Hervé 90
Vincent, Gene 114
Voigt, Jon 94

W< (Wild and Lethal Trash,
 brand) 128
Walker, Gerald; *Cruising* 112; See also
 Cruising (film)
Wall Street Journal (newspaper) 49
Ward, Richard

Warhol, Andy 11, 72, 94
Waterloo (film) 5
Waugh, Thomas 115
Wayne, John 72, 93, 94
Weber, Bruce 18
Weil, James A. 86
Welk, Lawrence 59
Wellington, Duke of (Arthur
 Wellesley) 5
Welles, Orson 5
Weltzein, Friedrich 121
werewolves 26
Wertham, Frederick; *Seduction of the
 Innocent* 134
West, Adam 122, 133
West, Mae 82
Westwood, Vivienne 117
Westworld (film) 89
Westworld (TV series) 89–90
White, Edmund 74; *Beautiful Room is
 Empty* 75–76
white negro, see Mailer, Norman
Wierzbicki, James 64 n.16
Wild One, The (film) 62, 93, 106, 107,
 110, 111, 118 n.7
Wild West 89–90, 91
Wilde, Oscar 13, 27, 27, 31 n.50; and
 vampires 22; Trial 22

Wilhelm, Kaiser II 71
Williams, Tennessee; *The Rose
 Tattoo* 73
Williamson, Milly 23, 25, 27
Wilsher, Toby 123
Wilson, Elizabeth 43–44, 78
Winkler, Henry 117
Winterhalter, Franz-Xaver 72
Wolverine 126
Wonder Woman 138 n.66
Woodstrock 109
Woolf, Virginia
World Superhero Registry 131
World War I see First World War
World War II see Second World War

X, Malcolm 36
X-man 126

Young, Terrance 38

Zehr, Paul 122; *Becoming Batman* 126
Zen Buddhism 63
Zizek, Slavoj 5, 21, 26, 125
zombies 26
zoot suit 58–61, 140, 142–147; Zoot
 Suit Riot 144
Zoot Suit (film) 146